# THE BIG BOOK OF DRAWING AND PAINTING THE FIGURE

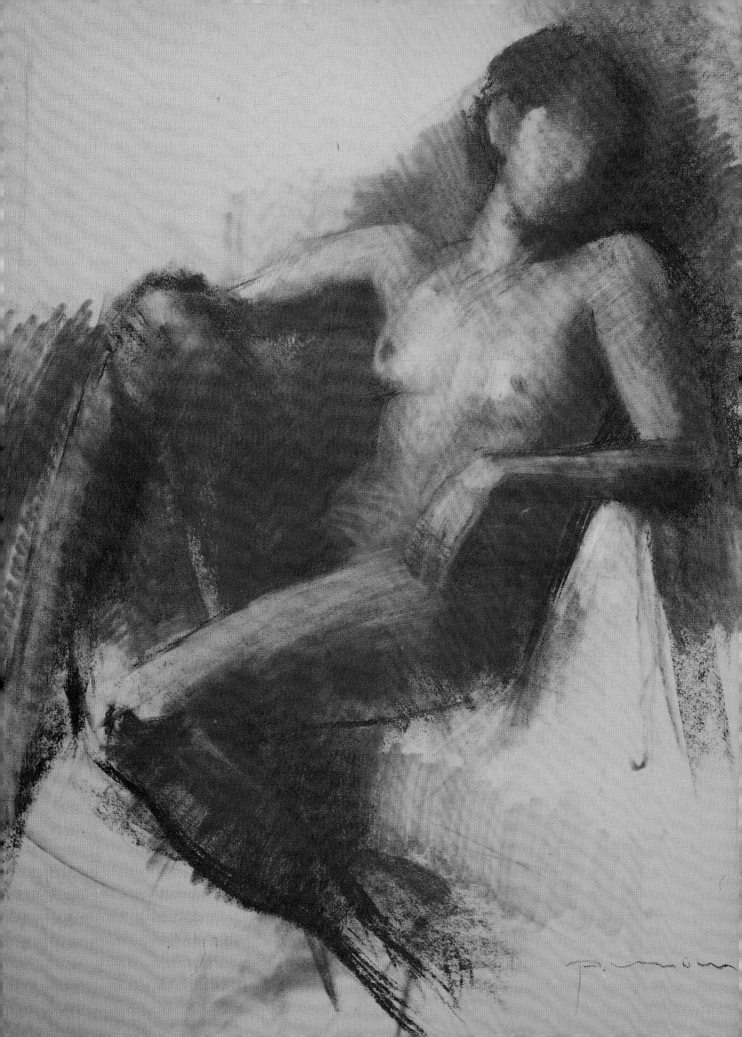

# THE BIG BOOK OF
# DRAWING AND
# PAINTING THE FIGURE

WATSON-GUPTILL PUBLICATIONS / NEW YORK

This edition first published in the United States in 1995 by
Watson-Guptill Publications, a division of BPI Communications,
Inc., 770 Broadway, New York, New York 10003

First published in 1994 by Parramón Ediciones, S.A., Barcelona, Spain
© 1994 Parramón Ediciones

Graphic Design: Josep Guasch Cabanas
Picture Editor: Jordi Martínez Bonifacio
Photography: Nos & Soto
Illustrations: Antonio Muñoz Tenllado
Production: Rafael Marfil Mata

**Library of Congress Cataloging-in-Publication Data**
Calbó Angrill, Muntsa.
[Gran Libro del desnudo. English]
The big book of drawing and painting the figure / Muntsa Calbó i Angrill.
p. cm.
ISBN 0-8230-3896-3
1. Nude in art. 2. Male nude in art. 3. Art–Technique. I. Title.
N7572.C3513 1995
757'.3–DC20
95-24579
CIP

Manufactured in Spain

**3 4 5 6 7 8 9 / 03 02 01**

# Contents

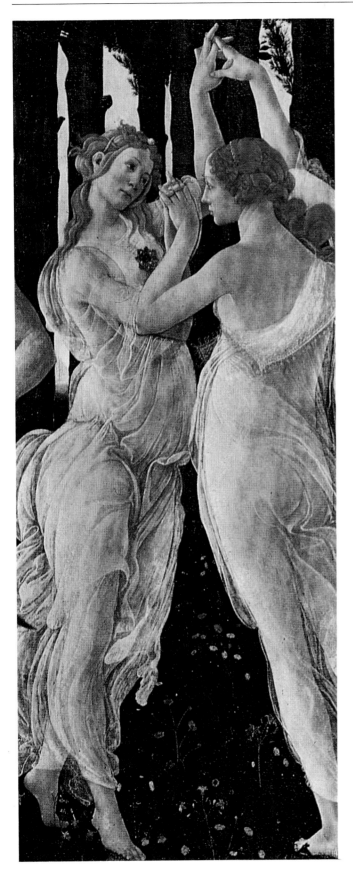

*This book is dedicated to my daughter, Martina. In spite of the marvelous distraction she presented during her first months of life, I managed to write this volume, which perhaps without her would have been less gratifying.*

M. Calbó i Angrill

Illustrations on pages 5 and 7: Sandro Botticelli, details from *Primavera*, c. 1478, 79 1/4″ × 122 1/2″ (203 × 314 cm). Florence, Uffizi Gallery.

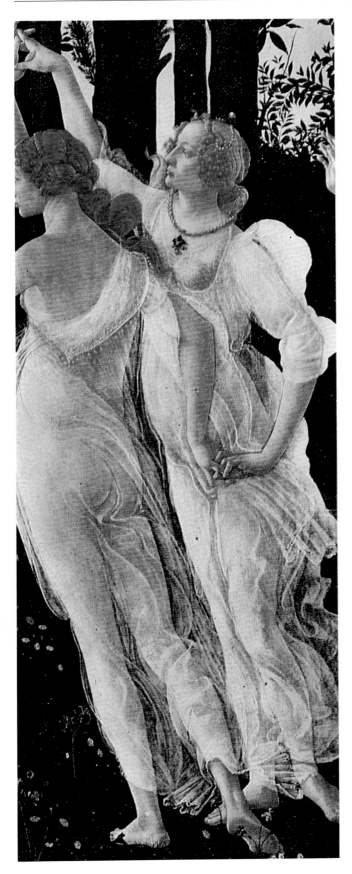

1

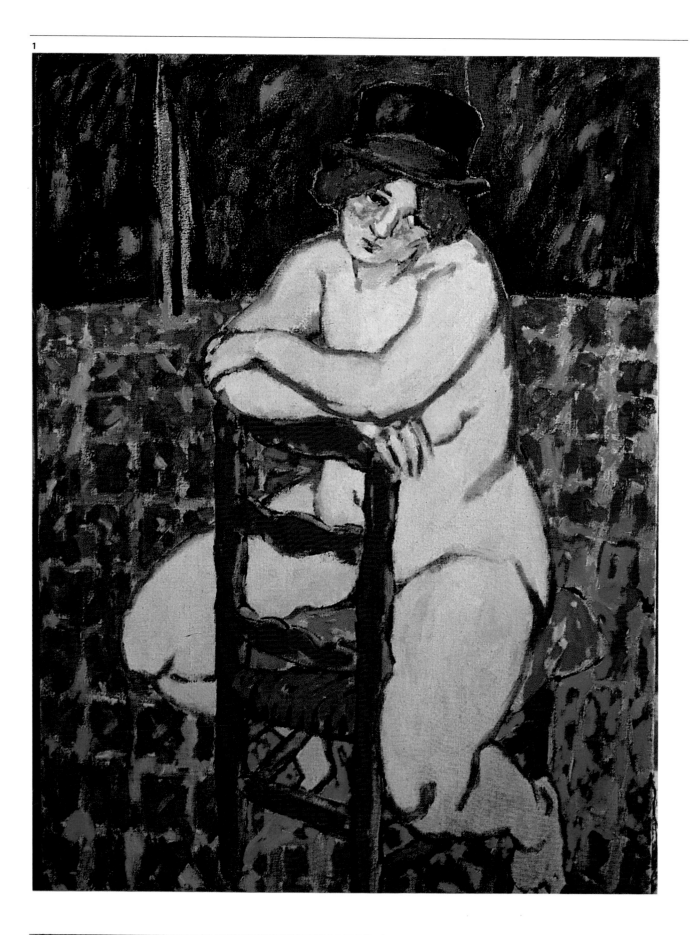

# Introduction

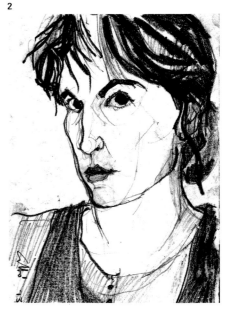

The great appeal of depicting the nude in art is the very fact that we are dealing with the human body in a way that gives us an insight into how we have viewed our physical selves throughout the ages. At first it might seem that there is, and always has been, only one correct way of painting a nude human figure. Nothing could be further from the truth. For example, we are used to considering the female body as more beautiful, more pictorial than the male; we tend to think the male body has little artistic interest. What would you think if I told you that this opinion is far more recent than it seems? The Greeks considered the male body much more beautiful and interesting, which explains why when they sculpted female figures (which they did only rarely), most were covered with veils, damp fabric, or clothes blown about by the wind in a way that revealed the body yet concealed it at the same time. For Leonardo da Vinci, a genius who lived five centuries ago, it was absurd even to consider a system of ideal proportions for the female body because a woman "does not have only one ideal size."

We might venture the hypothesis that as women acquired a more prominent role and greater freedom in society, their bodies came to be considered more interesting. It is obvious there is no perfect type of nude that would fit all periods of history. There are, however, superb nudes to be found in each period, nudes painted by such different artists as Titian and Matisse, Gauguin and Michelangelo. So when we are about to paint a nude, we must be aware that we are going to interpret, to create, to imagine, and to imbue it with meaning. We are not going to copy or reproduce the model. No reputable artist would contemplate the idea of copying; each of us has different talents and a different viewpoint.

This is the guiding principle used for the text and illustrations contained in this book. Different painters using different techniques have assisted in the making of this book-to enable us to clearly see the variety of possibilities and styles available, to enable us to understand that when we paint, we are expressing our subjective image of the nude, reflecting our feelings and those of the culture we live in.

Despite the desire to be far-reaching, this book is obviously limited by the prevailing attitudes of the specific time and culture that created it. Yet we should always keep in mind the general principles we have laid out as we enjoy a new understanding of the many beautiful and evocative images of the nude that artists have depicted throughout history.

Fig. 2. Muntsa Calbó, *Self-Portrait,* lithography pencil on paper. Born in Barcelona in 1963, Calbó holds a degree in fine art and is a contributor to Parramón Ediciones.

Fig. 1. Teresa Llácer, *Large Nude with Hat,* oil on canvas, 63 3/4″ × 51″ (162 × 130 cm). Private collection.

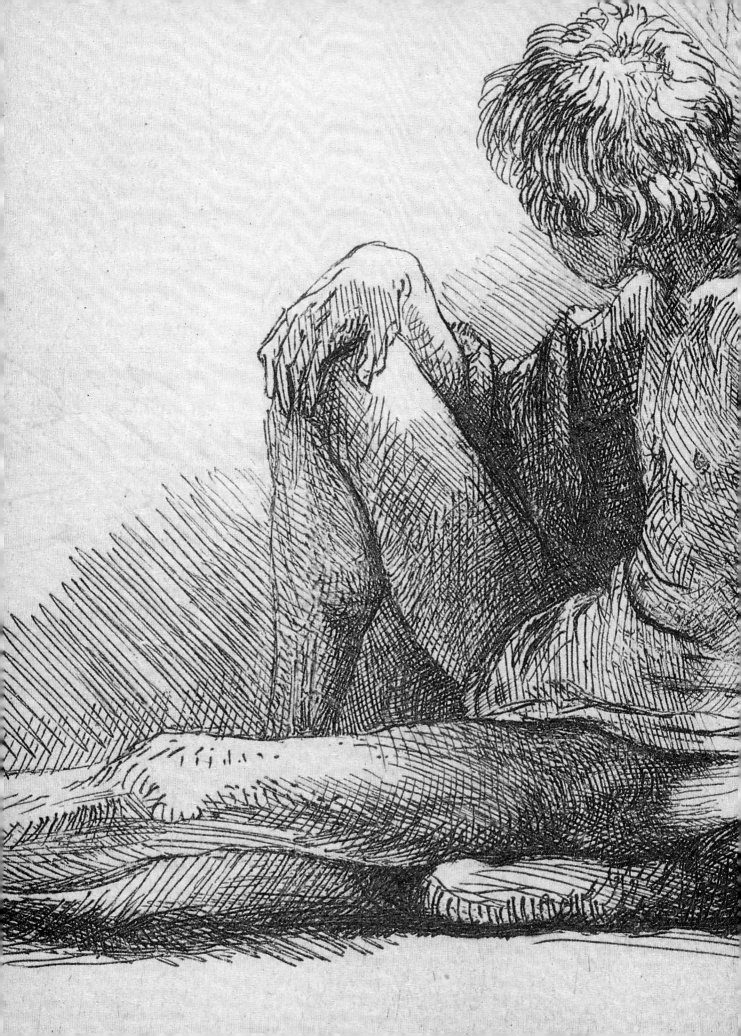

# THE NUDE IN THE HISTORY OF ART

Before dealing with the nude in art, we need to answer the question "What is a nude?" According to Sir Kenneth Clark, the author of one of the most thorough studies of the subject, the nude is an art form rather than merely an art subject. Why? Because the artist cannot transform the human form into art by simply "copying it" from nature, like a beautiful landscape. It is an arid, difficult, imperfect subject. When depicting a nude, the artist must seek to interpret, to "invent" an ideal. This is the raison d'être of the nude throughout history.

Fig. 3. Rembrandt, *Seated Male Nude*, etching. Berlin, Staatliche Museen, Kupferstich Kabinett.

# The representation of the human figure in prehistory

4

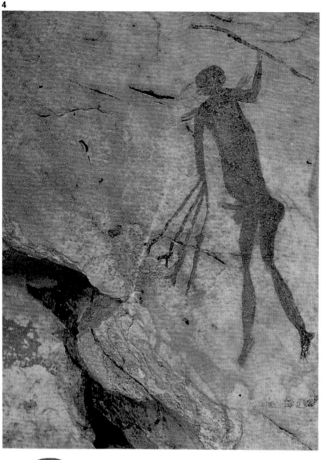

Fig. 4. Detail of prehistoric paintings with human figures from cave at Chimanimani, Zimbabwe. These are the earliest known paintings of nude figures and symbolize magical actions such as helping the hunters. Here the sex has been well defined and the anatomical representation is fairly accurate, both features that are uncommon in such works.

Very early representations of nude human figures have been found in paintings, relief tablets, and small sculptures. Admittedly, they are outnumbered by those of animals of all kinds and treated in quite a different way; whereas the figures representing bison, mammoths, and antelopes are beautifully drawn, naturalistic, and obviously the result of careful observation and what we might almost call "professional" work, the human figures are rough caricatures, almost deformed. The hunters are mere signs, most of them sexless, and the female figures found in reliefs and sculptures, despite receiving the name Venus, are expressions of woman's maternal role rather than her beauty. The shapes are exaggerated to the point of caricature, and the treatment is generally simplistic and unsophisticated. If we attempt to find a historical justification for a genre by considering its first known appearances, we shall see immediately that the problem of the genre is closely related to the problem of art in general. At what time and in what manner did these paintings, reliefs, and sculptures become works of art? Were they always considered so? Did they serve any specific purpose other than a purely

5

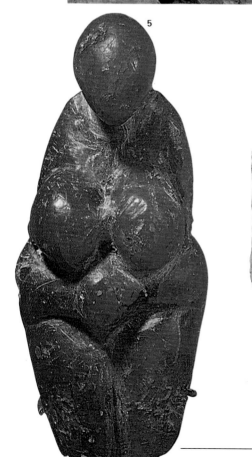

6

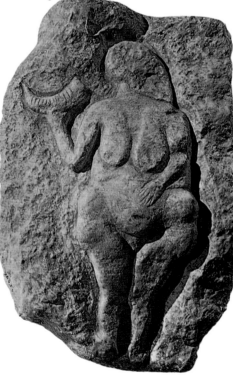

Fig. 5. *The Venus of Laussel,* ca. 15,000-10,000 B.C., 18″ (46 cm). Musée d'Aquitaine, Bordeaux, France. This female statuette was handmade, probably as a household fetish.

Fig. 6. *Venus with a Horn,* 17″ (43 cm). France, Museum of Saint Germain-en-Laye. Another of these small figures, this time in relief on a small stone tablet, exaggerates the most salient sexual and reproductive aspects of woman. Venus figures such as this one had a symbolic or magical function.

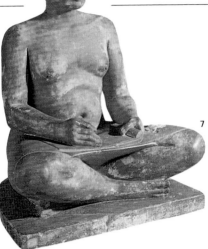

aesthetic one? Or did the art perhaps perform some other function? We refer here to a series of pieces dated between about 15,000 and 3000 B.C. It was during this period, the Neolithic, that the human race left its cave dwellings-where these paintings are to be found-ceased to hunt, and began to cultivate the land, raise animals, and build houses. This period of evolution is also when man began delving into the relationships among religion, magic, and art, although in most cases all three intermingled, making it difficult for us to ascertain the particular purpose of the various kinds of imagery produced at the time. Whatever the case, primitive art was not just art or, if you prefer, not quite art. In every drawing, the artist attempted to influence reality directly, using art as a protective symbol or a magical object, a prayer or an offering.

This original feature of art survived for thousands of years, perhaps because philosophy and magic provided the answers to basic questions such as humanity's intrinsic fears. (Surely, isn't it magical in a sense that we can recognize, in patterns of lines and colors, a human figure, an animal, or a tree?)

Fig. 7. *The Seated Scribe,* ca. 2600-2400 B.C., limestone with inset glass eyes; height, 21″ (53.7 cm), width, 17 3/8″ (44 cm). Egyptian sculptures like this one often create a sensation of realism that is seldom found in the history of art. This shows that when anatomical knowledge and observation are left unused, it is because of the desire to express other meanings.

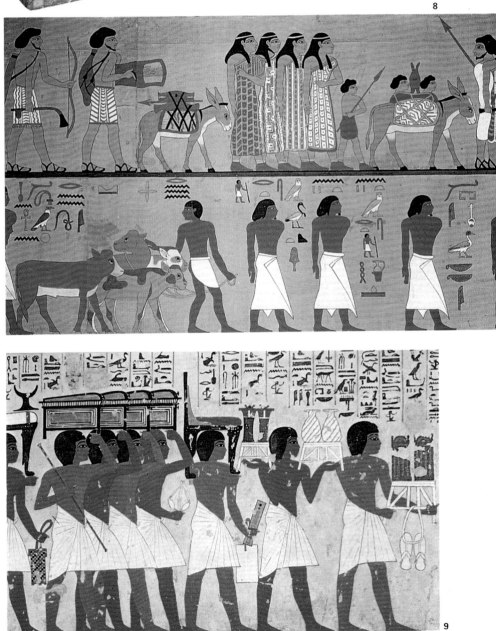

Fig. 8. *The Semitic Tribe Requests Permission to Enter Egypt,* 19th century B.C. Thebes, tomb of Beni Hasan. Here we can see the artistic standards of Egyptian paintings: figures in profile, except for the shoulders and one eye, with almost all of them looking to the right.

Fig. 9. *Funeral Procession,* 19th century B.C. Thebes, tomb of Ramose (no. 55). Almost six centuries later, Egyptian painting continues to use the same conventions. Notice the brick-red color of the male body.

# The figure in Egypt...

Egyptian civilization also evolved during the Neolithic period. Paintings and sculptures made over the course of four thousand years are characterized by imagery that relates to the cult of the gods and the dead, providing a language with which to tell stories, pray, and at the same time represent an ideal.

This ideal was the simple, orderly, and perfect life of humanity-an ideal expressed through figures that were always rendered to the same proportions (a canon we shall refer to later on). In the Egyptian system of representation, figures always appear with the torso facing front, the head in profile, the legs in three-quarter view, and so on; this was considered the most natural and convincing way to depict the human being. Figures always appear against a plain background, which was the expression of an eternal order. Color was also used symbolically: men were painted in a reddish color, women in yellow ocher. Generally, figures were depicted nude or only lightly clothed, reflecting the austerity of Egyptian civilization.

Fig. 10. *Scene from the Grape Harvest in Ipy,* 13th century B.C. Necropolis at Thebes, tomb no. 217. Both in this scene and in those that follow, we can appreciate a considerable move away from traditional expressive structures. These conventions were broken especially during the time of Amenophis IV, although artists had already begun to express themselves more freely, changing the direction and the movements of the body.

Fig. 11. *Lady's Toilette.* Thebes, tomb of Djeserkaraseneb (no. 38). Note that the female nudes are somewhat smaller than the lady.

Fig. 12. *Nubian Dancer,* ca. 1420 B.C. Thebes, tomb of Horemheb (no. 78). In this image the artist expresses the facial and body characteristics of the black race from the south of Egypt.

**10**

**11**

**12**

# ... and Eastern cultures

The art of India formed the basis of Eastern visual tradition, its influence spreading to China and from there to Burma, and from Thailand to Japan. One characteristic is its ornamentation and extravagance, qualities applied to images that celebrate the human form, the sensuality of dance, and the body in motion. Indian painting was originally a sacred art form devoted to the adoration of God. Based on Buddhist concepts, this art was used to express a love of life, which it exalted by means of sensual, even erotic imagery far removed from the static, relatively austere quality of Egyptian art.

Early Indian paintings are mostly frescoes found in Buddhist temples. Books with miniature paintings appeared during the 16th century; these beautiful works feature clearly defined lines and bright colors that, above all, express the flowing strength of the human body and the dynamism of loving couples united in a world of dance and music.

Around 100 B.C. the great Persian empire exerted an influence on Islamic, Buddhist, Hindu, and Shinto art (always via India to China and Japan). Calligraphy, the taste for abstract ornamentation, and the sensuality of nature reached their maximum expression in Japanese engravings called Ukiyo-e (19th century). Wood blocks, first colored by hand and later printed in different colors, show scenes taken from everyday life, the theater, and brothels, including all the courtesans of Edo in passionate embraces that, although elegant, do not shy away from detailed depictions of erotic postures. As always, all Oriental art, thanks to its Hindu origins, is not so chaste as that of Western civilization. It is unafraid of the body; its free, sensual expression is not considered wicked, which perhaps explains why it never becomes morbid, malicious, or pornographic.

Fig. 13. Cheik Ahmed Misri, *The Order of the World and Its Marvels,* Syria or Egypt, 1563. Istanbul, Library of the Topkapi Sarayi Museum.

Fig. 14. Boundi School, *After the Bath,* ca. 1775, 8 5/8″ × 6 1/4″ (22 × 16 cm). India, Allahabad Museum. A beautiful Indian miniature showing Arab influences.

Fig. 15. *Anthology of Iskandar: Iskandar Observes the Sirens Bathing,* Chiraz, 1410, 9″ × 5 1/2″ (23 × 14 cm). Lisbon, Gulbenkian Foundation. A Persian miniature in which decoration and voluptuousness are apparent.

# Greece and Rome: the birth of the nude in Western art

In such a brief glance at history, we cannot avoid large gaps in covering the development of the nude as a genre. The first Greek figures, for instance, obviously did not appear from nowhere but were related to Cretan figures, primitive figures, and above all, Egyptian figures. This evolution can clearly be seen on water vessels and also in Greek sculptures, whose form and concept are similar to those of the Egyptians. Then, after several centuries, in approximately 5 B.C., Polyclitus "invented" a new figure, one that, despite its overall artificiality, was to start a movement based on a new balance. The figure rests on a different center, with a slight turn of the hip and one leg a little farther forward than the other. This new symmetry was to be the basis of classical art and the system of proportions. The Greeks believed a canon must exist; Polyclitus chose the head as the basic unit of measurement for determining all other proportions. An ideal body was considered to measure seven-and-a-half heads.

From the 7th century B.C. onward, the Greeks considered the representation of the human figure-above all, the male figure-as the perfect example of art used for the expression of an aesthetic and philosophical ideal. Greece provided a basis for the nude in the West that lasted well into the 19th century: the set of values represented by the human body has both an aesthetic and ethical basis. This springs from the consideration of man as the center of the universe and the essential figure in creation in Western thought. This almost metaphysical principle was epitomized by Phidias's sculpture of Apollo, whose elongated figure expresses his identity as the man-god, the luminous, rational, beautiful, and

kind god. Greek art sought a stylistic balance between nature and the ideal, a physical balance between strength and gracefulness, and a spiritual balance between the ancient religion and the new philosophy, As it evolved, it sought different solutions to different problems. Certain artists, uninfluenced by the rigid methods

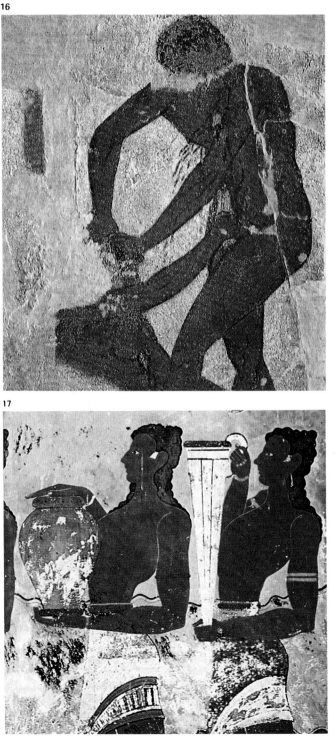

**16**

Fig. 16. *Duel Between Eteocles and Polynices,* Etruscan, 2nd century B.C. Vulvi, French tomb.

**17**

Fig. 17. *Water Bearers,* Knossos. Both this figure and the previous one form part of the Mediterranean heritage before the Greek civilization. The influence of Greek culture can be seen, mixed with the primitive Etruscan cultures. These are a clear forerunner of the images on Greek terra-cotta vases. Greater freedom of observation and representation can clearly been seen.

of Polyclitus or the attempts by Phidias to represent divinity, aimed to define ideal physical beauty not simply in terms of mathematical formulas, but as an expression of strength and kindness. New kinds of men evolved out of this gradual move toward reality, which was to have an enormous influence on Roman art

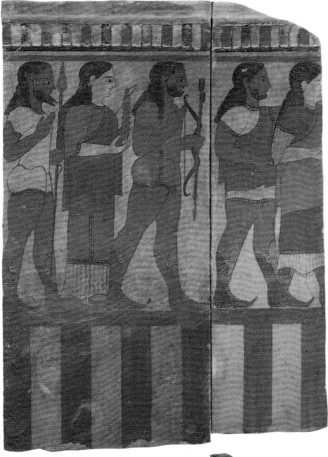

Fig. 18. Mural panels, c. 530 B.C., terra-cotta. These panels are a typical product of Etruscan art combined with Greek civilization. They were used to decorate funeral monuments.

Fig. 19. Greek vase in the shape of a duck, 4th century B.C., terra-cotta. Paris, Louvre Museum. A wonderful Greek vase in the shape of a duck, with a nude painted on the side. The artist's mastery of the figure shows Egyptian influence in the clarity of the silhouette.

Fig. 21. *Warrior Fighting,* called the *Borghese Gladiator,* 1st century B.C., marble. Paris, Louvre Museum. A typical Greek sculpture by Agasias of Ephesus, which shows how knowledge of the male figure had developed in Greece. Probably based on Lysippe's canon, which was more drawn out than that of Polyclitus.

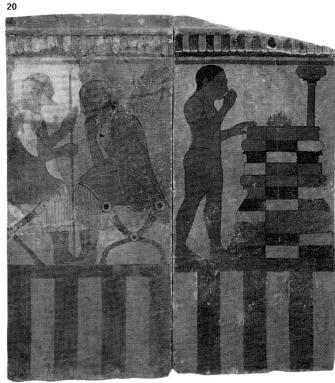

Fig. 20. Mural, ca. 530 B.C., terra-cotta. Paris, Louvre Museum. This belongs to the same group as fig. 18. Although the silhouette is still used and the figures are in profile, the shoulders are also seen in profile, not from the front.

**22**

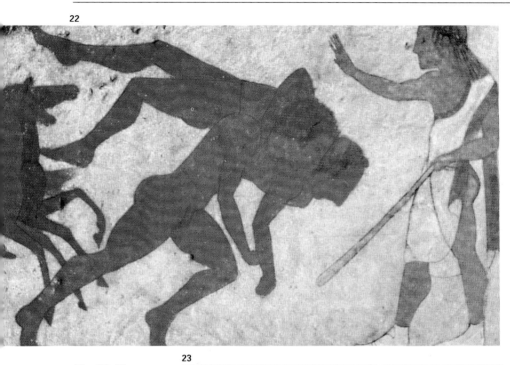

and, much later, the European Renaissance. This evolution toward natural representation led to the arrival of a certain anarchy or aesthetic disorder that produced the sensual yet spiritually devoid figures that are often found in Roman art.

The female figure did not appear in Greek sculpture until the 6th century B.C. The concept of the nude Aphrodite was originally an Eastern one, and yet the female figure was eventually to represent the physical desire for beauty, bound up in a "celestial," divine ideal of symmetry and proportion. In principle, the male body seems much better suited to representing artistic and philosophical ideals.

**23**

Fig. 22. *The Fighters,* Chiusi, tomb of Singe. This example of archaic nude painting shows the difference between sculpture and painting but is also a natural depiction of bodies in motion.

Fig. 23. *Winged Victory (Nike of Samothrace),* ca. 190 B.C.; height, 129″ (328 cm). Paris, Louvre Museum. This female figure representing Victory is characteristic of Greek artistic expression and the preference for scant clothing that is moved by the wind to show the nude body without revealing it directly.

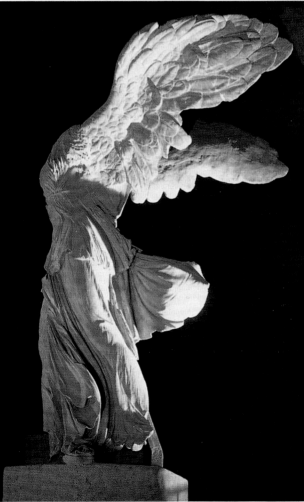

The female figure appears on terra-cotta vessels, always in scenes of day-to-day life: these range from mothers and wives to, at the other extreme, courtesans. Early sculptures of women, which showed them dressed in wet clothing that revealed the shape of the body while hiding its "defects," apparently were just as attractive to the Greeks as those of young athletes. The female nude did not appear until 400 B.C., in a pose similar to the tradition established by Polyclitus, stressing the sensual balance of feminine curves: two opposing arches.

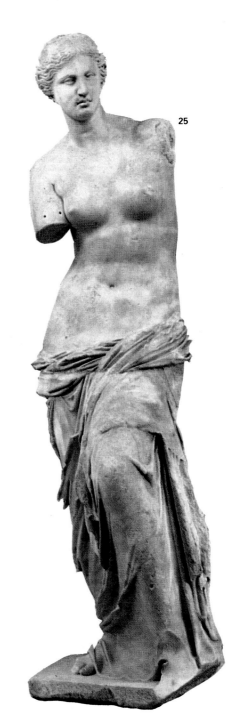

**25**

**24**

Fig. 24. *Woman Being Flogged and the Dance of the Bacchanal,* ca. 4th century B.C. Villa of Mysteries, Pompeii. These works are virtually the only remains of Greco-Roman painting. The female bodies represent initiation rites of pleasure, suffering, pain, and transformation.

Fig. 25. *Venus de Milo,* marble; height, 79 1/2″ (202 cm). Paris, Louvre Museum. This semi-nude Aphrodite is one of the best known sculptures in history, a suggestive figure despite the lack of arms.

# The Middle Ages: disappearance of the nude

**26**

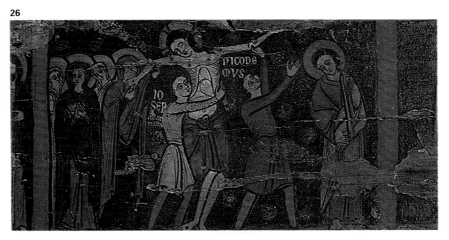

Fig. 26. *Scene from the Passion,* ca. 1200, altarpiece. Barcelona, Catalonia Art Museum. Christ's body is treated far more symbolically than realistically.

Fig. 27. *Dead Christ,* polychrome carving. Paris, Louvre Museum. This body of Christ probably formed part of a "Descent," a typical Romanesque figure group in Catalonia, although this particular one was found in France. His arms and legs are elongated and thin, in the expressionist style.

**28**

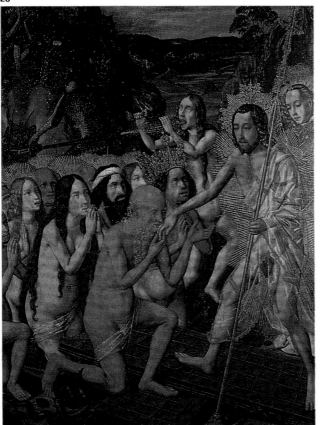

Fig. 28. Bartolomé Bermejo, *Christ's Descent into Hell,* ca. 1475, altarpiece. Barcelona, Catalonia Art Museum. These realistically rendered figures reflect the Flemish Gothic influence.

**27**

After so many centuries in which the representation of the nude was an essential aspect of art, characteristic of the ideals of civilization, there was a long period in which it ceased to exist. Forgotten was the god Apollo and, with him, human light and reason; there remained only mystery and darkness. This was the Middle Ages, during which incipient Christianity struggled to represent God and God-fearing humans. In short, nude representations, totally opposite in concept to the earlier ones, were confined to the Scriptures, certain martyrs, and as the maximum representation of punishment in hell for the sins of the flesh; even so, nude bodies did not appear again for several centuries. Even Christ on the cross often appears dressed until just before the Renaissance.

The concept of the nude was lost, and with it the unitary concept of humanity. Christian philosophy divided the person into body and soul: a corrupt and perishable body, an immortal soul. The ideal, therefore, was to be found in the soul, in the spirit; the body was no more than an unwelcome appendage, undeserving of the slightest consideration because, among other things, it was the root of human sins, stimulated by low, sensual instincts. Both envy and gluttony stemmed from physical longings; the body therefore had to be forgotten, except in the creation of Adam and Eve, which was an expression of the power of God: pure, eternal bodies that the devil was soon to corrupt and make mortal.

As always, the relationship between art and religion was a profound one and determined the imaginary world of the age. Medieval painting was conceived as

instruction, visual lessons in the fear of eternal punishment, which were easily understood by illiterate people.

Figures in medieval art functioned as images within a language. Unconcerned with naturalist representation, they seek to teach. A series of conventions was used, and any relation with ideal proportions or the direct observance of a model was forgotten. For the same reason, the first nudes again appeared in temples: the sacred body of Christ on the cross, the bodies of those condemned to Bosch's hell in the 15th century, and Adam and Eve in the first paintings of the Northern and Italian pre-Renaissance. It is in Gothic art where these bodies began to writhe, in a search for the expression of human suffering; for the body is the source not only of pleasure and sin but also of illness, death, and pain.

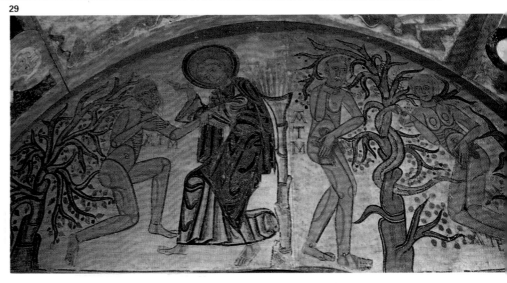

Fig. 29. Master of Maderuelo, *Creation of Adam and Original Sin,* 12th century, mural painting transferred to canvas; width, 14'9" (450 cm). Madrid, Prado Museum. Marvelous original, writhing bodies.

Figs. 30 and 31. Below: Giotto, *Judgment Day* (detail of Hell), 1304-1306. Padua, Scrovegni Chapel. Right: Hieronymus Bosch, *The Garden of Earthly Delights* (detail), 1450-1516, oil on panel, 76 3/4" × 43 1/4" (195 × 110 cm). Madrid, Prado Museum.

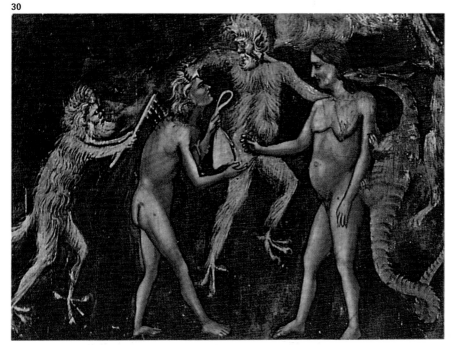

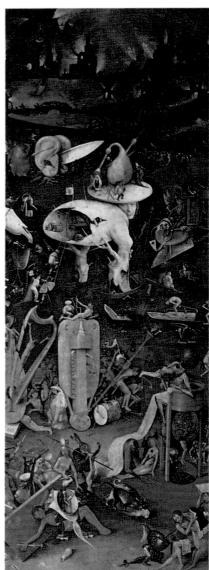

# The Renaissance: man as the center of the universe

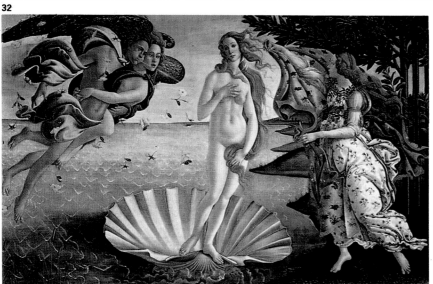

How that shrouded, deeply religious society turned into a new vision of man and God, of the universe, a totally different vision that slowly appeared and which we call the Renaissance, is too complex a subject to address here. Let us say that a set of social, economic, and philosophical circumstances came together seamlessly to create a different society.

One of the major factors underlying this change was probably the newfound wealth of certain nobles, bourgeois city dwellers who were able to pay artists to work

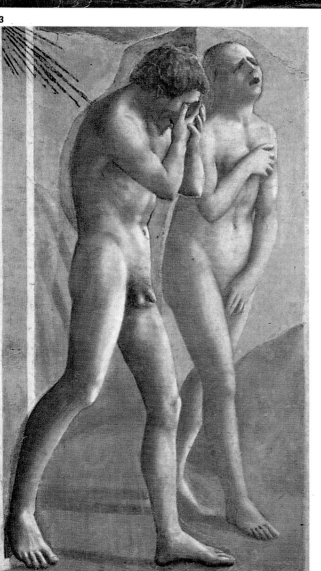

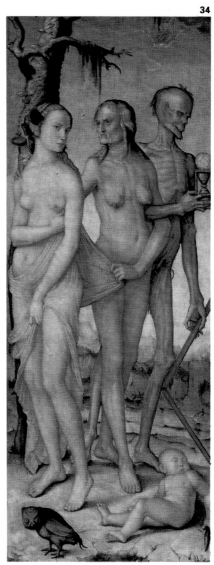

Fig. 32. Sandro Botticelli, *Birth of Venus,* ca. 1485, 68 7/8″ × 85 1/2″ (175 × 278 cm). Florence, Uffizi Gallery. A vision of the classical goddess.

Fig. 33. Masaccio, *Adam and Eve Expelled from Paradise,* ca. 1426, 81″ × 35″ (205 × 88 cm). Florence, Brancacci Chapel.

Fig. 34. Hans Baldung Grien (1484/5-1545), *The Three Ages and Death,* oil on panel, 59 1/2″ × 24″ (151 × 61 cm). Madrid, Prado Museum.

for them, contributing to the independence of art from religion. We find new formulas in form and substance: in the substance because man is represented in classic and pagan, literary and poetic settings; in the form because these representations are much more naturalistic yet also seek the ideal of the classical body.

The combination of Greek and Roman sculptures with the expressive painting of the late Gothic period and its fondness for movement led to this new creation of gestures and proportions. This first change did not spring from the observation of nature. Even the first studies by Dürer of proportion are based on drawings of the Apollo Belvedere (a marble statue, discovered in 1479), and not on the actual measurements of a model. The same applies to Italian painters such as Botticelli and subsequently Raphael, although they, unlike the Northern artists, were no longer "afraid of the body" and took from the classics only their use of light and elegance, creating new figures in every painting. For Botticelli, the female and male nudes were equally beautiful; in his nude paintings, pagan allegories about classical gods, he used the real faces of his contemporaries. Botticelli relished this sensual freedom until his sensitive soul began to wonder if his imaginary world was legitimate; this explains why his beautiful Florentine ladies, transformed into Venus or pagan Graces, finally become Madonnas or celestial Virgins with their children in their arms.

This incipient Italian eroticism found its Northern counterpart in the painting of Cranach. The North also received the religious warning concerning the ephemeral nature of earthly pleasure (Hans Baldung Grien's painting *The*

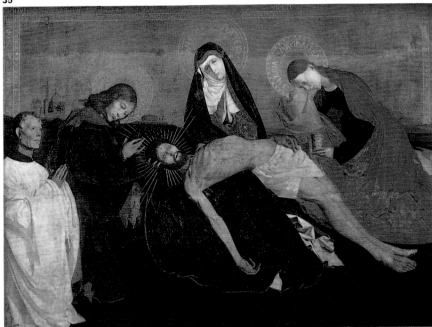

Fig. 35. Enguerrand Quarton, *Pietà*, ca. 1455, altarpiece from Villeneuve-lès-Avignon, 64 1/8″ × 85 7/8″ (163 × 218 cm). Paris, Louvre Museum.

Figs. 36 and 37. Albrecht Dürer, *Adam and Eve*, ca. 1507, oil on panel, each 82 1/4″ × 31 1/2″ (209 × 80 cm). Madrid, Prado Museum. While Adam is fully Apollonian, Mediterranean, and classical, Eve still has northern Gothic characteristics.

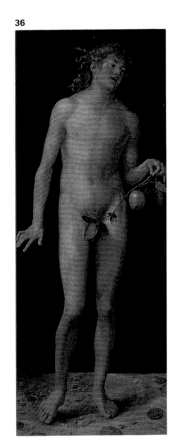

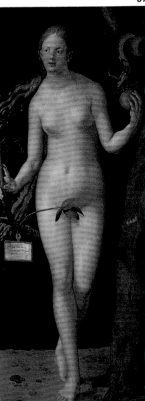

**38**

**39**

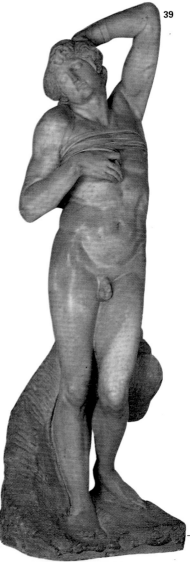

*Three Ages and Death,* fig. 34, is a good example). In southern Europe, however, this was used to produce sumptuously carnal paintings, such as this *Allegory of Venus and Cupid* (fig. 43) by Bronzino, with its marked sensuality. Michelangelo used the human body to express his faith in divinity, shared with his faith in humankind. He was unafraid of the body and drew from nature, seeking to apply the canons of proportion. He was unique in his passion for real movement, the strength of the muscle groups, the freedom of pose. He represented a new classicism, a rebirth of ideas and forms. Renaissance, of course, means a rebirth of classical ideas.

Yet it was more than this, because this classicism was combined with Christianity. Artists continued under the auspices of a powerful church and nobility and now began to use sacred subjects for representing all kinds of human bodies. There was a longing for knowledge, science, anatomy and medicine, geometry and perspective.

The prototype of the new man, the modern man who expressed curiosity for all these new sciences,

Fig. 38. Leonardo da Vinci, *Study for Leda, Kneeling,* ink and white chalk, 6 1/4″ × 5 1/2″ (16 × 13.9 cm). Private collection.

Fig. 39. Michelangelo, *Slave* (also called *Dying Slave*), unfinished sculpture in marble; height, 89 3/4″ (228 cm). Paris, Louvre Museum.

**40**

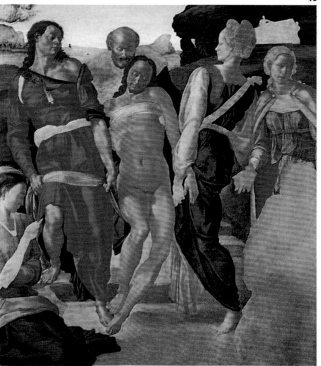

Fig. 40. Michelangelo, *The Burial of Christ,* ca. 1505, oil on wood panel, 63 5/8″ × 59″ (161.7 × 149.9 cm). London, National Gallery.

who had a restless and creative spirit, was Leonardo da Vinci. As a result of his tireless investigations, we find in his drawings a study of the human body, the rudiments of anatomy (he would dissect dead bodies of any age or sex, at first in secret), and a canon of proportions. There is also a strong element of realism based on true models. Both Leonardo and Raphael believed in the human being and shared the Renaissance belief in man as the center of the universe. Raphael's frescoes highlight the beauty and strength of God's major creation: the human being.

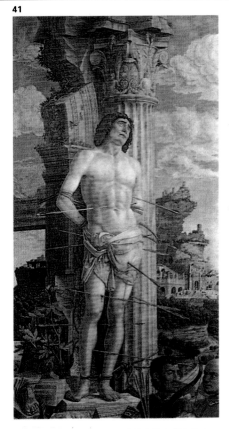

Fig. 41. Andrea Mantegna, *Saint Sebastian,* 1480; height, 100″ (255 cm). Paris, Louvre Museum.

Fig. 42. Raphael Sanzio, *The Triumph of Galatea,* ca. 1514, mural painting, Villa Farnesina, Rome. This painting is noteworthy for its subtle composition, which imbues such a large group of nudes with movement and rhythm.

Fig. 43. Bronzino, *Allegory of Venus and Cupid.* London, National Gallery. Another allegory based on the classical gods. The eroticism of the image implies great freedom of expression.

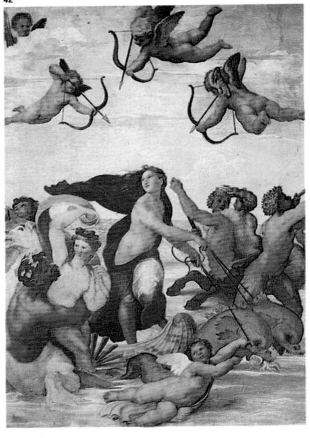

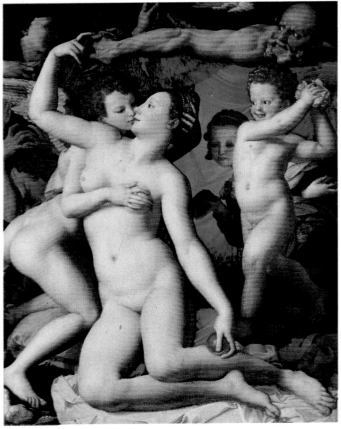

# Baroque, chiaroscuro, contradiction

This new concept of man allowed the nude to evolve: from using the pretext of religion, then that of mythology, until finally no excuse was needed. Although earlier we made reference to Dürer, the Renaissance, as far as the nude was concerned, appeared in Italy. Spain continued in the grip of religious faith and imperial power; France was still struggling with the late Gothic period. Dürer brought this new Italian adventure north, yet despite his beautiful Adam and Eve, neither he nor his pupils painted such sensual and authentic nudes as did Titian, their contemporary. Cranach saw the start of the Reformation, the division of the Christian church. His chosen nudes were Northern, German beauties with narrow hips and thin legs, completely different from the nudes painted by the Italians and, above all, the Venetians, who in a certain way started a revolution. These were the painters of light and color, the painters of the body's sensuality, of voluptuousness, an airy atmosphere blending into the golden light of dusk. In all of Titian's work, and to a lesser extent in that of Tintoretto and Veronese, the only motif is that of beauty and pleasure; even the allegories are those of Love, the goddesses of Beauty and Love, completely removed from earlier representations and painted in a

44

45

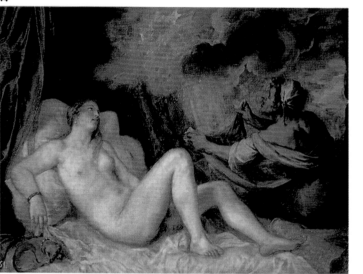

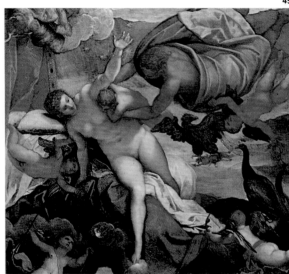

Fig. 44. Titian, *Danae*, ca. 1553, oil on canvas, 50 3/4″ × 70 7/8″ (129 × 180 cm). Madrid, Prado Museum. Although of a classical type, the pose and the flesh of this goddess are characteristic of Titian's sensual painting.

Fig. 45. Tintoretto (Jacopo Robusti), *The Origin of the Milky Way,* ca. 1570, oil on canvas, 58 1/4″ × 65″ (148 × 165.1 cm). London, National Gallery. The entire painting breathes sensuality, color, and light.

Fig. 46. Titian, *Venus of Urbino,* oil on canvas, 46 7/8″ × 65″ (119 × 165 cm). Florence, Uffizi Gallery. Even the most unknowledgeable people are captured by the beauty, sensuality, and serenity of this composition–beauty in the harmony of the colors, sensuality in the fleshing out of the figure, and serenity in the gentle, everyday background.

46

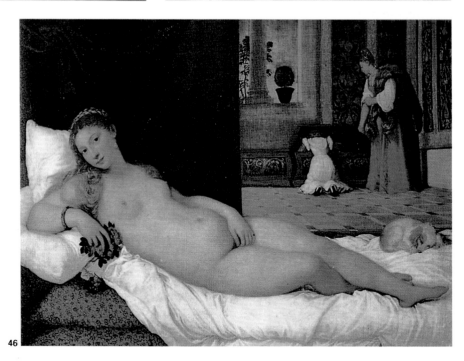

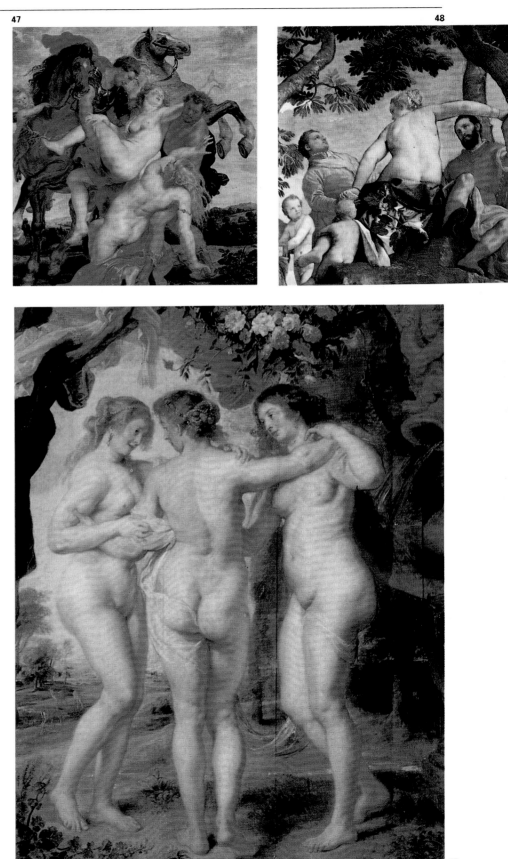

light that brings out the rosy or pearl-colored flesh. We are in the Baroque period. The Reformation countries forewent this delight in nature for a closer relationship with God by means of rigid morality. In the Catholic countries, artists such as Ribera and El Greco showed their mastery of the nude inherited from the Italians in paintings of religious subjects, showing beautiful bodies in contortions of ecstasy or agony, young and old, and containing sharp contrasts of light, as suggested by Caravaggio. Rembrandt in the north also painted in this style, with nudes in biblical scenes and models that were very different from the Mediterranean beauties. And Rubens, whose art was the maximum expression of the Baroque, combined in his work the vast knowledge from recent times with religious worship, the earthly power of kings, and the sensual nature of human bodies. In terms of style, Rubens combined northern and southern sensibilities to some extent; he was able to create complex allegorical-historical compositions that featured beautifully rendered figures rivaling any Italian master's, although his use of color did not reach the heights achieved by the Venetians, by whom he was so influenced.

Fig. 47. Peter Paul Rubens, *The Battle of the Amazons,* 1577, 47 5/8" × 65" (121 × 165 cm). Munich, Alte Pinakothek.

Fig. 48. Paolo Veronese, *Allegory of Love,* oil on canvas. London, National Gallery.

Fig. 49. Peter Paul Rubens, *The Three Graces,* oil on canvas, 87" × 71 1/4" (221 × 181 cm). Madrid, Prado Museum. Compare these three Graces with those of Botticelli (see pages 5 and 7) and you will see how painting developed, although the allegory is still a classical one.

50

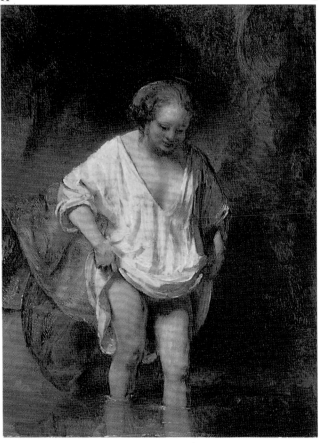

Fig. 50.
Rembrandt,
*Woman Bathing in
a Stream,* oil on
canvas. London,
National Gallery.
A painting with
a much more
intimate subject,
highly original at
the time.

Fig. 51. Diego
Velázquez, *Venus
in the Mirror,* ca.
1650, oil on
canvas. London,
National Gallery.

51

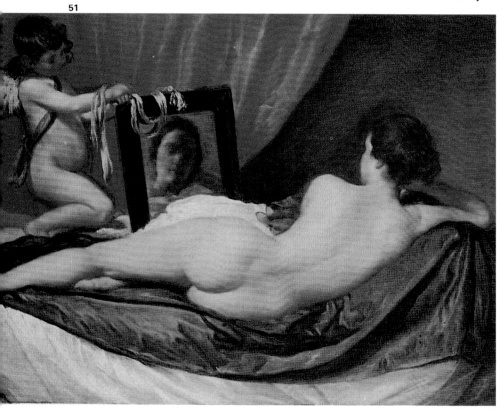

In Spain the nude was hardly the most preferred subject among great painters. There are very few nudes from this period, perhaps because the Baroque became the expression of the Counter-Reformation in that country: religious subjects and portraits were painted, but in Velázquez's works, for example, we find only one nude, *Venus in the Mirror* (fig. 51). But what a nude! It exceeds the sensual allure of Titian's nudes. The pose is original yet rather chaste, as she has her back turned. The most important aspect of both this painting and several other contemporary works is the appearance of a deep feeling for realism, a real appreciation of natural beauty, without the need for any other source than the simple presence of the model for "artistic" inspiration. It is somewhat similar to Rembrandt's work, although Rembrandt's belief in the Reformation informs his paintings with a contrast that expresses the power of doubt. This is conveyed by the artist's realistic handling of color and use of tenebrism—deep shadow punctuated by dramatic illumination—in modeling form.

As the absolute monarchy's power in France grew, a large court was established in Paris. It was to produce a significant revolution in the field of arts and science, and as a result the 18th century is called the Age of Enlightenment or of Reason. This court, full of nobles, artists, literary figures, and scientists, increasingly liberalized ideas in general and devoted themselves to courting, seduction, and indulgence. It was to produce works such as those of Watteau, Boucher, and Fragonard, among others. Boucher's nudes, especially, are the clearest expression of the provocative nature of contemporary works: the apparently virginal and the most subtle seduction are

blended in his half-portraits of attractive nude women, who, as it happens, were ladies of the court. This is French Rococo, which spread to other parts of Europe but was fated to be short-lived, owing to its own opulence and decadence. This period of luxurious pleasure at the expense of the poor came to an end with the Revolution.

Fig. 52. José de Ribera, *Saint Andrew,* oil on canvas, 48 1/2″ × 37 3/8″ (123 × 95 cm). Madrid, Prado Museum. The strong contrast of light underscores the expression, the anatomy, old age.

Fig. 53. Jean Honoré Fragonard, *Bathers,* ca. 1765, oil on canvas, 25 1/4″ × 31 1/2″ (64 × 80 cm). Paris, Louvre Museum. A work painted under the influence of Boucher in the French Rococo.

Fig. 54. El Greco (Doménikos Theotokopolous), *The Trinity,* 1577, oil on canvas, 118″ × 70 1/2″ (300 × 179 cm). Madrid, Prado Museum. The nude in religious paintings continues to be used in Spain.

52

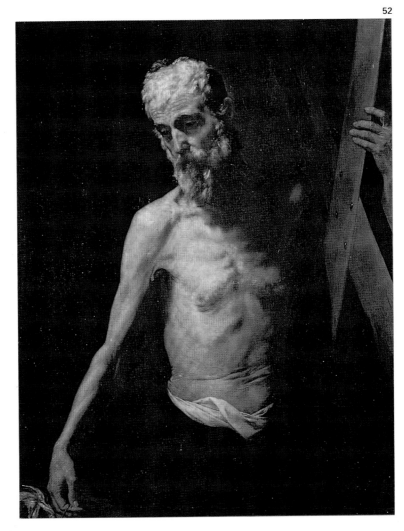

53

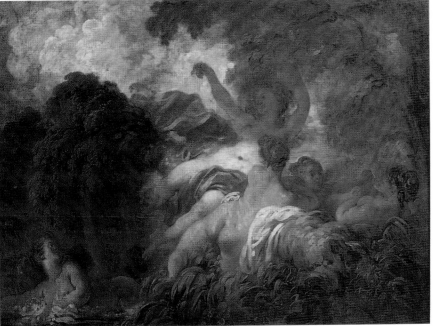

54

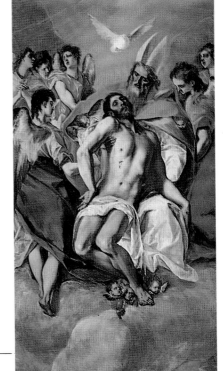

# The Neoclassical and the Romantic

Fig. 55. Jacques-Louis David, *Mars Disarmed by Venus and the Graces,* 1824, oil on canvas, 121 1/4″ × 103″ (308 × 262 cm). Brussels, Fine Arts Museum of Belgium. This painting is an example of the attempts to recapture the Greek classics, which were generally unsuccessful because of their lack of substance.

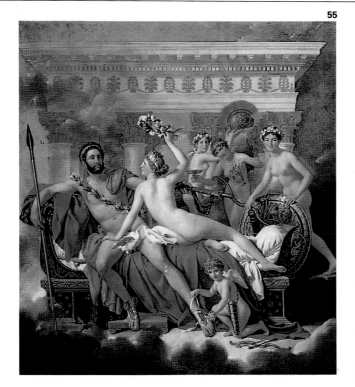

**55**

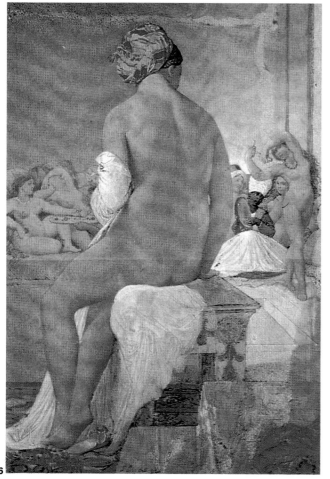

**56**

Fig. 56. Jean-Auguste-Dominique Ingres, study for *The Turkish Bath.* Bayonne, Bonnat Museum. Ingres followed classicism, but in a much more personal form; his paintings therefore breathe with more emotion.

We again find the word classicism toward the end of the 18th century and into the 19th, until it appears to be contrasted with the Romantic. Classicism always signifies a return to ideals considered a standard that defines taste, aesthetics. For as we have seen, classical Greek sculpture and painting represent an ideal, not a reality or an emotion. Perhaps as a reaction against the excesses of the French Rococo (whose abuses were not confined to the more or less legitimate field of art, but spread to all aspects of society through the exploitation of the lower classes and therefore became an underlying cause of the 1789 Revolution, with the fall of the king and the establishment of a new form of government based on equality among individuals), society sought a more serene and honest version of artistic ideals. Beauty is not a justification in itself, but depends on morals, on kindness. To what source should artists look in order to produce morally correct, even educational art? To classicism, which always provides a solid basis. The artists of the Revolution and the Republic, most notably, David, thus painted large historical and mythological subjects with the intention of reestablishing high ideals in public life. The figures are again, for the most part, nudes, yet they do not stress the sensuality of the bodies but their spiritual fortitude and healthy, honest convictions.

This Neoclassical vision was opposed to that of the new Romantics who, above all, wished to express the subjective view stemming from their emotions. Interestingly, most Romantic painters also used mythological, historical, or legendary subjects, although they are entirely different in appearance. Romanticism features a

**58**

return to the pleasure found in light and color; to expressive movement of the body; to powerful, realistic backgrounds (often landscapes), the ultimate expression of the untamable forces of nature.

Both of these two mutually dependent approaches were present toward the beginning of the 19th century. The works of Ingres and Delacroix complement each other, as if one could not exist without the other, as expressions of the sacred right to individual freedom—one of the basic premises of the revolutionary thinking of the time, later to form the basis of all art up to the present day. This idea of the artist as a free person who expresses his or her ideas and emotions is actually very modern; we have not found it at any earlier time.

Fig. 57. Ingres, *The Turkish Bath*, 1862, oil on canvas, diameter 42 1/2″ (108 cm). Madrid, Prado Museum. The sensual subject of the bathers is repeated in Ingres's other work.

Fig. 58. Eugène Delacroix, study for *The Death of Sardanapalus*, pastel. Paris, Louvre Museum.

Fig. 59. Marie-Guillemine Benoist, *Portrait of a Black Woman*, ca. 1800, oil on canvas, 32″ × 25 1/2″ (81 × 65 cm). Paris, Louvre Museum. A Neoclassical painting that nevertheless contains a certain Romantic exoticism.

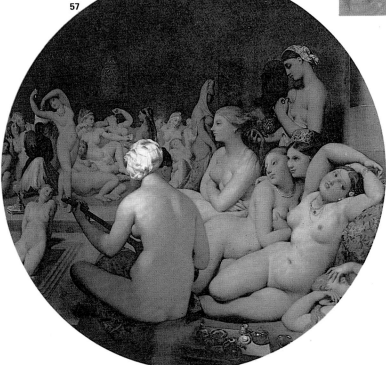

**57**

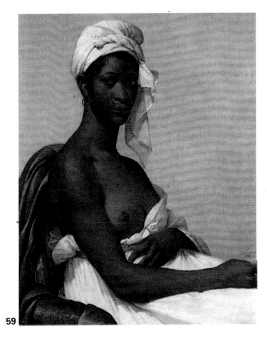

**59**

Fig. 60. Delacroix, *The Massacres at Scio,* watercolor, 13 1/4″ × 11 3/4″ (33.8 × 30 cm). Paris, Louvre Museum. In this study for a great painting, we can see Delacroix's Romantic and expressive concept of the nude.

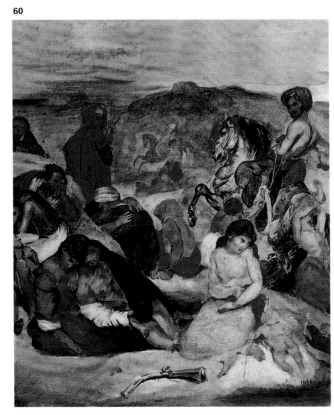

From the 16th century onward, artists' studies and sketches were preserved, but it was not until this time that they were considered to be an important aspect of their work. Both Ingres's drawings and Delacroix's travel notes and sketches are key to understanding their work and ideas. Ingres's drawings, as well as his paintings, are based upon the silhouette as the delimitation of volume and seek to create ideal beauty from

Fig. 61. William Blake, *The Genius of Shakespeare,* 1809, watercolor. London, British Museum.

Fig. 62. Henry Fuseli, *Satan and Death, Separated by Destiny,* 1792-1802, oil on canvas, 36″ × 28″ (91.3 × 71.1 cm). Munich, Neue Pinakothek. The English Romantics painted many subjects described by contemporary English poets.

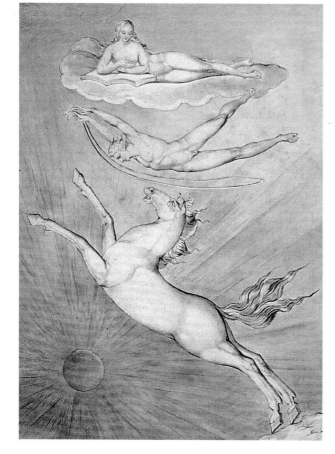

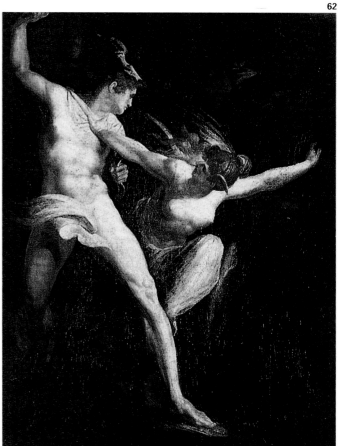

the whole. The bodies of his "odalisques," or concubines, are based not upon an anatomical study but on perfect proportions and geometrical shapes. For Delacroix, the nude was the perfect means for expressing strong emotions, thanks to its body language. This idea is evident in his carefree pictorial treatment based on fluent use of color and brush, on contrasts of light and realistic anatomy.

However, for other Romantics, such as the English artists (Blake and Fuseli, for example), the representation of the body was subordinate to expression. Only a great artist such as Goya was able to capture his personal demons, the terror of the age, the contradictions between the new rational school of thought and the power of Catholicism, which sought only to perpetuate itself. Perhaps for this very reason he was the only artist capable of producing a set of paintings such as the *Dressed Maja* and the *Naked Maja* (figs. 63 and 64) as an entertaining diversion for some noble (similar to undressing a doll), which he transformed into the most modern nude painting produced up to that time, with her immodest pose and provocative look. This marks the development of painting throughout the 19th and 20th centuries.

**63**

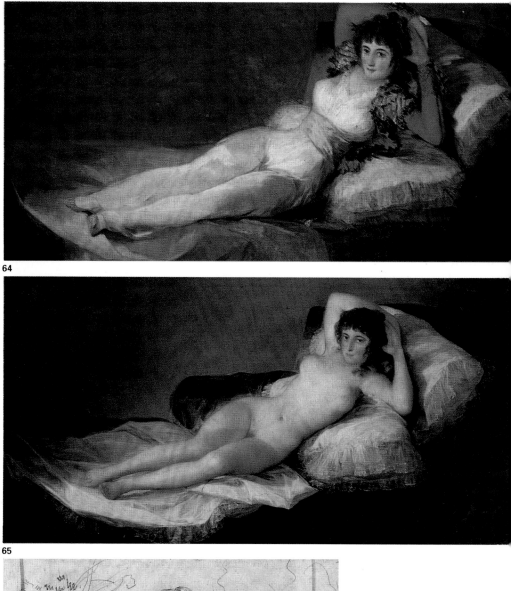

**64**

**65**

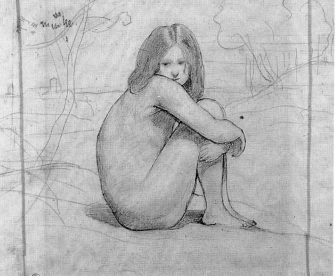

Figs. 63 and 64. Francisco de Goya y Lucientes, *The Dressed Maja* and *The Naked Maja,* oil on canvas, 37 3/8″ × 74″ (95 × 188 cm) and 38 1/2″ × 75 1/4″ (98 × 191 cm), respectively. Madrid, Prado Museum. This nude requires no introduction, and is the first truly modern nude in the history of art.

Fig. 65. Jean-Baptiste Camille Corot, *Girl in a Landscape,* pencil and black ink on paper, 8 5/8″ × 10 1/4″ (22 × 26.2 cm). Paris, Louvre Museum.

# Realism, Impressionism, Postimpressionism

**66**

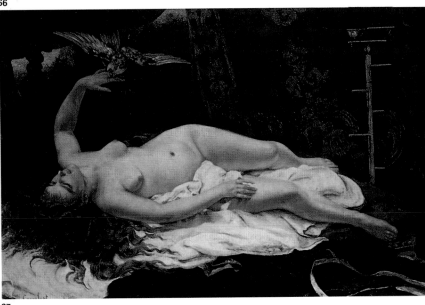

**67**

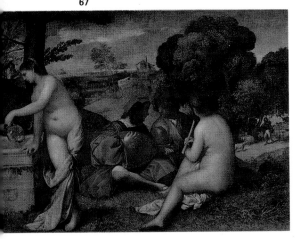

Fig. 66. Gustave Courbet, *Woman with a Parrot*, 1866. New York, Metropolitan Museum of Art. Realistic, spontaneous, and shameless.

Fig. 67. Titian (or Giorgione, according to some scholars), *Pastoral Concert*, 1510/11, oil on canvas, 43 1/4″ × 54 3/8″ (110 × 138 cm). Paris, Louvre Museum.

Fig. 68. Édouard Manet, *Luncheon on the Grass (Le Déjeuner sur l'herbe)*, 1863, 7′ × 8′ 10″ (213.3 × 269.2 cm). Paris, Orsay Museum. Novel in color use and subject treatment.

**68**

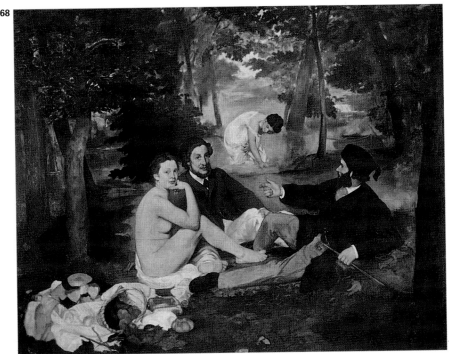

In effect, Goya, together with the old Spanish master Velázquez and various other northern painters, was to become a major influence during the middle of the 19th century. Except in England, where the Romantic Pre-Raphaelite Brotherhood was founded, artists began to shed academicism, which assigned merit solely on the basis of pre-established subject matter: historical, allegorical, mythological, or religious subjects. Like Goya with his "Maja," Corot and especially Courbet began to paint what they observed, occasionally taking this realism into the field of social consciousness. Courbet painted courtesans on the banks of the Seine and female nudes that are surprisingly indecent. He needed no other reason than the painting itself. This is easy for us to understand, but it was not so at the time. The Impressionist painters, who under the direction of Manet took Courbet as their master from 1870, quickly learned this lesson.

It is interesting to note that Manet's work *Luncheon on the Grass* (fig. 68) was found appalling by the same public who knew and admired Titian's *Pastoral Concert* (fig. 67). It was this work that inspired Manet to paint his. Nevertheless, thanks to the introduction of the Salon des Refusés, works such as Manet's could be exhibited and the younger painters who did understand them began to search for a new style, far removed from the prevalent academicism. They had already seen realism of subject matter in Courbet's work, but Manet added clear, luminous pink, white, and cold blue colors quite different from the somber tones in fashion in the academic galleries. His *Olympia* (fig. 69), inspired by Goya, succeeded in establishing his point of view and also in creating an even bigger scandal than his previous work.

# From the 19th to the 20th century

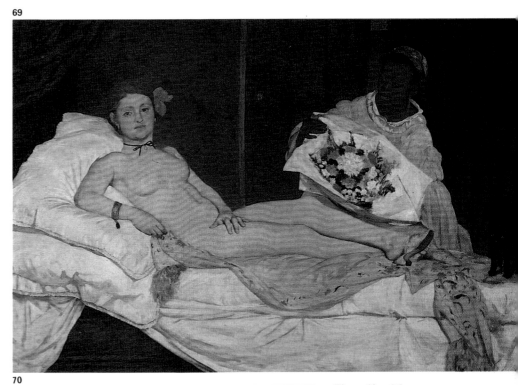

Manet and all the young artists who followed him, first Cézanne and Monet, later Renoir, Pissarro, Sisley, Bazille, and Degas, together with Berthe Morisot (his sister-in-law) and Mary Cassatt, an American living in Paris, created a revolution in painting and laid the basis for the avant-garde movements of the 20th century together with a new concept of art that also affected the nude (although it mainly involved the landscape). These artists were influenced not only by Courbet's and Goya's work, but also by Japanese engravings, with their clear silhouettes and flat colors, and by the kind of image cropping characteristic of photography. Another important influence was color theory, as science was applied to art in order to develop new methods: the Impressionists painted with flowing brushwork, leaving empty spaces and obtaining visual combinations that the observer notices when standing back from the painting (late in his life Velázquez had started to paint in this fashion). The artist's vision of the subject was highly important. It had to be natural, realistic, a representation of the world that surrounds us. Nudes, like those of Degas, for example, are set in day-to-day situations, as if caught at intimate moments. Degas's originality was not confined to this alone. He used settings and compositions, largely influenced by photography, that were so modern that fifty years earlier they would have been unthinkable.

Fig. 69. Manet, *Olympia,* 1863. Paris, Orsay Museum. This work, in its choice of model, in its color, and in its modernness, is inspired by Goya's *Naked Maja.*

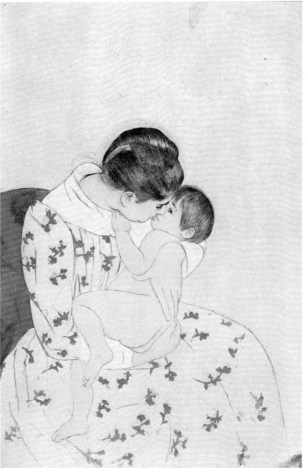

Fig. 70. Mary Cassatt, *A Mother's Kiss,* 1891. Washington, D.C., The National Gallery of Art. The influence of Japanese prints can be seen in the work of this Impressionist.

**71**

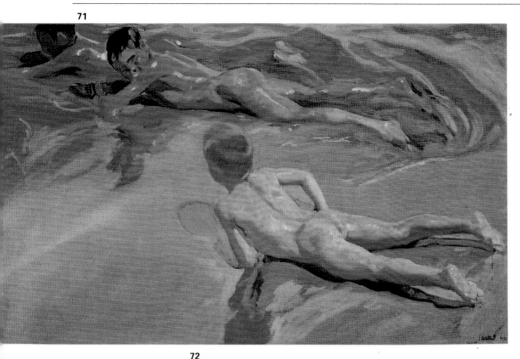

Japanese influences can be clearly seen in the woodcuts of Mary Cassatt and also in the works of the Postimpressionists Gauguin and van Gogh, as well as in Degas's work, although he never chose to throw himself fully into Impressionism, as it eventually blurred outlines, an effect he was not fully satisfied with, perhaps because his most admired master was Ingres. In any case, both for him and the rest of the Impressionists, the basic objective was to capture the reality of a given moment, the light, the shimmering atmosphere between forms.

For certain painters who came after the Impressionists, including Seurat, Toulouse-Lautrec, Gauguin, and Cézanne, this objective was also valid, yet they exerted their own individual freedom and search for a personal style in combination with a new concept of life. Seurat was an untiring worker, a prodigious talent who unfortunately died young. He left behind a series of remarkable paintings, several nudes done with a technique that came to be known as pointillism, which might be described as color theory taken to the extreme. Van Gogh also died young, without having painted any nudes. Gauguin, on the contrary, was a proud, rebellious painter who found his happiness and his subjects in the South Seas. He was also to find beautiful models with different skin tones, who posed perfectly naturally as the subjects for his work. He had already painted nudes in France, with beautifully clean brushwork. He was a painter who was particularly sensitive to color, who flooded his paintings with sharp contrasts and harmonies of yellows, greens, pinks, and violets. He tried to bring out the original, the primitive qualities of his subjects, the essence of form and painting itself.

Fig. 71. Joaquín Sorolla y Bastida, *Children on the Beach,* 1910, oil on canvas, 46 1/2″ × 72 7/8″ (118 × 185 cm). Madrid, Prado Museum. Sorolla's sure-handed brushwork and color handling endow his paintings with a feeling of great spontaneity.

**72**

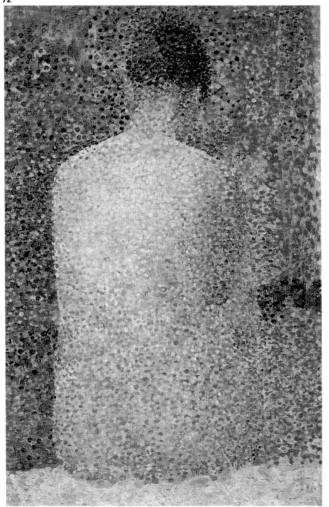

Fig. 72. Georges Seurat, *Seated Model with Back Turned,* 1886/7. Paris, Orsay Museum. Pointillism is based on the optical mix of colors.

73

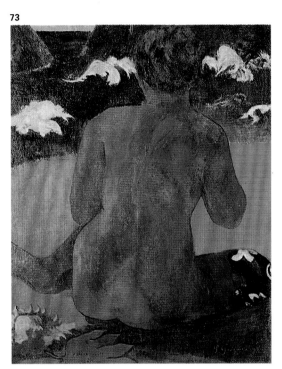

74

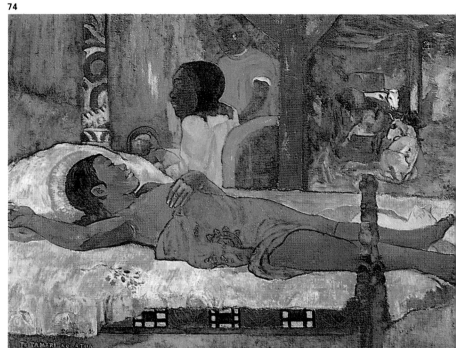

His lovely nudes are as natural as life itself.

For Cézanne, painting was a means of expression in which he searched above all for the balance between emotion and reason. We could also say that he would seek a simple, specific sensation and then transform it into a fine work of art. He was a solitary artist, and yet his work forms the basis for painting in the 20th century. His "Bathers" are a series of studies of nudes combined with landscape; in these works, composition is the overriding factor, with planes of color that are juxtaposed like small facets to create light and volume.

Fig. 73. Paul Gauguin, *Woman of the Sea*, oil on canvas, 36 5/8″ × 29 3/8″ (93 × 74.5 cm). Buenos Aires, National Fine Arts Museum. A magnificent back, like those by Ingres.

Fig. 74. Paul Gauguin, *The Birth of Christ*, 1896, oil on canvas, 37 3/4″ × 51 1/2″ (96 × 131 cm). Paris, Orsay Museum. The birth of a child expressed as a religious subject but with a different treatment.

75

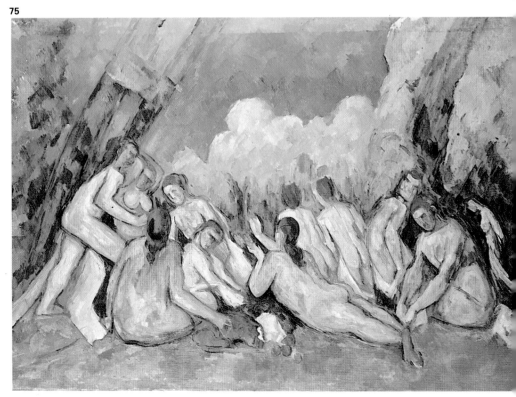

Fig. 75. Paul Cézanne, *Bathers,* between 1895 and 1904, oil on canvas, 50″ × 77″ (127 × 196 cm). London, National Gallery. Carefully composed, using a treatment based on planes of color.

# The nude in the 20th century

Fig. 76. Gustav Klimt, *The Three Ages of Woman,* 1905, oil on canvas, 70 7/8″ × 70 7/8″ (180 × 180 cm). Rome, National Gallery of Modern Art. In this work, Klimt produces a modern and decorative version of a classical subject, an allegory of the Renaissance period.

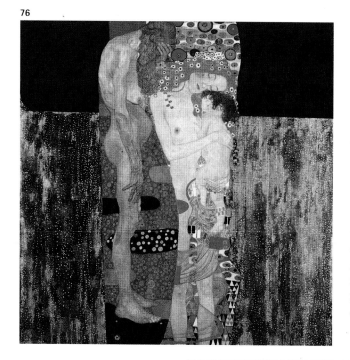

We have seen how it was not until well into the 20th century that the nude lost its religious, mythological, and historical connotations–its ideal form. Even toward the end of the 19th century and the start of the 20th, a period when reality was vindicated as a true art subject, this implied a new school of thought: humankind's relationship with respect to nature, silhouettes dissolving as does society, and thus continuing throughout the 20th century. The first avant-garde movements, grouped under the name of Expressionism, were a result of the desire to express emotions and, later, different

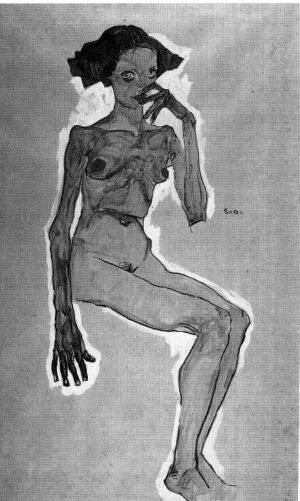

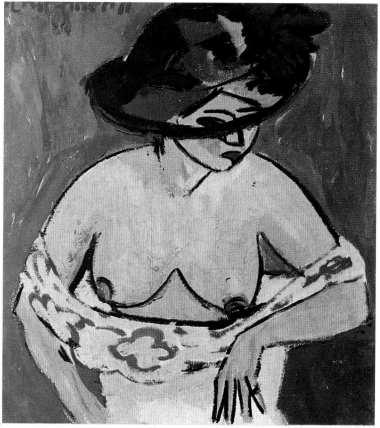

Fig. 77. Egon Schiele, *Girl Seated,* 1910, watercolor and gouache on paper. Vienna, Albertina Museum.

Fig. 78. Ernst Ludwig Kirchner, *Female Nude with Hat,* 1911, oil on canvas, 30″ × 27 1/2″ (76 × 70 cm). Cologne, Ludwig Museum.

79

80

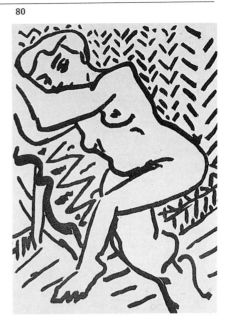

visions of reality through the use of color in ways that were totally removed from what is actually seen. But color was also the basis of composition and painting itself, especially for the great 20th-century artist Matisse. Matisse had an extraordinary talent for interpreting the nude; unlike most of the Expressionists, he shaped the human figure in order to convey, peace, calm, and serenity. One of his first paintings, called *Luxury, Calm, and Voluptuousness,* is virtually a declaration of his principles.

Modernism was the last of the movements to uphold, if only in part, Romantic ideals. The numerous nude figures in the drawings and paintings of Gustav Klimt represent his own canon of beauty. They are thin, pallid figures, beautiful yet tortured, writhing with emotion. He painted such classical subjects as allegories of sin and virtue and

reminders of mortality like *The Three Ages of Woman* (fig. 76), in which he emphasized the skeleton. Egon Schiele shared the same ideas, but his paintings were soon to become definitively Expressionist.

Cubism provides a different

Figs. 79 and 80. Henri Matisse, left: *Pensive Nude in Hammock,* lithograph, 14 3/4″ × 10 1/2″ (37.4 × 26.9 cm); right: *Seated, Sleeping Nude,* woodcut, 18 3/4″ × 15″ (47.5 × 38.1 cm). Both in New York, Museum of Modern Art. Beautiful images by an artist who loved nudes and their decorative potential.

81

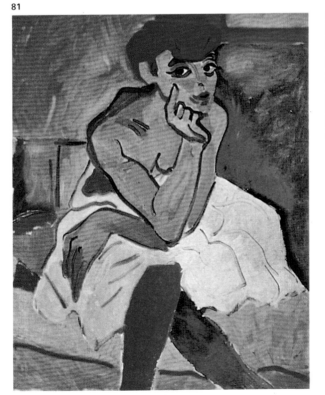

82

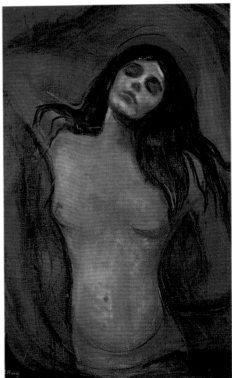

Fig. 81. André Derain, *Woman in a Chemise,* 1906, oil on canvas, 39″ × 31 1/2″ (100 × 81 cm). Copenhagen, National Museum of Art. The strong contrasts in this painting result from pairs of complementary colors.

Fig. 82. Edvard Munch, *Madonna,* 1895, oil on linen, 35 1/2″ × 27 1/2″ (91 × 70.5 cm). Oslo, National Gallery.

**83**

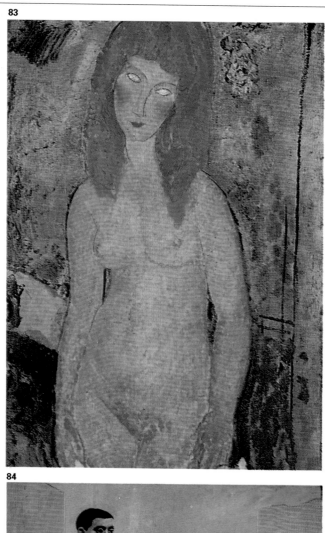

Fig. 83. Amedeo Modigliani, *Blonde Nude,* 1917. Private collection. Modigliani painted beautiful nudes in soft, sensuous colors with a Cubist treatment.

**84**

Fig. 84. Pablo Ruiz Picasso, *The Pipes of Pan,* 1923, oil on canvas, 80 3/4″ × 68 1/2″ (205 × 174 cm). Paris, Picasso Museum. Picasso painted all styles of nudes throughout his life.

vision of the human being in relation to space and time: it deals with a new way of looking that finally breaks away from the idea of the static observer, the single viewpoint that had been compulsory since the Renaissance. Objects and forms are seen from different angles; the painter's eye "sees" someone's forehead and back at the same time. Cubism was the invention of Picasso and Braque, who dared to break with existing formulas and to see the act of painting as a way of building reality, of creating whatever one wishes on the canvas. Apart from his Cubist period, Picasso painted many nudes throughout his life in every possible style, as if in homage to the body, upon which he projected his passions, fears, and obsessions with absolute freedom. They are odes to life, to love, to the human race. Modigliani was a desperate painter whose dramatic life reveals the influence of primitive art, as well as Cubism. His nudes (which account for a large part of his work) are truly marvelous, sensual, compact, and provocative.

Since the middle of the 20th century, few artists have painted realistic nudes. Abstract and new approaches to movement, material, and concept are the dominant characteristics. Nevertheless, certain painters, such as David Hockney and Edward Hopper, paint nudes in the general sense of the term, while others, such as Nicholas de Stäel and Willem de Kooning, represent nudes in purely abstract fashion.

The nude continues to fascinate artists, and at any art exhibition one is likely to see as many images of the subject as there are in this book. Students of fine art are generally required to learn how to render the nude because

it occupies such a central position in our visual tradition. In that spirit, this book focuses on how to draw and paint the nude in a wide variety of mediums.

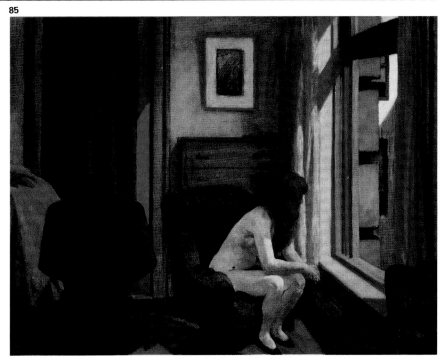

Fig. 85. Edward Hopper, *Eleven in the Morning,* 1926, oil, 28″ × 26″ (71 × 92 cm). Washington, D.C., Smithsonian Institution. Hopper was one of the few contemporary painters to use naturalist techniques to paint desolate subjects.

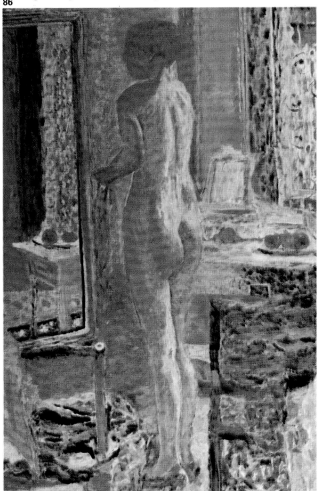

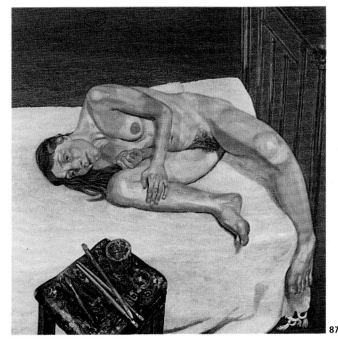

Fig. 86. Pierre Bonnard, *Nude Before the Mirror.* Venice, Museum of Modern Art. Bonnard's colorism expresses his unique sensibility.

Fig. 87. Lucien Freud, *Nude with Painter's Palette,* 1972/73. London, National Gallery. This British painter has based his entire work on the expressionist representation of the nude.

# THE NUDE: THE IDEAL AND THE REAL

For Renaissance artists, returning to the Greek notion that the human body had to fit into geometric forms (which for the Greeks represented perfection) was an act of faith, a guiding principle, and the basis of their philosophy. At the same time, Renaissance artists believed profoundly that studying the inner structure of the human body would inevitably reveal the cause of that perfect form.

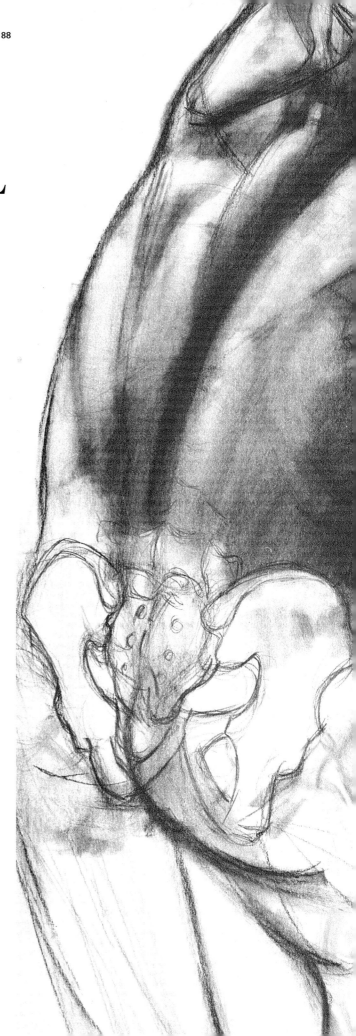

Fig. 88. Ramón Sanvisens, *Anatomical Study,* charcoal pencil on paper. A study like this one goes beyond the field of pure anatomy and into the world of art. Achieving success with this genre, however, is difficult; you need talent and knowledge.

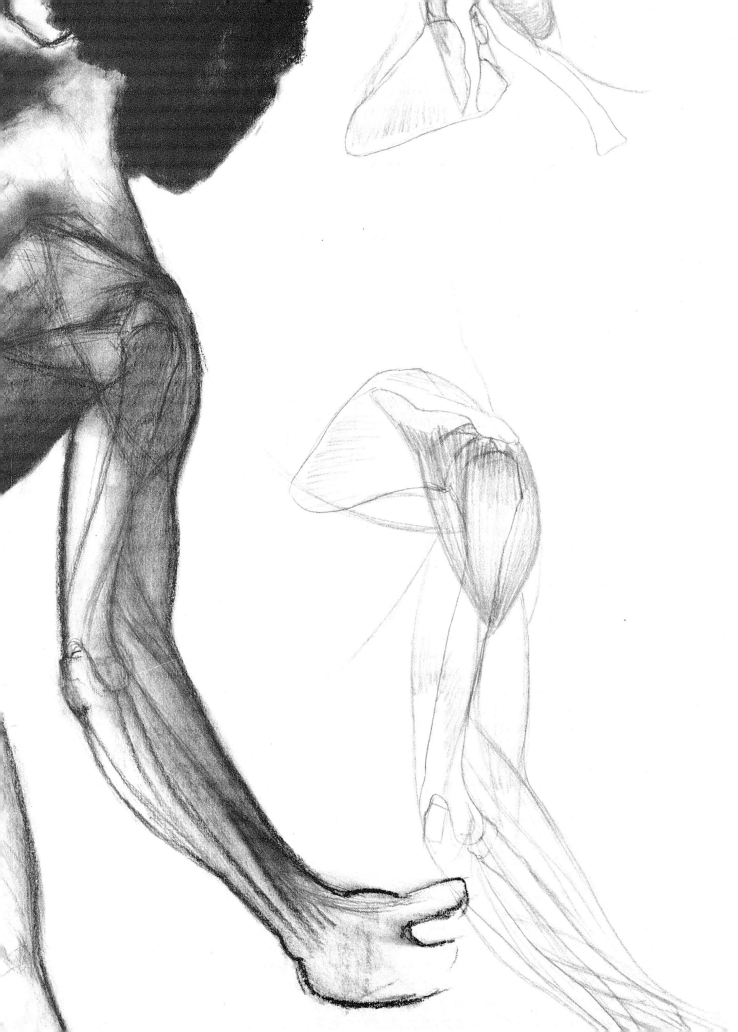

# Introduction to the ideal: the canon

Drawing or painting the human body is not as simple as it looks. As we saw in the previous chapter, the various cultures viewed the figure and its representation in art differently, and with every era ideas about the human form and its image evolved.

These factors concern all aspects of art history. Yet they become fundamental with respect to the human body, where artistic symbolization is extremely important. There are several reasons for this. First, the human body is the prime representation of the person. It can thus reflect a set of ideas about how humans see themselves. Second, when people represent the body in an un-guided way, they can easily slip from the sublime to the ordinary.

Given this fundamental risk, we have to be very clear about how we approach the body. We must avoid simple or absurd copies of what we see. Our work should belong to the properly artistic sphere.

This has been obvious from the very beginning of art history. The prehistoric dancers and hunters depicted in cave paintings are not just human bodies. They are also symbols and ideals that had social and even magical functions, representing the human spirit as well as the material body.

Although the body is often represented in art because of this spirituality, it also appears as a "natural" object, as was the case with the ancient Egyptians. Yet if we look closely at the many figures in Egyptian art, we find they are remarkably similar. Of course, this could be because people at that time were actually much the same. But it is far more likely that the artists employed some kind of convention or norm.

Some time ago archaeologists came across Egyptian tomb paintings that had various kinds of grid lines. Studies have since strongly suggested that these lines were used to reproduce norms for the proportions of the human body. Bodies conforming to these norms were considered beautiful in terms of the Egyptian ideal. The proportions varied a little between the Old and New Kingdoms (see figs. 89 and 90). But in both cases the basic unit, or "module," seems to have been the width of the clenched fist or the length of the middle finger. In the Old Kingdom the height of the ideal body was 18 1/4 "fists"; in the New Kingdom it was 21 1/4.

Many elements of Egyptian culture were transmitted across the Mediterranean to the ancient Greeks. But for the Greeks, unlike the Egyptians, the human body and its

Fig. 89. A grid superimposed on a drawing of *Mykerinos and His Bride,* a statue from the Old Kingdom in Egypt, illustrates the "18-fist" canon of proportions that may have been used.

Fig. 90. *Girls Playing Musical Instruments* (detail), a New Kingdom wall painting from tomb 52 at Thebes. The figures are less rigidly conventional than those of the previous period. The canon for their height appears to have been 21 1/4 "fists."

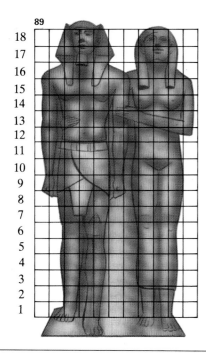

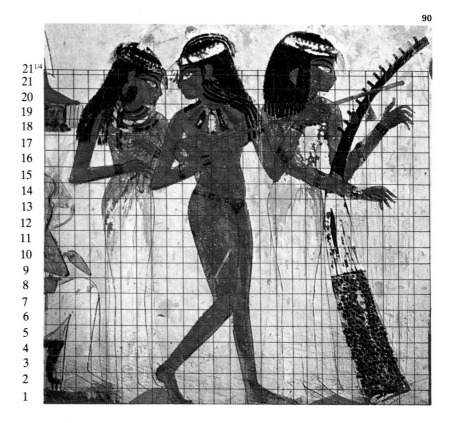

representation was something more than a "natural" object. The Greeks saw man as the center of the universe, and thus their gods looked and acted like humans. The fundamental part of the body was thought to be the head, and documents show how Greek artists used a system of proportions in which the height of the head was the basic module. The height of the body was equal to a certain number of "heads," depending on the idea to be expressed. A height of 8 1/2 heads resulted in a stylized, more godly figure; 7 1/2 heads produced a more robust, human body. The Greeks called the basic proportion the Kanon, after the name of the Doryphoros, a superb statue by Polyclitus. The English term "canon" nowadays means a principle or accepted criterion applied in a branch of art.

People seem to have forgotten about the human body during the Middle Ages. There was no principle of conventional proportions. The body was simply not considered important or beautiful. Not until the Renaissance were the ideals of ancient Greece given new life.

The Renaissance artists, as well as philosophers and scientists, gave much thought to the ideal body as authentic beauty. Their task was complicated by an insistence on natural truth. They wanted the body to be not just an ideal of the mind but a fact of nature as well. Despite the great difficulties of this double goal, artists like Leonardo da Vinci produced superb representations of the body (fig. 93). We still more or less follow their canons today, although different periods and artists, of course, have aimed for slightly different ideals. Rubens did not paint figures the same way as his contemporary Titian; Giacometti's nudes are not like Matisse's.

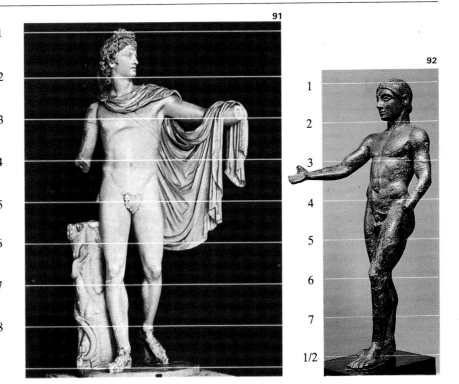

Figs. 91 and 92. Two Greek statues show different systems of proportion. In the statue known as the *Apollo Belvedere* (fig. 91) the canon is 8 1/2 heads, giving a more spiritual vision of the god. The statue at right follows an older canon of 7 1/2 heads.

Fig. 93. Leonardo da Vinci, *Study of the Proportions of the Human Body*. Venice, Academy Gallery. Leonardo used the ideas of the Roman architect Vitruvius as the basis for his canon. He also refused to believe that women had any perfect proportions.

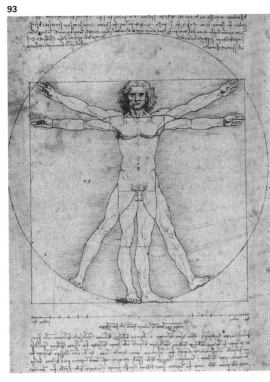

Fig. 94. Drawing based on Albrecht Dürer's sketches, showing proportions of the male body.

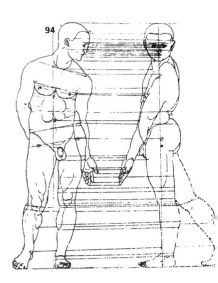

# The modern idea

Despite minor variations, the Renaissance proportions are still largely respected today. We place the navel in the middle of the body, the distance of outstretched arms equals the height of the entire figure, and so on. And yet, for about the past hundred years, artists have no longer tried to express the classical ideals of beauty. They have sought the reality of life itself, expressing the individual spirit of both the model and the artist. The canon has given way to greater expressiveness and individualism.

All artists nevertheless use some kind of canon in order to represent the human body. No drawing can do without basic guidelines concerning ideals. After all, as we said in the introduction, the aim is not to copy the bodies we see. This can be done quite adequately by photography. We have to do something more.

The canon can provide a way of beginning our drawing, giving measurements that we can then adapt to each model or figure. One of the simplest modern canons is shown in figs. 95, 96, 98, and 99, indicating different proportions for adults, children, and infants. You can see for yourself how the

Fig. 95. The modern canon for the male body uses the head as the basic module. The height equals eight heads, and the width across the shoulders is about two heads. The side view shows how the shoulder blades and the buttocks reach the same vertical line.

Fig. 96. The modern canon for the female body is based on the same proportions of eight heads for the height and two heads for the width, although this particular woman is rather thin and stylized. The side view shows some important differences: the buttocks go beyond the line of the shoulder blades, the breasts are slightly lower, and the waist is narrower than the man's.

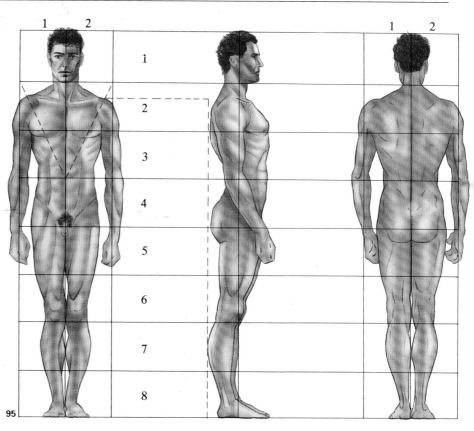

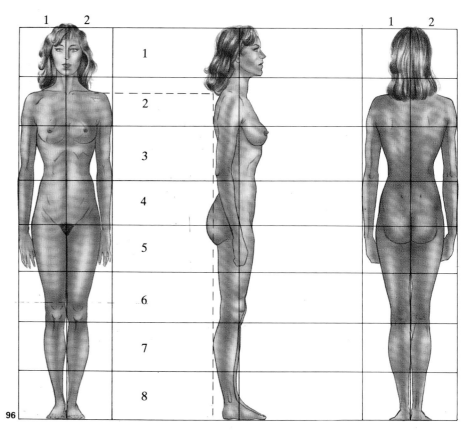

measures vary in both height and width.

Canons can also be used as a basic way of measuring the relations between the parts we observe. Awareness of a canon can keep us from drawing legs too short, heads too small, or arms too long. But we should not follow canons blindly, as if they were laws. Models can differ quite significantly from the norms, as shown in fig. 97. This is why we should not believe the apparently scientific idea that canons represent the average proportions of a great number of randomly selected people. In principle, canons are not averages. They represent ideals of perfection. Of course, when we want to say why certain figures are beautiful or perfect, we cannot find any timeless answer. Each period has its ideas, its beliefs, its symbols, and its opinions. That is why representing the body in art requires imagination just as much as it requires knowledge. Its ultimate object lies between the two, in human nature.

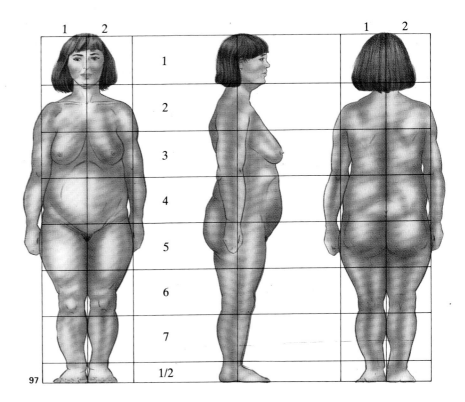

Fig. 97. The modern canon cannot be applied to all figures. The artist should be aware of this. In this case, the height equals 7 1/2 heads, and the width is greater than the norm.

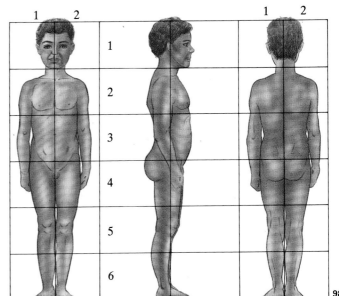

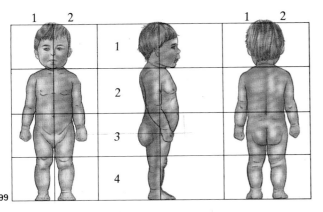

Figs. 98 and 99. These illustrations show different canons for drawing a toddler (one or two years old) and an older child (six years old). The proportions change with age, since babies are born with their heads very large in proportion to the rest of their bodies.

# Artistic anatomy

Anatomy is the study of the way the human body is structured based on direct or indirect observation. Much of our knowledge has come from dissection. How does it apply to art? Anatomy is clearly useful for understanding how to represent the body. It tells us about the inside of what we see, the structures beneath the skin that make physical movements and gestures possible. Yet anatomy is both more and less than this. For many centuries no one was interested in the inside of the body. Even the Egyptians, who cut open bodies, seem not to have used any anatomy in their art. For a long time dissection was even prohibit-ed. Yet anatomy eventually became an obsession for certain artists. Some even made it the direct subject of their art, as can be seen from the countless skeletons that have been painted in the course of history.

Like most of the questions we have been dealing with in this book, the usefulness of anatomy is open to debate. In principle, knowledge of the body is always positive. Yet an artist who doesn't know much about anatomy can certainly draw a beautiful body. Careful observation and attention to proportions can sometimes suffice.

I am not suggesting that you should skip over the following pages. On the contrary, I want to make you think about what you're doing. Even though observation may be enough, the artist's task becomes easier when supplemented with knowledge. The more we know, the better we paint.

Figs. 100 and 101. Leonardo da Vinci, *Study of the Human Skull* and *Study of Legs*. England, Windsor Castle. For Leonardo, drawings like these were the basis for the study of the human body.

100

101

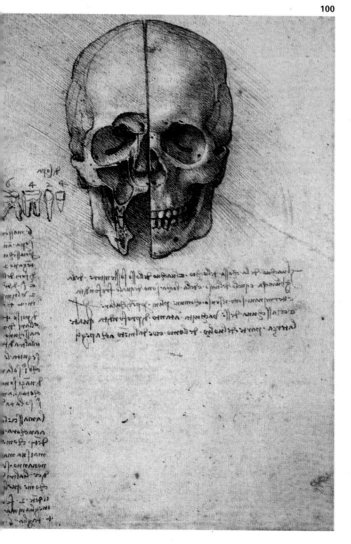

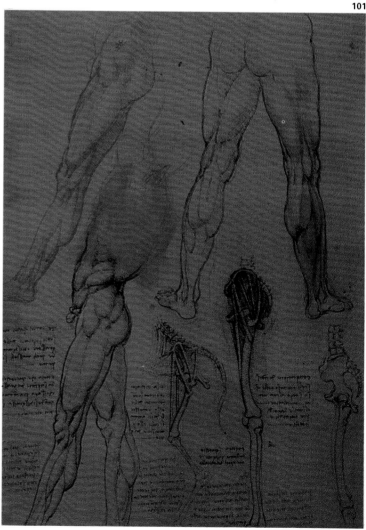

Of course, our task is not to create anatomical documents. Anatomy simply helps us avoid the errors that make some drawings illogical: bodies that seem about to fall down, arms coming out of rib cages, or hands and wrists that don't belong with each other.

As the illustrations shown here indicate, anatomy is also beautiful in itself. It can even become a game, as we shall see later in this chapter. There is a certain delight in seeing how bone structures form a certain pose, creating a marvelous balance between all the different parts of the body. The following pages show the inside of the body: first the skeleton, then the muscles that hold everything together and make our movements possible.

There is no need to learn all the names. Just observe the parts and their interrelations. Note, for example, that the backbone forms an S when seen from the side, so there is no excuse for drawing flat backs. The pelvis is one large bone from hip to hip, so when one side goes down, the other must go up. And pay close attention to the muscles. See how the one running up the inside of the leg starts from the pelvis and can take on many forms. When you observe the arm muscles properly, the bodies you draw will have well-curved forms rather than naïve bulges.

We shall later see drawings based on the use of a mannequin that works something like the skeleton. But the important thing now is that you start to draw your own basic skeletons. The fundamental elements are the backbone, the pelvis, the bones of the arms and legs, the rib cage, the shoulder blades, and the skull. This simple skeleton can be the first step to drawing any human figure. When you work like this, anatomy becomes a game in which you soon develop your own personal interpretations.

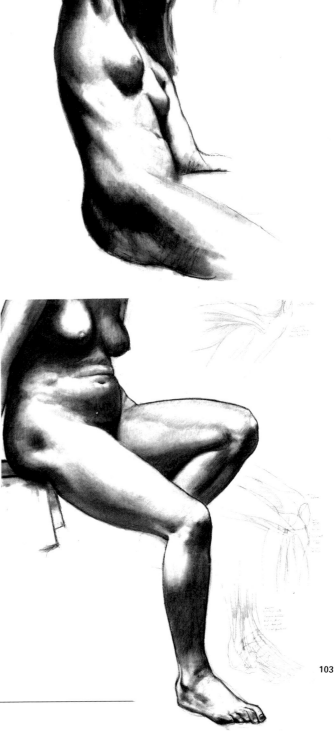

Fig. 102. Ramón Sanvisens, *Anatomical Study: Woman with Raised Arm,* charcoal on paper, 39 3/8″ × 27 1/2″ (100 × 70 cm). Sanvisens's attention to correct structure makes him an expert in anatomy. The beauty of the complete drawing comes from knowledge of how the various parts of the body interrelate in difficult poses. Here we see this anatomical knowledge illustrated alongside the model, illustrating the inside of the body.

Fig. 103. Ramón Sanvisens, *Anatomical Study: Legs of a Seated Woman,* charcoal on paper, 39 3/8″ × 27 1/2″ (100 × 70 cm). This is another superb study using chiaroscuro and detailed anatomy. The artist shows how he has analyzed the more complicated parts of the body and even the foot, which presents many problems for beginners.

102

103

# The human skeleton

The skeleton is the framework of bones that supports the human body. Bones are hard and cannot be bent, no matter how many bad drawings show them as bent. They are not welded together but are articulated, fitting into each other and joined by muscles in a way that allows the body to sit up, turn, walk, grasp objects, and so on. Articulations occur at the joints connecting the various bones, like the knee, the elbow, and the shoulder. The backbone, or spinal column, allows the most movements because it comprises numerous small bones articulated one into the other, like a chain. The hand also has many articulations, allowing countless different movements. As our illustration shows, the bones are rounded at the articulations in such a way that they can turn without friction or cracking.

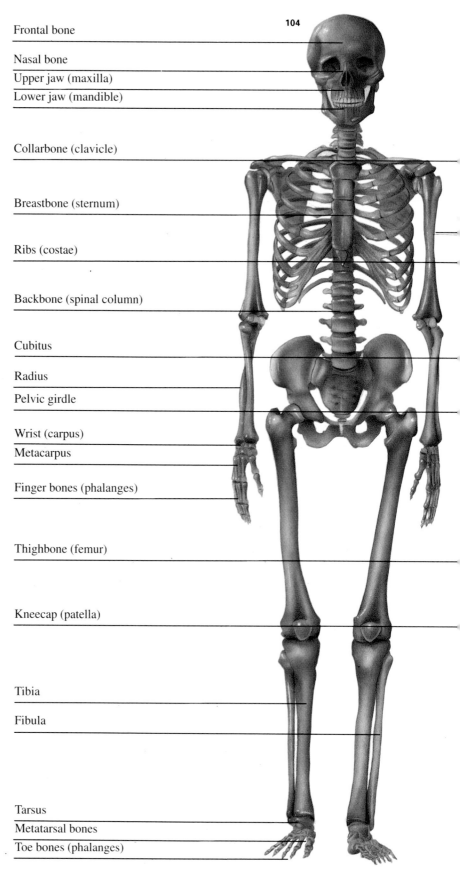

Frontal bone
Nasal bone
Upper jaw (maxilla)
Lower jaw (mandible)
Collarbone (clavicle)
Breastbone (sternum)
Ribs (costae)
Backbone (spinal column)
Cubitus
Radius
Pelvic girdle
Wrist (carpus)
Metacarpus
Finger bones (phalanges)
Thighbone (femur)
Kneecap (patella)
Tibia
Fibula
Tarsus
Metatarsal bones
Toe bones (phalanges)

104

Fig. 104. The human skeleton as seen from the front, indicating the main bones. The skeleton is the frame of the body, giving it external form and keeping the muscles from falling to the ground in a soft heap. The exquisite balance of the skull, the backbone, and the legs makes the human being the only mammal to stand on just two legs.

Fig. 105. The human skeleton as seen from the back. This view shows some bones that are not seen from the front. The most important are perhaps the shoulder blades, whose triangular form holds together the arms, the collarbone, and the back. Observe that the thighbone is not exactly vertical but slopes inward as it goes down.

Fig. 106. The side view of the human skeleton clearly shows the curves of the backbone.

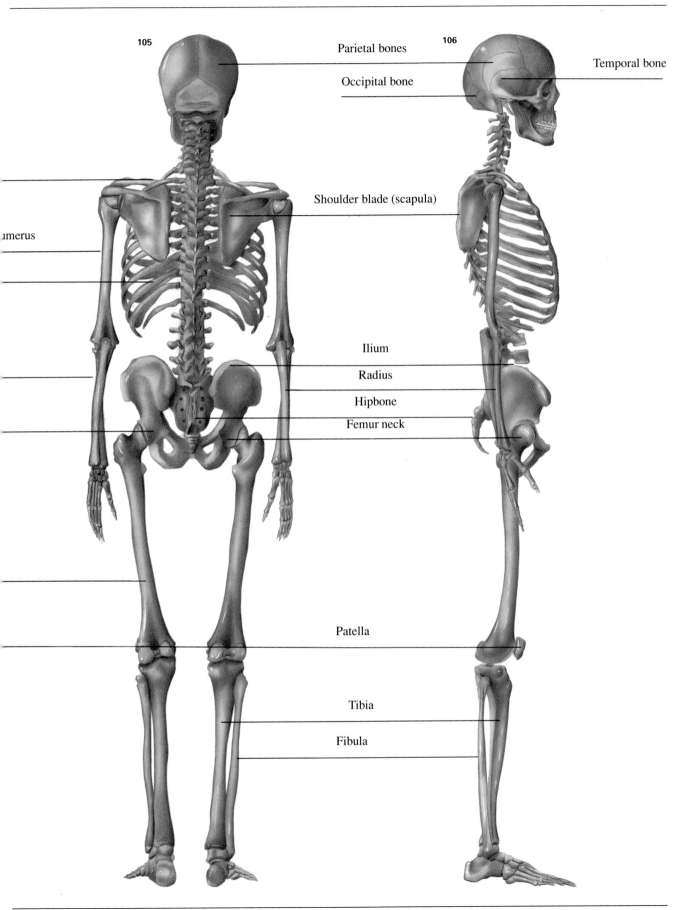

105

106

Parietal bones

Temporal bone

Occipital bone

Shoulder blade (scapula)

umerus

Ilium

Radius

Hipbone

Femur neck

Patella

Tibia

Fibula

# The muscles of the human body

The muscle system is more complicated than the skeleton. There are far more muscles than bones, and they are interrelated in very complex ways, both between themselves and with the skeleton. This makes any particular movement difficult to describe, since numerous muscles are usually involved.

A general overview of the muscle system is nevertheless useful. After all, the muscles give the body its external form. They are made of fibers that, when stretched out, always run in a certain direction. But the stomach muscles, the chest muscles, and the muscles of the arms and legs are all quite different. Brief consideration of these differences should help you understand why some body forms are as they are.

The form of each muscle depends on the function or movement it has to carry out. Muscles can be circular (like rings, to close tubes or conduits), leaf-like (as in the muscles that close the eyes), flat and wide (like the muscle of the forehead), fan-like, or spindle-like (bulging in the center and thinner at the edges, like the arm muscles shown in figs. 107 and 108). These

are the most frequent shapes and the ones that have most to do with the way the body moves.

Figs. 107 and 108 show good examples of spindle-like muscles, which work on the principle of the lever. By contracting and stretching themselves, the muscle fibers make the arm move. When they contract, they bring closer the parts of the body that they connect. Of course, most movements require interactions between numerous muscles. In fact, any movement could virtually involve the entire body. That is because whenever we lift an arm or take a step up, our body would lose balance if the whole structure did not move to offset the individual movement.

This marvelous coordination is the essential beauty of anatomy. It might help us understand why Renaissance artists worked in secret with early scientists interested in medical knowledge, stealing bodies in order to dissect them. They slowly built up knowledge about how the body works. In fact, they came to see the body as the center of the universe, the perfect machine that was the crowning point of all creation.

Figs. 107 and 108. The movements of the arms show how muscles apply the principle of the lever. Here the fulcrum of the lever is the elbow, where the humerus, cubitus, and radius muscles meet. The biceps in the front and the triceps at the back push and pull the movement as they are contracted and relaxed respectively.

Figs. 109 and 110. The main muscles in the human body are as follows:

1. Occipitofrontalis
2. Temporalis
3. Orbicularis oculi
4. Orbicularis obis
5. Maseter
6. Sternocleidomastoid
7. Trapezius
8. Deltoid
9. Pectoralis major
10. Infraspinatus
11. Teres
12. Biceps
13. Triceps
14. Serratus
15. External oblique (abdomen)
16. Rectus
17. Latissimus dorsi
18. Supinator
19. Palmaris longus
20. Flexor digitorum
21. Cubital
22. Extensor digitorum
23. Gluteus
24. Sartorius
25. Tensor of the fascia latia
26. Rectus femoris
27. Vastus medialis
28. Vastus lateralis
29. Semitendinosus
30. Biceps femoris
31. Popliteus
32. Gemellus
33. Tibia
34. Extensor digitorum
35. Achilles' tendon (tendo calcaneus)

**107**

**108**

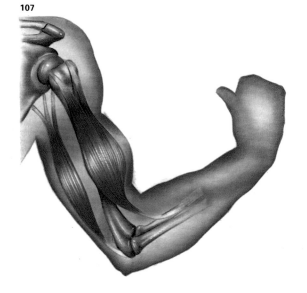

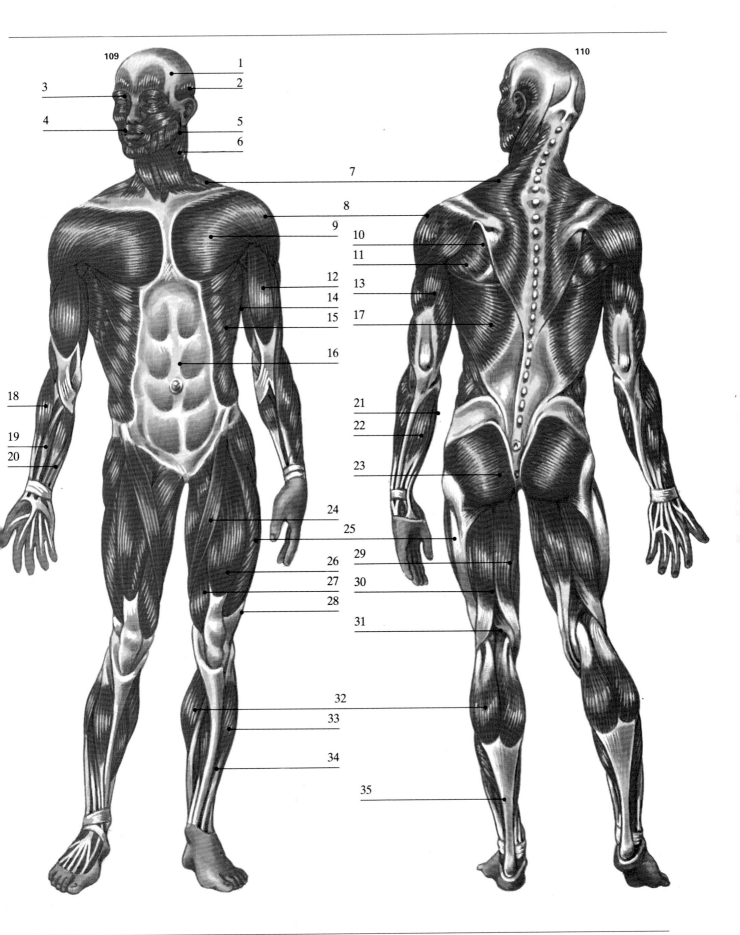

# Sketching the skeleton form

Figs. 111 and 112. One of the many ways in which a mannequin can represent the human body, helping us to understand the complexity of certain positions.

111

112

Having studied the previous pages, you can now put into practice everything you have learned. The usefulness of this knowledge should become clear as you go along. If you can now sketch the main lines of a skeleton, you have understood how the body holds together. Your sketches should include the head with its individual shape (not round like a ball), the spine as the basic axis of the body (like an S when seen from the side), the rib cage (like a compact box with highly rounded edges), the pelvic girdle (a more or less triangular or conical shape), then the legs (with the thighbone going from the hip to the knee, not vertical but sloping inward as it goes down), the bones of the lower leg, and the triangular shape of the foot. You should then return to the rib cage to add the shoulders and arms. And there you have it–a basic skeleton form.

You can do a lot of things with this basic form. You can draw series of little skeleton-men in various positions. You'll have to check to see what happens when one part moves. You can do this by observing a model or by looking at people in the street or at home or even by studying photos. In each case you should try to see the basic skeleton form. With a little practice this exercise will help you avoid many common mistakes that beginners make when sketching the body.

The facing page shows several skeleton forms at rest and in movement (fig. 113). They have been drawn by our illustrator, Antonio Muñoz, who has put in quite a few details. But your outlines can be more abstract. There's no need to draw the ribs one by one; the general shape of the chest will do. Nor do you have to show the holes in the face or the vertebrae in the spine (which can become just one line). Once you know how to do these little skeleton-men, the next exercise is to give them flesh by drawing in the muscles.

Another way of drawing basic skeleton shapes is to use a jointed mannequin like the one shown in fig. 112. Once there were life-size figures like this that you could dress up. The modern version is based partly on the principles of the skeleton and partly on external forms, since it is made of shapes rather than lines. These mannequins reproduce the body's movements fairly well, although some details, like the subtle curves of the spine, are inevitably lost. Such models help us understand and draw the body, uniting the lines of the skeleton with the geometric forms of the body parts. We'll soon see how this works.

**113**

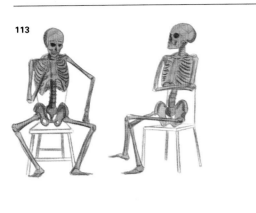

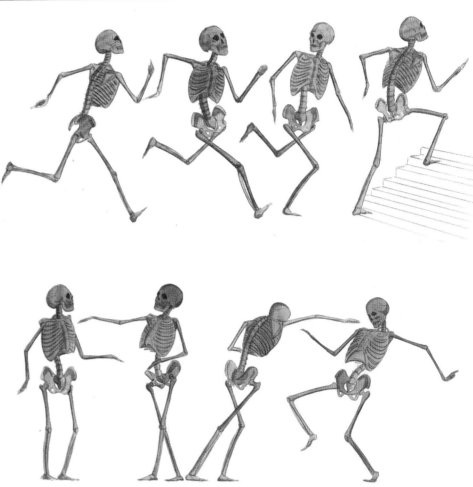

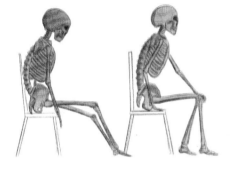

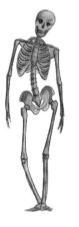
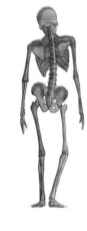

Fig. 113. Look closely at these little skeleton-men. They express a wide range of body positions: sitting down, standing up, running, walking, and gesturing. By copying these drawings, you will gain a better understanding of the most important bones and the way they interact. Then observe the position shown in the drawing just to the left of this text. This is a very common posture, with the weight on one leg, the hips at an angle, and the shoulders sloping the other way. These two opposed angles allow the body to stay balanced. Why not stand up and prove it to yourself?

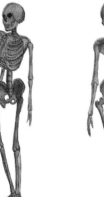
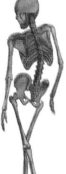

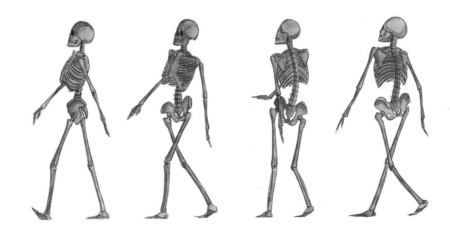

# An anatomy exercise with tracing paper

Figs. 114 to 116. Although this exercise should be done with sheets of paper one on top of the other, here we have separated the three sketches so you can see each step on its own. First, observe the model and do a simple line drawing (Fig. 114). Second, place a sheet of tracing paper over the first sketch and draw in the bones as carefully as possible, paying attention to the way they interact. Third, on another sheet of tracing paper on top of the others, draw in the muscles, observing how they are attached to the bone structure and the way they move together. All these sketches should be done as studies, with as much patience and care as possible. The aim here is to learn and memorize, not to produce a work of art.

Here we'll do a basic anatomy exercise that should help you practice what you have just learned about the human body. The purpose is not to show how skillful you are. Our exercises are simply designed to make your studies useful. After all, the best way to learn about art is by doing it. Just looking at hands and faces can certainly teach you something. Yet if you don't actually use what you learn, if you don't make the ideas clear and concrete, your memory will soon fail you.

Our exercise is as follows. Looking at a model or a photograph, draw the visible lines of a body. This should be a simple rough sketch, with just a few details and no shadows. Antonio Muñoz gives

us a very clear example in fig. 114, but you can do any figure or position you like.

Next, take some transparent or semi-transparent tracing paper and place it over the sketch. Checking with a drawing of the skeleton and using the sketch as the base, draw in the main bones as carefully as possible. Begin with the shape of the rib cage, the skull, the spine, and the pelvic girdle. For each bone, check with the drawing of the skeleton to see how it should look. Fig. 115 shows how Antonio Muñoz did this part of the exercise.

Now place another piece of tracing paper on top of the previous sketches and start drawing in the muscles. Pay special attention to

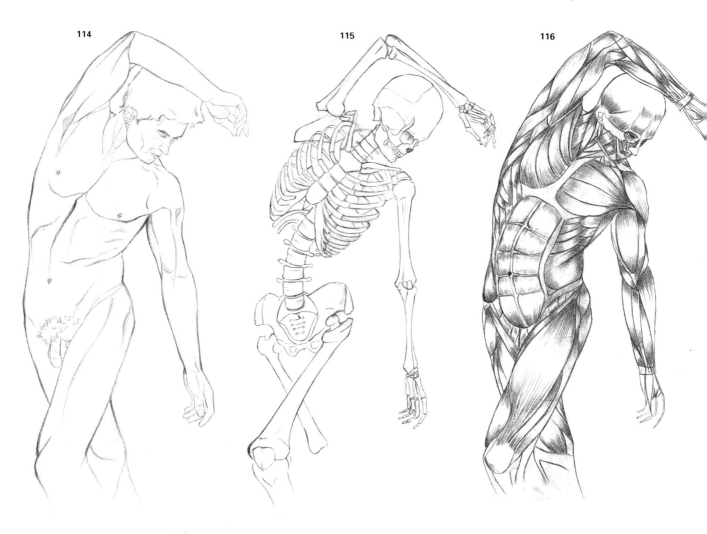

114

115

116

where each muscle comes from and what it is attached to. This is especially important with the pectorals, the biceps, the sartorius, and the stomach muscles, since these are the muscles that should construct the figure. A mistake here can lead to serious deformations.

Observe all the muscle shapes closely, particularly the way they always form convex curves along the outside of the body. In this part of the exercise you should aim for as much detail as possible, using a large sheet of paper if necessary. This doesn't mean your work has to be as perfect as the drawings by Sanvisens that we saw on pages 48 and 49. The important thing is that you avoid all random lines. Each mark you make must have a reason for being there; it must represent some body form. If you're not sure about a line, don't draw it. Check to see exactly where it should go.

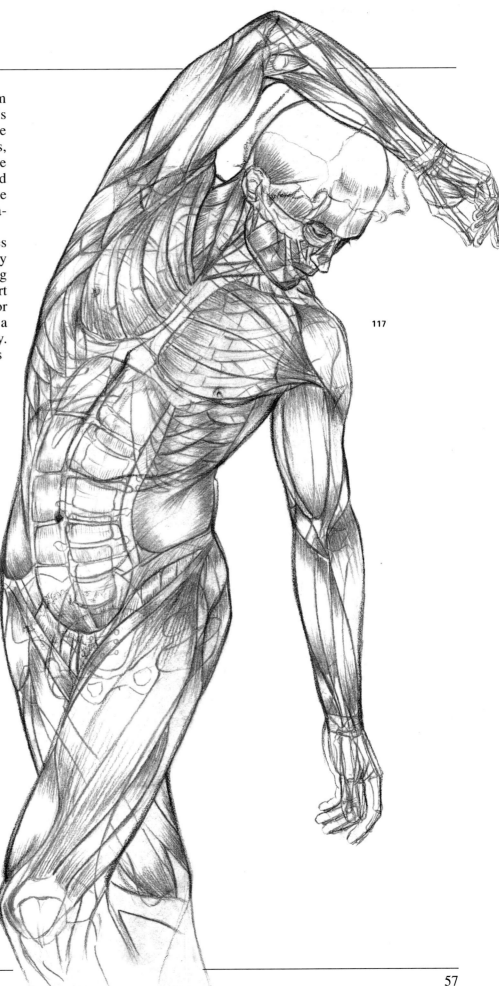

117

Fig. 117. Here we see how the finished exercise should really look, with the three drawings placed on top of each other. Three different colors have been used, but you can do the whole exercise with charcoal or a graphite pencil. But make sure you work at a scale that is large enough for all the details to be shown. You need plenty of room to take in all the aspects of this complex study.

# Exercise with a jointed mannequin

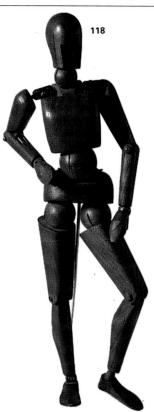

**118**

**119**

Fig. 119. Here Miquel Ferrón has just outlined the mannequin's general pose, indicating the main joints, the angle of the legs, and the shape of the pelvis.

Another good way of applying and developing your knowledge is to use a jointed mannequin as a model. We asked Miquel Ferrón to carry out this exercise, with the results that you can see on these pages.

First put the mannequin in the position that you want to draw. Then draw exactly what you see, from whatever angle you like.

Although we still haven't really explained how you should draw the human figure, the mannequin itself should introduce you to the essential points. This is because the mannequin reduces the body to its simplest geometric shapes. By starting from these shapes we make sure our drawings hold together. The lessons learned in this way can then be applied when drawing human models.

Once you've put the mannequin's

Fig. 118. This exercise is a good way of learning how to construct correct drawings of the human body. The jointed mannequin is first put in the position to be represented.

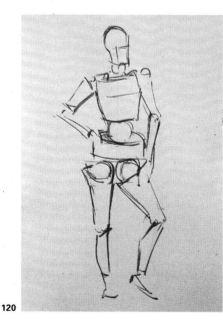

**120**

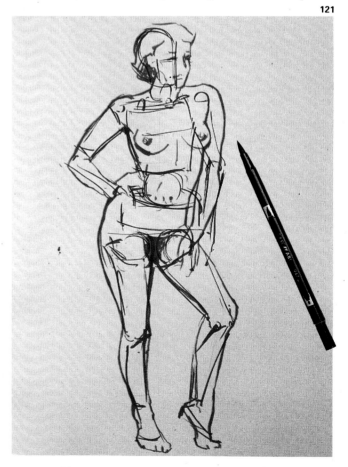

**121**

Figs. 120 and 121. The sketch is then developed by adding further details until you have a human figure, in this case a female figure. Note that the pose here is a version of the "weight on one foot" one that we talked about with respect to bone angles. The mannequin can give us a good general view of the shapes and angles that form such a position. Of course, several corrections have to be made if we want the drawing to represent a particular person.

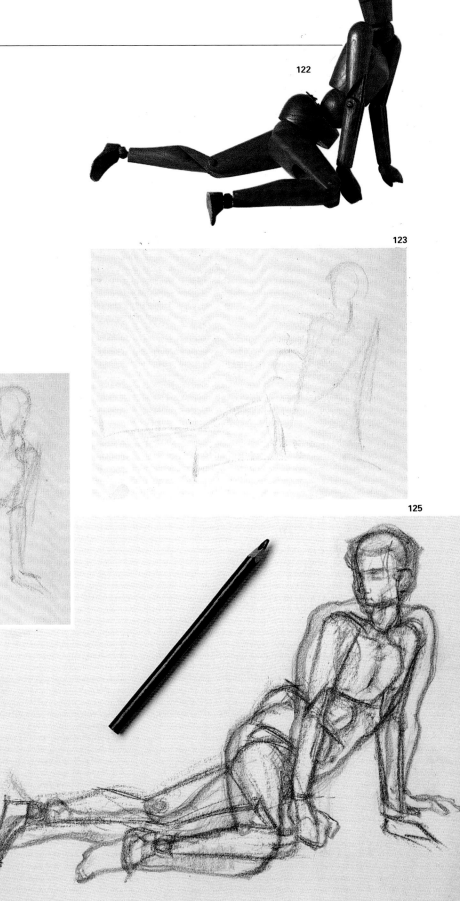

shapes down on paper, go over them, adding details and defining forms so they become human and lose the rigidity of the wood figure. You can use this exercise to experiment with different drawing techniques, as has been done in our illustrations. Miquel Ferrón did the first sketch with a very soft graphite pencil. For the second he used an ink pen with a soft, brushlike point.

Of course, you can do as many sketches as you like. The important thing is that you gain knowledge and confidence about how to draw the human body.

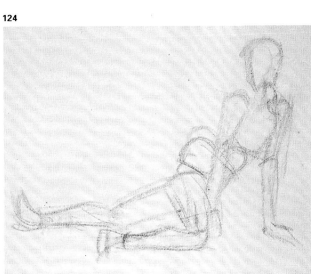

Figs. 124 and 125. As in the previous example, here Miquel Ferrón has copied the geometric shapes of the mannequin fairly closely before going over them to make them human, in this case producing a masculine body. He has partly done this so you can see the various steps involved. But he has also had to make some changes to individualize the shapes, reducing some gestures, shortening the right arm a little, and rounding the curves.

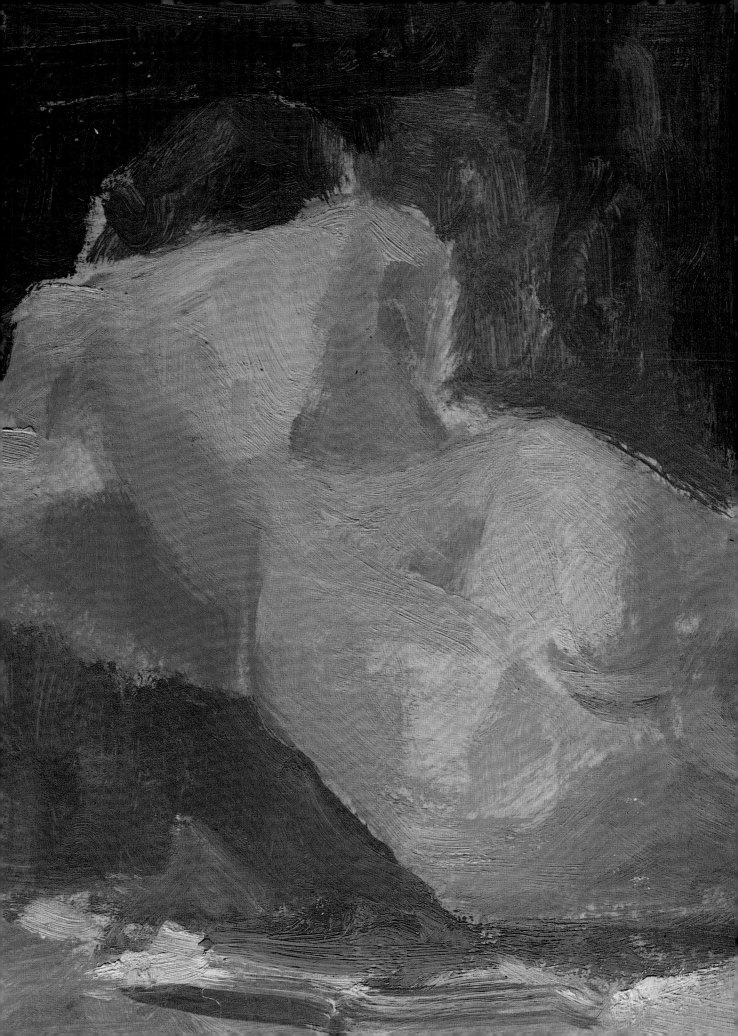

# THE ARTISTIC STUDY OF THE NUDE

This is a very practical chapter. Drawing the human body is not an easy matter. Basic difficulties have been experienced by everyone who has tried it or who has attended art school. Wrists come out disfigured, lines don't connect, positions are incomprehensible, and there are errors and imperfections that only experienced artists know how to avoid. Most important, when students first attempt to draw the nude, they often fail to produce a unified body. The first thing you have to learn is how to make the shapes fit together.

Fig. 126. Muntsa Calbó, *Study of a Nude Figure,* oil on cardboard, 8 5/8″ × 13 3/8″ (22 × 34 cm). This study is based on color, particularly soft pink and cooler tones. The focus on color explains why the back has been reduced to just a few planes, emphasizing the foreshortening that results when the body is seen from this angle.

# Drawing the nude

**127**

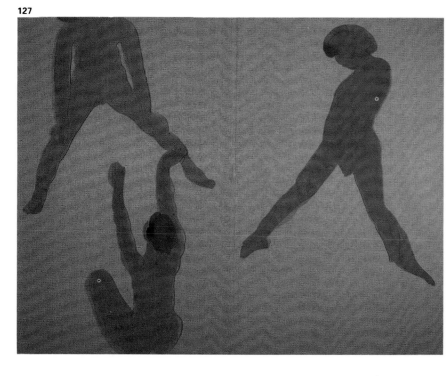

and abstract. Rarely can they be put in words. That is why their meanings are expressed in the language of forms, lines, and colors. Only by working with this language can we fully appreciate the principles of our task. In matters of art, rational recipes are not much use.

We have to let ourselves be attracted by the nude itself. The body form is so close and well known and yet remains unreachable and exasperating. When all is said and done, our task is to capture not the body as such, but the spirit inside it.

Fig. 127. Auguste Rodin, *Sheet of Paper Mounted with Three Cutout Figures,* 1900, pencil and watercolor. Princeton, New Jersey, Princeton University Library. The artistic nude can be sensual, as in Rodin's watercolors, suggesting the strange, the erotic, and even the pornographic. Yet these images always retain specific artistic qualities that are not like those of advertising art.

Fig. 128. This is a photo like the kind that sometimes appear in advertisements. The lighting and the pose are not really like those we would want to paint.

**128**

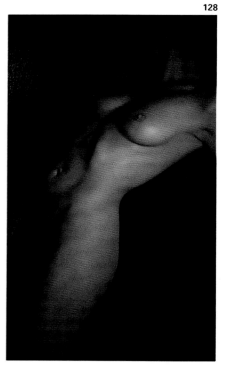

By now you should have picked up enough basic knowledge to be able to draw or paint a human body. You should also have a general idea of why the nude is such a significant subject in art history.

When we set out to represent the nude aesthetically, there is never any question of just copying the details of a human body. Our work has to have artistic value. Knowledge of anatomy or of canons is never enough to make a good artist. We have to approach the model from an aesthetic perspective, modifying our knowledge through the use of numerous artistic techniques. The rest of this book will be concerned with these techniques. Each will be fully explained and illustrated with the work of professional artists.

All artists know that nothing is really straightforward when we talk about art. Nothing is as simple as it looks. Rubens's models were not necessarily voluptuous fat ladies, nor were Botticelli's necessarily tall and stylized goddesses. And even if the models were different,

it was because of the different artistic visions that were to be expressed. After all, artists select their models. They also determine the pose, place the lighting, and choose the background or setting. What counts is the idea that the artist wants to describe or express. All this boils down to basic artistic purpose, the intention that gives meaning to a picture of the human body. Different intentions lead to different meanings, as you can see when you compare the figures represented in advertisements, comics, or serious paintings.

Why is it that one painter focuses on a model's rounded organic rhythms while another, looking at the same model, sees sharp angles and a stark silhouette? Why does one artist paint with flesh colors and the other in reds and blues? Exactly what makes Rodin's drawings so erotic? How do Picasso's strangely fleshless nudes convey ravaging sexuality? These kinds of questions can never be fully answered. The motivations and intentions of artists are usually personal

No matter how good our intentions are, nothing comes without work. You have to begin with humility. You must learn how to feel each line, the body's energy, and the model's pose. When we see a finished study, we tend to believe that everything was just the way it has been represented, in exactly that pose and with exactly that form. But there is nothing more difficult than trying to interpret the human body when you come face to face with it for the first time. As an object, the body has long extensions and strange movements. The face always diverts attention away from the rest of the form. And because the model is human, like the artist, we often have difficulty gaining enough mental distance to appreciate the forms in purely artistic terms. A careful approach or attitude is necessary before you can draw the nude. Here we'll begin with some rough drawings as a warm-up. We'll learn how to make several kinds of quick but correct sketches. Further sketches will introduce us to more advanced techniques later.

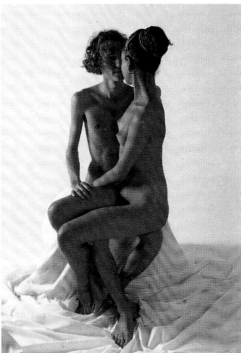

**129**

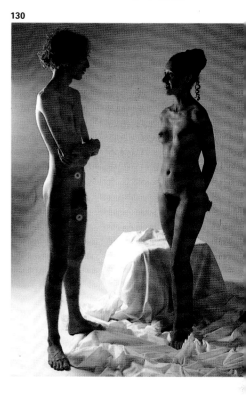

**130**

Figs. 129 and 130. We are never obliged to represent reality exactly as we see it. We can select the models, decide on their relationship, and place ourselves at a certain distance or angle. Since the artist is always involved in the object, models like these will be represented by different artists with different meanings.

Fig. 132. Muntsa Calbó, sketch. Even a simple sketch, designed as a study, can express a certain artistic intention.

Fig. 131. Illustration by Francesc Infante for his book *Tina Bloom*. Nudes nowadays appear frequently in a certain kind of cartoon. The line drawings are usually very well done, indicating good knowledge of the body. But these nudes generally do not express the same intention as we find in purely aesthetic drawing and painting.

**131**

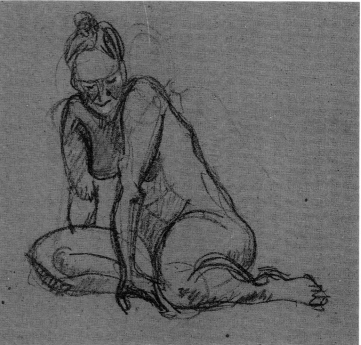

**132**

# Sketches of anatomical structures

**133**

**134**

Here we will use sketching as a step toward the study of the nude as art. Our sketches will be studies of various different approaches.

But first let's go back to what we were saying about the canon and anatomy. When we find ourselves in front of the model, be it a man or a woman, tall or short, we ask them to try out several poses. These can be the positions that they want or the ones that we want. Now, once the pose has been decided, we are going to draw little skeletons, just as we did before, but this time straight from nature, observing the body and trying to grasp its internal structure.

To do this, first draw the body's main line of balance and then the spinal column, the thorax, and the pelvis. If you do this correctly, you should have no trouble putting in the skull and the limbs.

If these little skeleton figures are done carefully and are well proportioned in terms of the canon, the rest of the sketch should come easily. Soon your skeleton will look like a human figure. Just try it. Our illustrations here give quick examples based on various poses. Sketches like these will help you memorize aspects of anatomical structure, so when you later do sketches without the skeleton structure, you will still be aware of the underlying bones. A classical pose is the position where the angle of the pelvis is clearly visible because the model's weight is on one leg. This position is very easy to draw if you remember that the hip that goes up is the one on the side of the leg that bears the weight, and that the shoulder on that side normally goes down. Once we understand this basic pose, we can observe what happens in many others. But you'll have to make these observations for yourself.

**135**

**137**

**138**

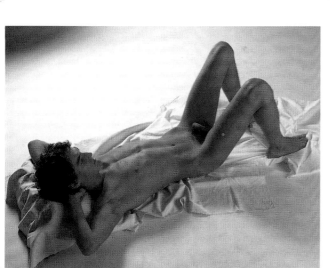

**136**

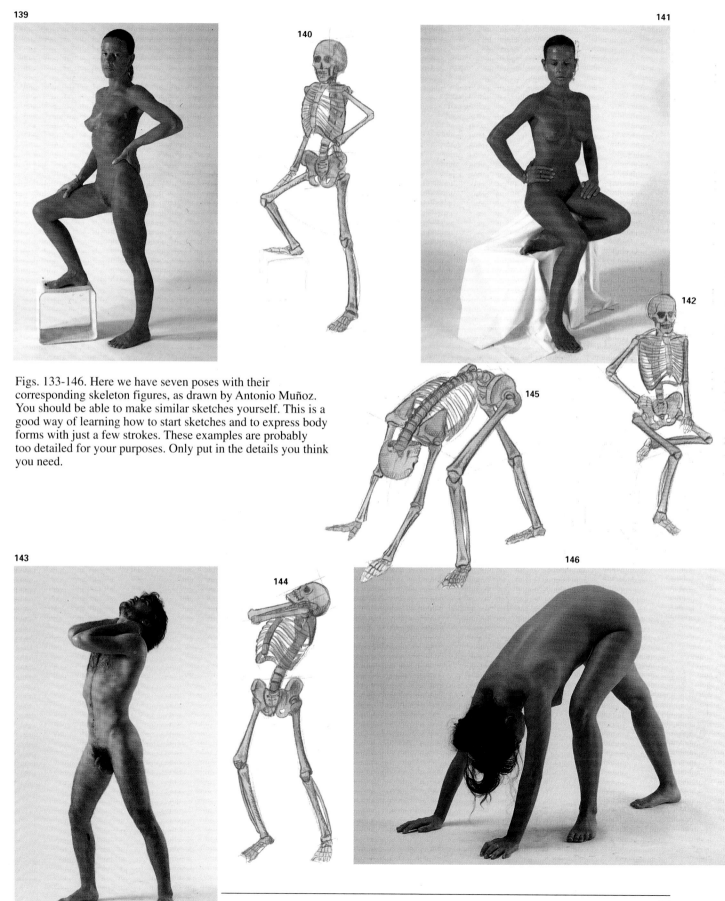

Figs. 133-146. Here we have seven poses with their corresponding skeleton figures, as drawn by Antonio Muñoz. You should be able to make similar sketches yourself. This is a good way of learning how to start sketches and to express body forms with just a few strokes. These examples are probably too detailed for your purposes. Only put in the details you think you need.

# How to sketch the nude: rhythms, proportions, and framing

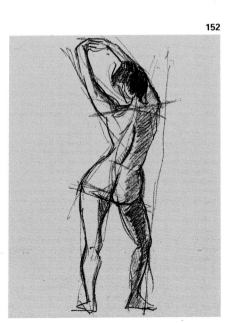

Anatomical sketches are a good way to start. But then you should move on to other techniques that incorporate further aspects of the body. The most important techniques involve the rhythm and balance of geometric forms, together with their framework, proportions, and values.

In practical matters like this, a picture is worth a thousand words. Our examples are thus two-step illustrations showing you how to build up a sketch. The most important step is the first, since it leads to the second and should help you avoid fundamental mistakes.

*Rhythms, structural lines, and balance.* Figs. 147 to 150 show sketches based on two different poses. Each sketch has been begun from just a few essential lines. Fig. 147 shows a pose in which the model's weight is on his left foot and his right shoulder is raised. The essential form here is the cross formed by the line between these two points and another running up the right leg and intersecting with the spine. The balance is then established by the lines indicating the angles of the shoulders and the pelvis (fig. 148). Once these lines are in place, we can fill in the other details, although only a rough sketch is necessary at this stage. Fig. 150 requires the same kind of observation. The most important line is the one that goes up from the left leg. Around this central axis we have the S shape of the spine, associated with the right leg. Then we put

Figs. 147-152. Here we have two examples of quick sketches done in two steps. First the basic movements, rhythms, and balances are expressed with just four lines. This should give you a general idea of how to approach the nude.

in the lines showing the angles of the pelvis, the shoulders, and the arms. This gives a firm basis for the further lines and details that make this rough sketch a study of complex relations, rhythms, and directions.

In fig. 153 we have a pose that looks simple enough and yet is quite difficult precisely because it is so normal, without any prominent movement. Here we once again have to look for the main rhythms and balances. The central line goes at several angles, framed by the outline of the silhouette. The horizontal lines then form a kind of fan, starting off parallel to each other and then opening up, indicating the position of the knees, hips, waist, breasts, shoulders, and head.

*Proportions.* Getting the proportions right is a fundamental aspect of sketching. Proportions are the relations between the whole and the parts and between the parts themselves. Every canon is thus a system of proportions. For most poses the artist has to measure or visualize the basic proportions. The pose shown in fig. 156 is a good example of why this should be done. If we draw this pose straight off, without assessing the strong foreshortening, we're bound to make mistakes. So we have to make some rough measurements. Here we can begin with the easiest measure, the height of the legs, where there is no foreshortening. Then, holding a pencil upright and closing one eye, we can relate the other parts to this basic measure. This could involve drawing in a series of intersecting measurements (fig. 157) and then building up the sketch from there (fig. 158). There's no need to erase the original lines showing the rhythms or proportions. One thing you can be sure of is that if you use no system of proportions, the back shown in this sketch will be much higher than it should be.

**154**

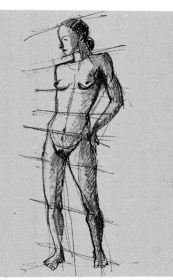

**155**

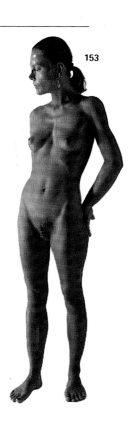

**153**

**157**

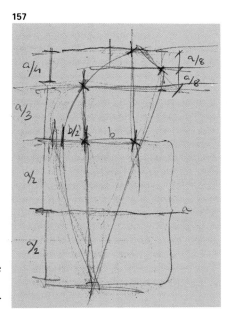

Figs. 153-158. Here I've done a few more two-step sketches to help you understand techniques for correct rendering of the nude. Pay special attention to the relationships between all the parts (in fig. 154 these are the shoulders, breasts, hips, knees, and feet), and be prepared to measure proportions where necessary (fig. 157).

**156**

**158**

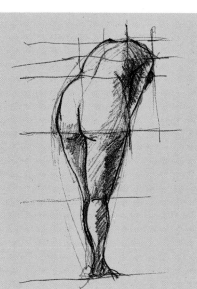

*Framing geometric forms.* Framing is a very simple way of beginning most sketches of the body. It is suited to almost all poses in which the figure is hunched up, sitting, or kneeling.

The main idea of framing is to find a shape that brings all the parts of the figure into one form. The body has to fit inside this shape, which becomes a kind of made-to-measure outline. In fig. 159 the frame is a right-angle triangle.

Fig. 162 shows another triangular frame, this time an isosceles triangle. This frame helps define the relations between the head, the breasts, and the legs. Fig. 165 is more complex because of the foreshortening that comes from looking at the model from above. In such cases a general frame is a very useful way to start. Here we begin from a triangle or pyramid. Proportions then have to be measured, since the head is close to us and looks larger than normal.

All these techniques can help you get started with your sketches. Of course, there are more techniques that we will see in a moment, and you still have to use the head as a basic module when constructing the rest of the figure.

When artists have gained a certain amount of experience at sketching the human body, they rarely have to go back to drawing frames, proportions, or basic lines. Sketches are then structured more by intuition. But even very experienced artists still use these techniques when working on large-scale drawings and paintings, particularly when foreshortening is involved.

Figs. 159-161. In this case I have used a triangular frame to make the figure hold together. I took measurements to fit in the other parts. This is easy to do when working from a photograph. With a live model, proportions are more difficult to measure and compare.

159

160

161

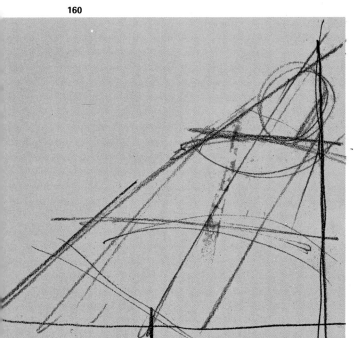

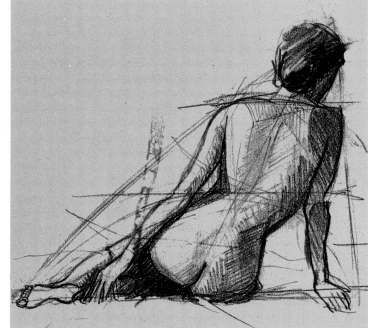

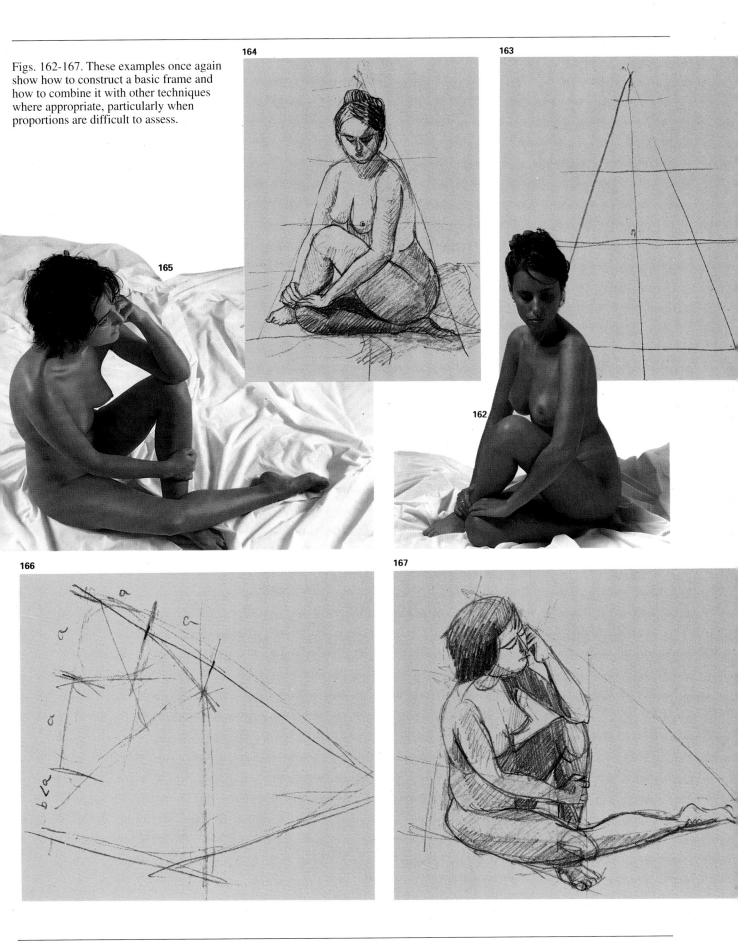

Figs. 162-167. These examples once again show how to construct a basic frame and how to combine it with other techniques where appropriate, particularly when proportions are difficult to assess.

# Other approaches to modeling form: curves, rhythms . . .

**168**

**169**

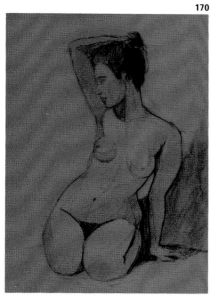

**170**

We shall now see a few other ways of starting off rough sketches of the human body. We should continue using charcoal or a graphite pencil for all these exercises.

*Curves.* We've already talked about rhythmic lines and directions. Now we will look at organic, round rhythms. Poses like the one in fig. 168 are better expressed with curves than with straight lines. Here you should start drawing with a loose wrist, making circles and curves that look like they could dance. Without forgetting the proportions, use just three or four curves to express the figure. Fig. 171 is a similar case, except that here one large curve gives the shape of the whole figure. Interior curves and a few straight lines then position the details of the sketch.

Figs. 168-173. Here we see further techniques for beginning a rough sketch of the nude starting from a model. These examples use rhythmic, organic curves and a few straight lines.

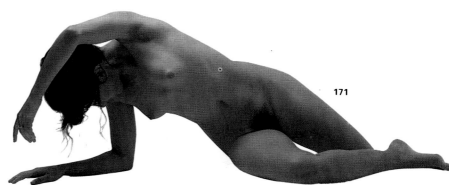

**171**

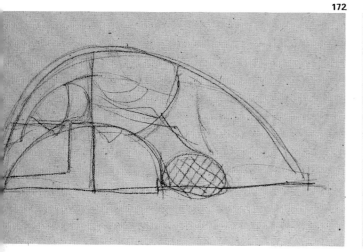

**172**

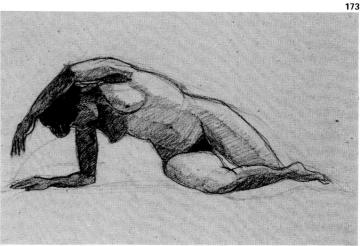

**173**

# . . . and interior spaces

*Interior spaces.* Complex poses like the ones in figs. 174-177 can be framed by straight lines and curves. Note how this relation between the two kinds of lines can give superb balances, as shown in figs. 175 and 178. But a further method has been used here. If you look closely, you can see that the general frames also enclose some empty spaces. Our forms are not just the body but also the "non-body," the spaces between the parts of the body. These spaces have been shaded in to make them clearer in these two examples. No matter whether they are squares or triangles, circles or semicircles, these interior spaces must always be correctly measured. This is particularly important when, as in these two cases, there are foreshortening effects that tend to deceive our eyes.

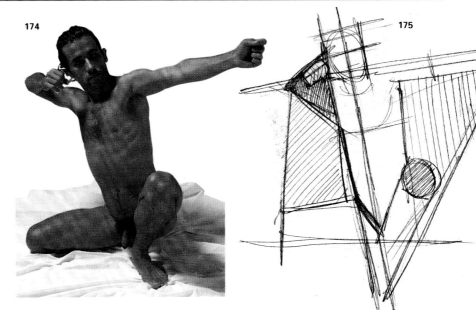

174

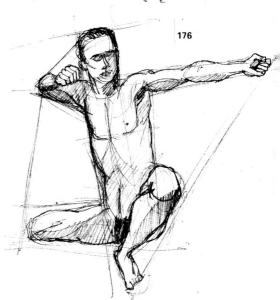

175

176

Figs. 174-179. These examples not only combine complex frames and proportions but also show the importance of the empty spaces that are found between the parts of the body.

177

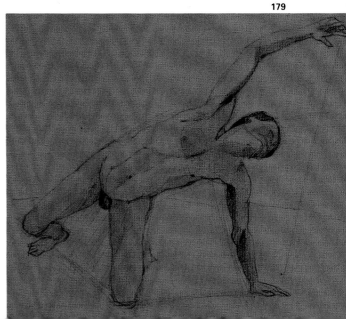

178

179

181

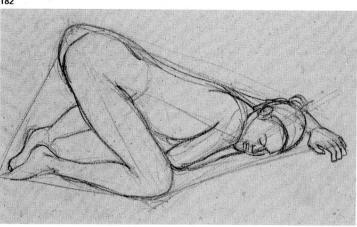

182

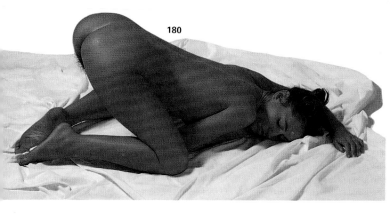

180

Figs. 180-185. These complex poses require combinations of all
the techniques we have been studying, especially the use of
frames comprising geometric forms that bring together the body
shapes and the interior spaces

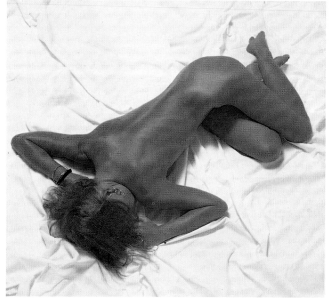

183

184

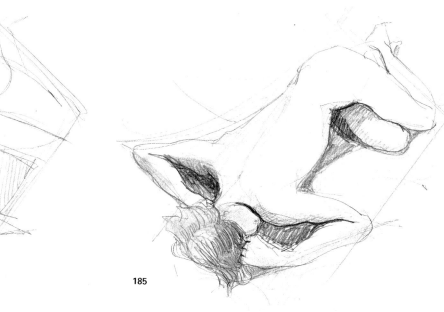

185

By combining the various techniques, we can find the key to some quite complex poses. In fig. 180 the basic shape is a pyramid, but then we discover interior triangles helping to position the legs and the arms. The pose in fig. 183 is similarly complex. To represent it, try to see it not as a human figure but as a big box holding a set of geometric shapes like triangles, curves, circles, and rectangles.

*Modeling volumes with shading.* All our examples so far have had very few shadows, so there has been little question of expressing volumes in terms of light and dark areas. Yet this can be a simple way of sketching the body. It has its advantages and disadvantages.

*Advantages:* Shaded volumes can sometimes be used to begin a sketch. The most important thing is that you see the entire figure as light and dark areas that can be reduced to perhaps just two values, such as white and gray. When drawing, you begin with a gray (a value) to shade in the area in shadow, leaving as much light as

possible. If you like, you can also add a darker gray (another value) in the areas that are clearly darker. Fig. 187 gives an example of how this first step expresses volumes as more or less geometric planes. Working from this base, you then compare the various shadows. For instance, look to see if the shadow of the left leg is lighter than the one on the thigh or the right foot, and if these are lighter or darker than the hair in the light, which is not to be confused with the hair in the shadow. You thus build up a system of grays that express the volume of the entire figure (fig. 188). You don't need many grays, since it's always better to use too few than too many. Fewer tools mean greater courage.

*Disadvantages:* The great risk of this technique is that you might not see the figure as a whole. There is always the temptation to look at the lights and shadows as individual parts. The result can be like fig. 189 or even worse. When each part is independent, the overall form doesn't hold together.

Figs. 186-188. Analysis of the figure in terms of light and dark areas has to be done with care and patience to avoid strong contrasts. That is why you should begin with a light gray and then compare the various areas to build up the overall form.

Fig. 189. If we look at each part as an individual element, the overall distribution of light and shadow will be incorrect.

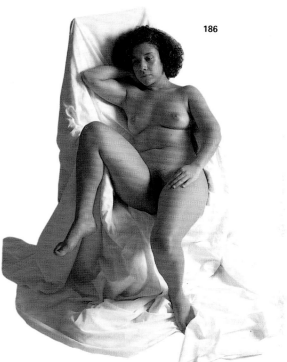

186

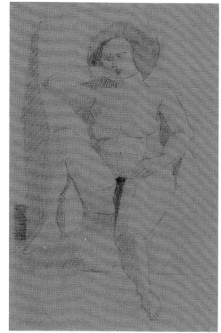

187

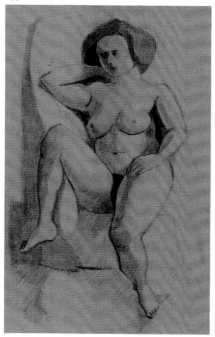

188

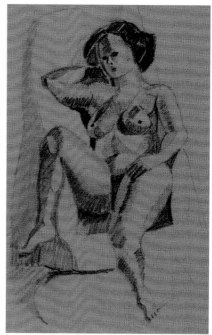

189

# More examples of sketching techniques

Here you have a small gallery of sketches that make direct or indirect use of the techniques we have been explaining. Fig. 190 shows a form that requires a clear sense of balance, with the sloping line expressing the direction of the movement. The sketches in figs. 191, 193, and 195 could not have been done without an assessment of proportions. Fig. 192 starts from an oval-shaped frame with interior spaces. Figs. 194 and 196 are examples of the search for rhythms and organic tensions.

Fig. 191. Muntsa Calbó, sketch in charcoal. This sketch results from a quick analysis of the lights and darks and an assessment of the proportions of the torso and the arm with respect to the main lines.

**190**

Fig. 190. Muntsa Calbó, sketch in graphite pencil. This study pays special attention to the way the body leans forward and is balanced by the tension of the arms and the leg that takes the weight. Note how the position of the head follows this line.

Fig. 192. Muntsa Calbó, sketch in graphite pencil. The essential technique for this pose is the frame.

**191**

**192**

Fig. 193. Muntsa Calbó, sketch with Conté crayon. The basic element here is the S formed by the body and the foreshortening of the back.

Fig. 195. Muntsa Calbó, sketch with Conté crayon. From this angle, the foreshortening is so strong that the artist has to trust concrete proportions rather than vague ideas about the human body.

**194**

**193**

Fig. 194. Raimón Vayreda, sketch with felt-tip pen. The inclination of the body is balanced by an arm that we know must be resting on something.

Fig. 196. Raimón Vayreda, sketch with felt-tip pen. This pose has been analyzed in terms of the weight on one foot, the angle of the hips, and the balanced rhythm of the rest of the body.

**196**

**195**

# Antonio Muñoz sketches a model in sanguine and sepia

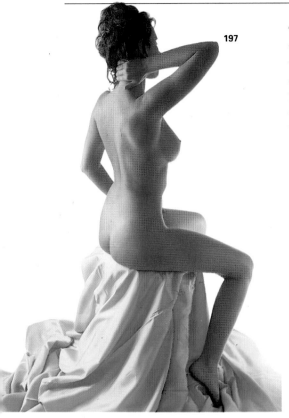

197

These illustrations show how Antonio Muñoz goes about sketching the nude. Note that he has selected a certain pose and has looked for the abstract lines that help him construct the figure on paper. Here the lines are the central axis, a vertical line connecting the knee and the elbow, and two diagonals that meet at the top to form a kind of pyramid. Antonio Muñoz has then estimated a few measurements and added new lines, some of them horizontal and others vertical. This gives the basic form. Next he has shaded in a few areas, giving all the darker areas the same soft value. This shading is the same for the head, the body, and the drape, but without any details. We can see the relations between these areas. The large dark area to the right balances the lighter areas to the left. Of course, this balance does not alter the relations between the lines of the arms and the legs. Finally, the artist has shaded the remaining volumes and finished off the sketch with a few quick strokes. In addition to the sanguine base, he has used sepia chalk to express a few darker shadows.

Figs. 197 and 198. These photos show the pose, the position of the artist with respect to the model, and the studio setting.

Fig. 199. The first step is to put in the frame that will make the individual parts fit together. These lines give the figure its balance and abstract form.

198

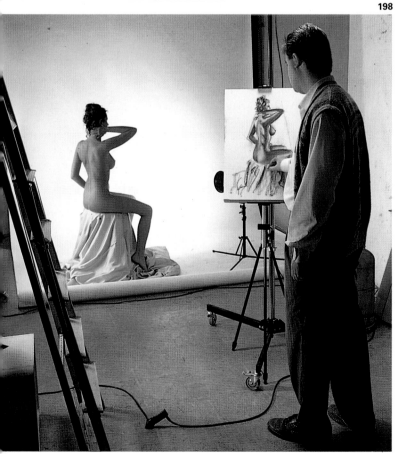

199

**200**

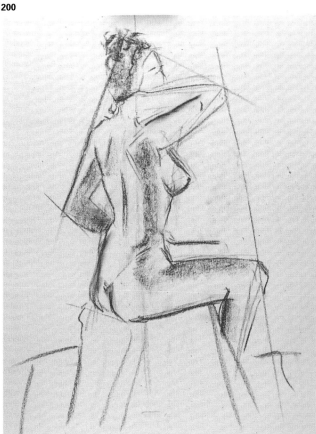

**201**

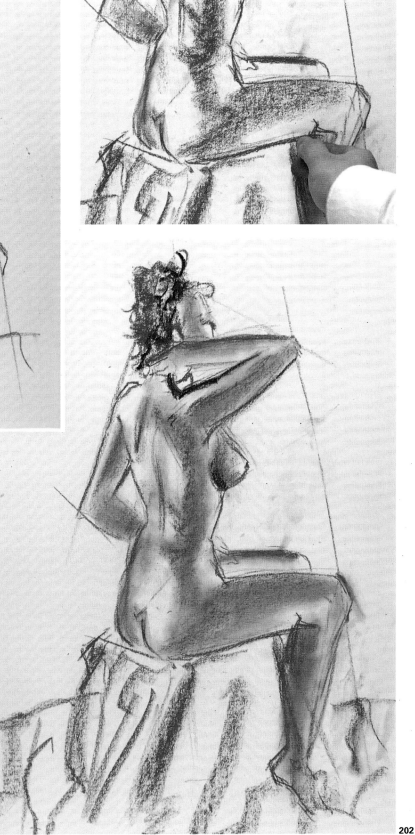

Fig. 200. Even at this early stage, Antonio Muñoz has rounded the original lines, giving them a more human shape. He has also done some initial shading with the side of the chalk.

Fig. 201. The artist now goes about drawing the figure itself, using strong lines to reinforce the original construction. He has also emphasized many of the darker shadows.

Fig. 202. We'll leave the sketch at this stage, since the main problems have been solved. Antonio Muñoz has done a little more shading by rubbing the chalk with his finger and adding a few touches of sepia. These techniques make the sketch softer and less rectangular, compensating for the geometric qualities of the initial construction.

**202**

# Pere Mon sketches two figures

A composition with two figures can become very complicated if you don't understand how to see it as a whole. You have to begin quickly, positioning just the main volumes and relating the two bodies as if they were parts of a single form. Unlike Antonio Muñoz in our previous example, Pere Mon has begun by massing in light and dark values and establishing volumes that are full of rhythm. The main feature is the rhythm of the lines formed by the two bodies, mostly comprising curves and close parallel strokes that strongly suggest the forms to come. The artist has used powdered red pigment, applied with his fingers and a flat brush (fig. 205). With the same quick strokes, he next makes some areas darker in order to emphasize the contrasts. At no point have the silhouettes been outlined, even though their form gradually becomes clear. Pere Mon has used a charcoal pencil in some areas to draw in darker planes like the woman's back and arm. By comparing values, he has seen that the man's legs need the same shading. The dark areas have been put in with rough strokes. This means that instead of connecting directly with each other, the planes form relations between themselves by means of their shapes and values. As the fingers and brushes work, a general flowing movement appears before our very eyes, expressing Pere Mon's personal interpretation. Finally, the artist has added a few strokes in white chalk on the upper planes of the woman's back and buttocks, adding light and

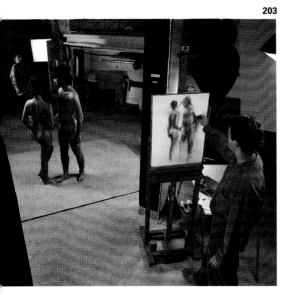

203

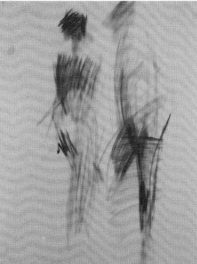

204

205

Fig. 205. Pere Mon applies pure pigment with a moist brush. This gives greater definition to the initial forms.

Fig. 203. When we sketch two models together, we have to capture the abstract forms with speed and certitude. If not, the sketch risks becoming cold and fragmented. Pere Mon works in this studio setting, which gives a complex play of light and shadow.

Fig. 204. Here a few quick rhythmic strokes have positioned the figures on the paper. The form is abstract, precise, and already has the basic lights and darks.

206

Fig. 207. He then adds darker colors with red and charcoal pencils. The details are suggested more than they are represented.

207

Fig. 206. The artist also rubs over some areas with a stump to obtain softer construction lines.

giving greater coherence to the overall volumes. And yet the form remains complex, with several balanced points of focus.

The important point is that this procedure is totally unlike the one we saw in the previous example. Of course, the result is also very different. But in both cases the artists started with a clear idea of the model as a whole and never abandoned this global vision of the nude as a form.

**208**

**209**

**210**

**211**

Fig. 208. At this stage the artist has made full use of the charcoal pencil to create abstract planes. This gives contrasts of light and shadow, emphasizing volumes and relationships.

Fig. 209. The process is continued with strokes going in different directions, as suggested by the bodies themselves. Here the artist has used sanguine and sepia chalk.

Fig. 210. The same effect is achieved with white chalk.

Fig. 211. The final stage involves highlighting the smaller planes. This gives a sketch that is not just correct, but suggestive and imaginative as well.

# THE ART OF THE NUDE: POSE AND LIGHTING

When working with a model, the choice of pose and the correct lighting must be considered before painting. Chatting with your model, asking him or her to try out different poses and unusual points of view, will all contribute to creating your own personal vision of the nude.

Fig. 212. Teresa Llácer, *Nude,* oil on canvas. In this chapter we are going give you advice on the various poses that the model can adopt. There are no rules concerning this; it is the painter's intuition that will decide which pose is most suitable for the meaning he or she wishes to convey.

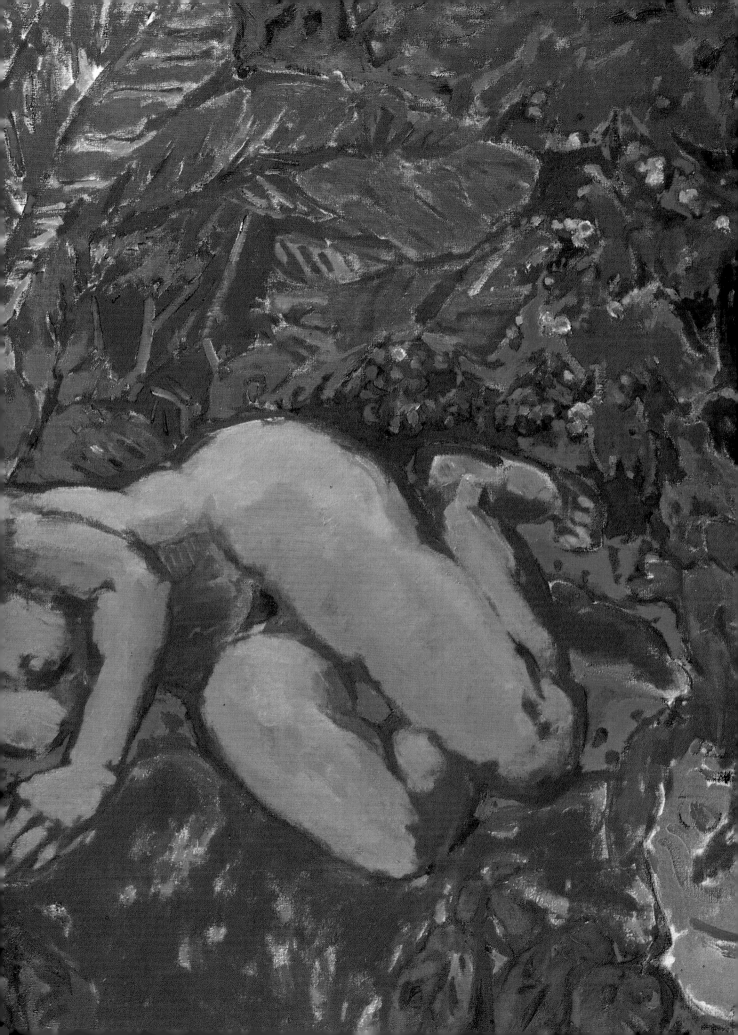

# Choosing a model

**213**

**214**

**215**

**216**

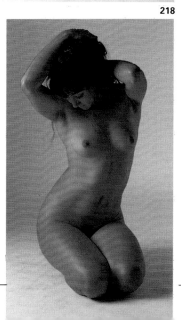

**217**

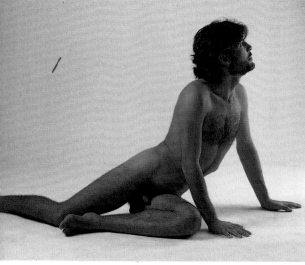

**218**

If you want to paint a nude, you will need a model. It is possible to paint a human figure from memory, but if it is a nude as we understand this genre, you need to look at a model. Every person has a distinguishing shape, color, characteristic gestures, and thus no one is repeatable. Painting nudes from memory will only result in hollow, characterless figures; our imagination can never produce the countless variations of reality.

The range of choices for models allows each artist to find one that he or she requires to express a particular vision of the human body. The artists that I know choose their models according to personal preferences: the type they enjoy painting, the kind of expression and subject matter they are attracted by. Although historical and mythological subjects are no longer painted, they are a good example of why it is necessary for your model to fit the idea you are trying to express. A strapping man or elderly woman, a slender or plump woman not only suggest different subject matter but different poses and gestures. Certain poses would look absurd with certain models; it is a question of common sense.

The idea, therefore, is that there is no such thing as an unsuitable model; every model is potentially attractive. He or she can "inspire" or evoke different subjects and treatments, whether they be sensual,

Figs. 213-218. These photographs show several models we have worked with. Each one has a particular figure, color, sex, or other characteristics that motivate the artist to paint. Each of these models requires appropriate poses that may be distinctive. It is important to speak to your models, to get to know them a little, and ask them to try out different poses.

colorist, expressionist, or intimate. The difference between a man and a woman is important. We are not referring merely to anatomy or canon but rather to something that the artist must capture through his or her work: a mixture of appearance, spirit, and gesture. To sum up, although the painter can choose one or another model, in reality an artist can always adapt to any model by accepting its significance and adapting the treatment according to the model's character.

On the other hand, the artist periodically changes models: he or she may spend time painting thin blonde models, then go through a period with strong, robust ones or plump and sensual ones. Each model will evoke different compositions, colors, types of lines, contrasts, and painting ideas because the nude is not only a nude but also a subject: a changing room, a bath in the sea, an intimate pose in front of a mirror. Remember also the infinite range of flesh colors, which enable us to work with beautiful color mixes, from transparent skin colors to dark and dense chocolate colors; the wealth is inexhaustible.

Figs. 219 and 220. Muntsa Calbó, studies. Two very different female models call for different poses and techniques. The first study, of young thin woman, is drawn in ink; the second depicts a mature woman and has been drawn in charcoal and white chalk to bring out the volume.

Figs. 221 and 222. Muntsa Calbó, studies. Here both models are young, but one of them was so thin and bony that the artist was motivated to draw an expressionist pose; the other, more muscular, provided the opportunity for drawing athletic poses.

**219**

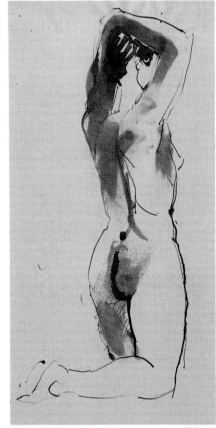

**220**

**221**

**222**

# Choosing a pose

The model is not a celestial and abstract being but merely a person. He or she carries out actions: sitting on the floor or bed, picking something up, getting dressed or undressed, looking at the artist, or staring, lost in thought. The model's existence is inseparable from his or her movements, attitude or personality, and, of course, age and physical condition. On the other hand, every position a person adopts has the power of changing his or her body language. When an artist decides to "freeze" the model in one or another pose, it is because that particular pose moves the painter, rouses a certain feeling or memory; in other words, it means something special to him or her.

Another point concerning poses: it is essential for the artist to learn how to find a position that both the artist and the model feel comfortable with. Throughout history, poses have undergone changes in style and technique. The Greeks used several standard poses that were repeated over a long time. They are even found in subsequent epochs because they had become the model to follow. Poses of Venus in the 16th and 17th centuries, for example, bear relatively few differences from their predecessors. In the French Rococo, poses became more varied and daring and were considered provocative even by their contemporaries; Goya's *Naked Maja* was judged as such. This trend continued up to the pictures and sculptures by Rodin, which display, in addition to a newfound freedom, a profound eroticism expressed by subtle movements and points of view. And what can we say about Degas's models? Again, a newly discovered freedom, this time to capture a woman during her most intimate moments, when she is apparently unaware of being observed, in the privacy of her own room. Not to mention the totally free poses of Matisse's and Picasso's models, who appear in the most mundane, everyday situations or in the most shamelessly revealing poses. Without doubt, painting is the best record we have of poses throughout history, as you can see in the reproductions in this book.

Fig. 223. *Marcellus,* end of the 1st century B.C., marble. Paris, Louvre Museum. A classic pose of Hellenistic art: the slight inclination of the hip causes the "ischiatic" position, when the weight of the body is supported on one leg. This pose was repeated umpteen times in later epochs.

Fig. 224. Edgar Degas, *After the Bath,* 1889, pastel and watercolor, 26 1/2″ × 23″ (68 × 59 cm). London, Courtauld Institute Galleries. Degas, on the other hand, discovered intimate everyday poses.

223

224

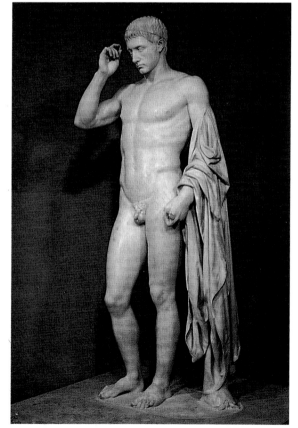

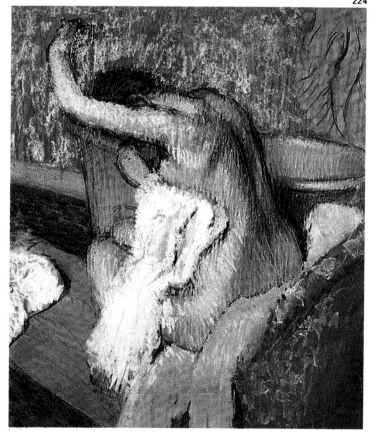

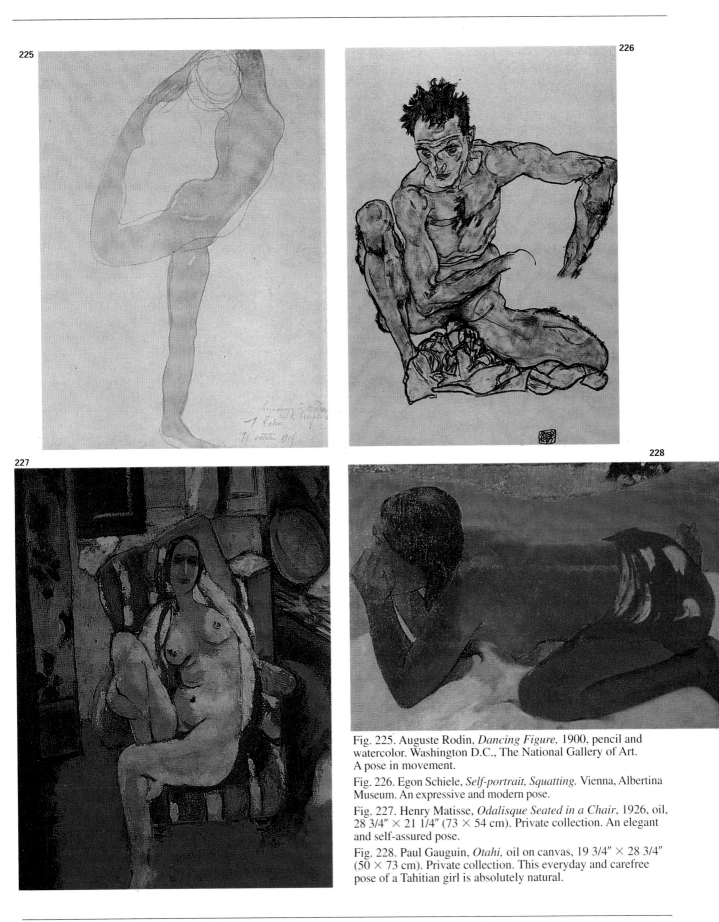

Fig. 225. Auguste Rodin, *Dancing Figure,* 1900, pencil and watercolor. Washington D.C., The National Gallery of Art. A pose in movement.

Fig. 226. Egon Schiele, *Self-portrait, Squatting.* Vienna, Albertina Museum. An expressive and modern pose.

Fig. 227. Henry Matisse, *Odalisque Seated in a Chair*, 1926, oil, 28 3/4″ × 21 1/4″ (73 × 54 cm). Private collection. An elegant and self-assured pose.

Fig. 228. Paul Gauguin, *Otahi*, oil on canvas, 19 3/4″ × 28 3/4″ (50 × 73 cm). Private collection. This everyday and carefree pose of a Tahitian girl is absolutely natural.

# Working with the model

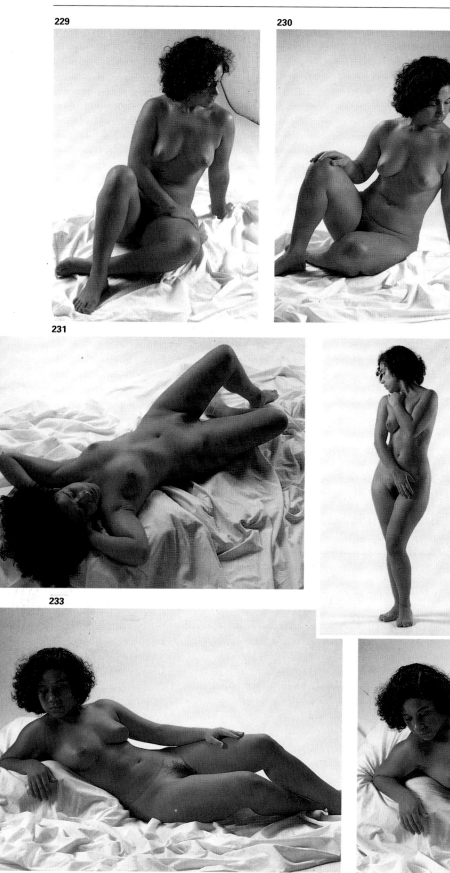

But what do you do once you have chosen your model? The first thing is to create a space where the model can feel comfortable. It might be the corner of a room with a sofa or chairs, a curtain, some cushions, sheets, and appropriate lighting that can be moved while working. When your model arrives, first ask him or her to sit down with crossed legs, for example, then with them together, now leaning back on the arms, now leaning the head back, turning it from side to side; ask the model to lie on his or her back or stomach; then ask him or her to face you straight on, from the side, with the hands on the hips or on the head–the combinations are almost infinite. When we start searching for a pose, we take into account, instinctively, the model's character, sex, and age. We would not ask an elderly man to pose like a Renaissance-style Venus.

It is difficult to explain a method for finding the most attractive poses or those that have inspired us in previous paintings. The only advice we can give you is to talk with your model: find out what kind of day she or he has had; maybe the model is tired, maybe he or she is full of energy and feels

like adopting contorted poses or standing up (the most exhausting pose for the model). Don't draw the first or second good pose you find, even when you have an idea in your head. The way you work with your model will probably follow along the same lines as the those shown in the photographs of our model, Vilma, that you can see here. Note the difference between the classical reclining pose (fig. 233) and the more modern and less usual one (in art) in Figure 231. For a pose to be attractive, more artistic in itself, it is essential that it not be too symmetrical; get the model to turn the head to one side, lean or lower the shoulders, lift or separate the legs.

Compare these photographs of Vilma with those of the other models that appear in this book, models of different types, sex, age, and so on. You will notice that each one is better suited to one particular pose and appears more constrained in others.

Nowadays, classical poses are largely ignored except in the study of the human body and in notes. On the other hand, the poses that today's artists find most attractive tend to be intimate, even sensual, and the painter is always looking for unusual points of view.

**235**
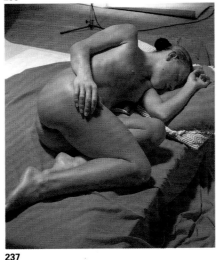

**236**
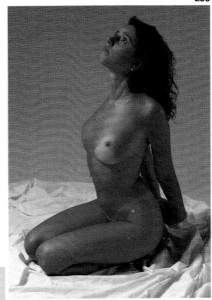

**237**
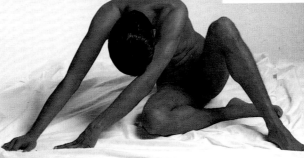

**239**

**238**
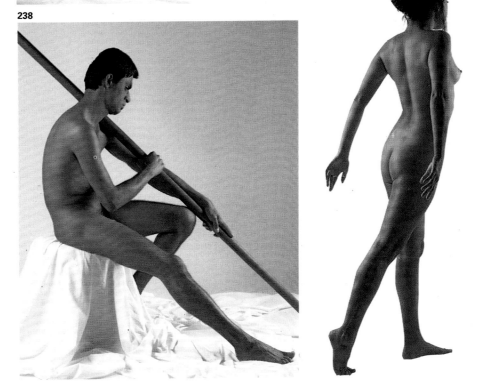

Figs. 229-239. On the facing page we can see a part of the long process an artist goes through with his or her model, looking for various poses. Once the artist has found a suitable one, he or she will make some slight adjustments before painting it. On this page, we can see various poses by different models, poses that seem appropriate for each of them according to her or his own aspect and character.

# Lighting the model: direction, intensity, and contrast

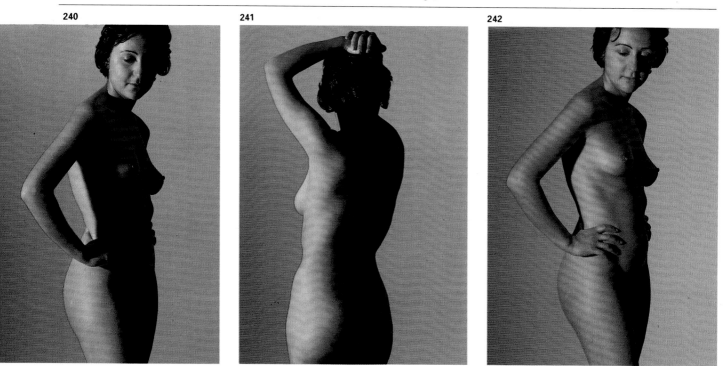

When the artist has resolved (in part) the problem of the model and pose, he or she is still not ready to start painting: there is still the question of what lighting to use, an extremely important matter.

The painter cannot solve every aspect of lighting separately. He or she must begin by considering the existing light in the studio, which can be used to make the pose more attractive. Also remember that each type of lighting is suited to a different treatment of the painting or drawing.

There are several points to take into account: one is direction (light from above, the side, and so on); another is the intensity of light (spotlight, diffused light, and so on); the color of light is another aspect, the color with which it "stains" the objects it illuminates. Since we cannot examine every aspect of lighting separately, we will limit ourselves to giving you ideas in the photographs and pictures so that you can try out different possibilities (it is not good enough to use just any light; the artist must spend time on lighting his or her subject).

We will state right away that "unusual" illumination (from below, from behind, etc.) is not advisable, at least at the beginning. When you feel more confident with your work, you can do what you want, because with experience you can afford the work a more original touch.

## Hard, concentrated light

A beam of concentrated light (as from a naked light bulb or a studio spotlight) creates contrast between the part of the model in light and that in shade (fig. 240). It boldly "models" the body; that is, it enables the artist to create stark contrasts in the picture. It is ideal for studies, since the light and shade can easily be synthesized (fig. 243).

Figs. 240-242. In these photographs we can see the result of illuminating the model with concentrated light, which produces sharp contrasts of light and shadow on the model's body. The difference between one or another type of illumination is determined by the direction in which the light shines, which can be varied as much as one desires: from very lateral to completely frontal.

Fig. 243. Vicenç Ballestar, *Study*. To be able to draw this study with Ballestar's experience, all one needs is line and shading to convey hard lighting from one side.

**244**

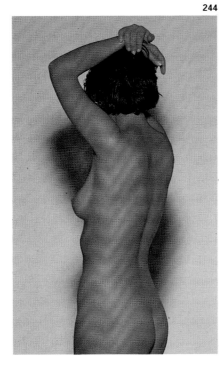

Apart from this, the direction of the light can be varied (examples in figs. 240, 241 and 242). See also the examples in paintings and drawings in which concentrated illumination "influences" or determines the treatment (figs. 246 and 247).

When concentrated lighting is frontal, it flattens the figure, "erasing" the shadows (fig. 244) and thus contributing to a flat, colorist picture (fig. 246).

Fig. 244. Here the illumination is also hard but frontal, to such an extent that most of the volume disappears.

Fig. 245. In this sketch by Ballestar we can see how concentrated lateral lighting is suitable for drawing quick studies of the model.

**245**

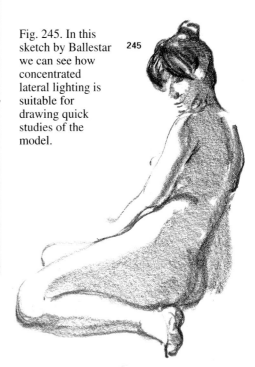

Fig. 246. Henri Matisse, *Bather,* 1909, oil on canvas. New York, Museum of Modern Art. This picture could be the result of frontal lighting.

Fig. 247. Mariano Fortuny, *Old Nude in the Sun,* 1870. Private collection. Zenithal-lateral lighting, also very hard, was used to paint this haggard body with such extraordinary force.

**246**

**247**

# Lighting, modeling, and color

248
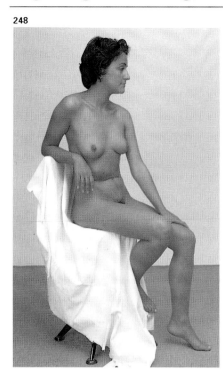

249
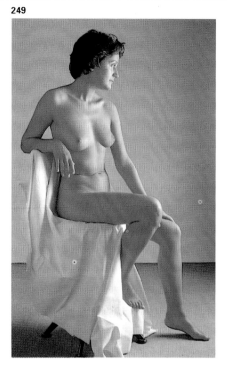

250
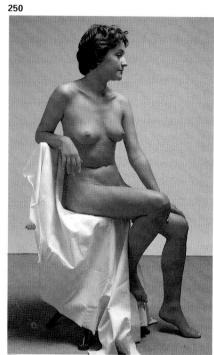

Figs. 248-250. This new pose is illuminated with diffused light, which may be natural daylight that comes through a window or skylight, or artificial light from a lamp with a diffuser. In fig. 248 the lighting is very even, creating a flattening effect. In the two other examples, light comes from a very definite direction, softly sculpting the body.

Fig. 251. Mariano Fortuny, *Nude on Portici Beach*, 5″ × 7 1/2″ (13 × 19 cm). Madrid, Prado Museum. A magnificent nude painted in difficult illumination: midday sunlight, which flattens forms and diminishes almost all sense of relief.

*Diffused light*

Soft or diffused light can be the atmospheric light of the studio, whether it be artificial or natural, and also daylight, especially under the sun or when it is cloudy and there are no shadows (this is what is known as totally flat, diffused, and enveloping light: fig. 248).
Flat light produces wonderful results in painting (fig. 251), but it should only be tried out when the

painter has acquired enough experience, because volumes are difficult to construct without any shadows. Flat light is also suitable for line drawings.

Fig. 252. José Puigdengolas, *Nude,* 1934, 33 7/8″ × 49 5/8″ (86 × 126 cm). Barcelona, Museum of Modern Art. An example of lateral and diffused light, which the painter has wisely exploited to achieve this soft value scheme.

251

252
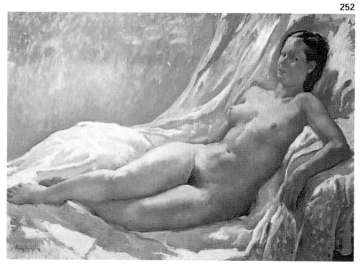

**253**

**254**

**255**

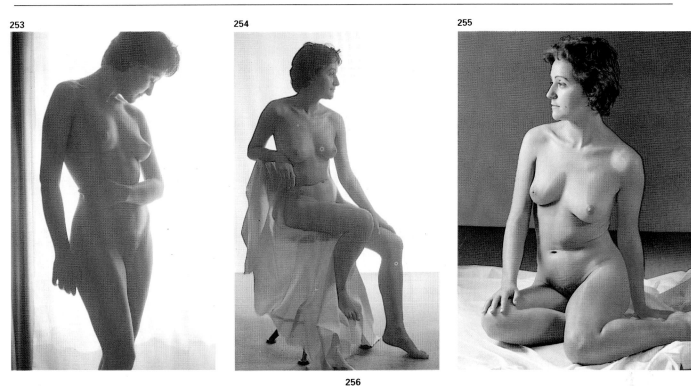

**256**

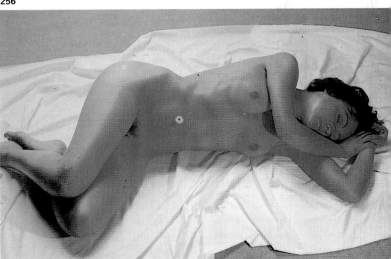

**257**

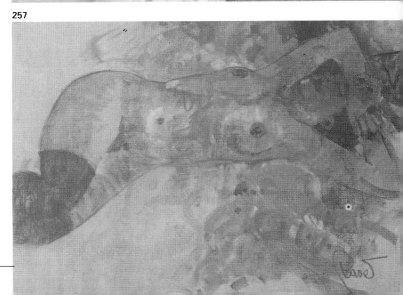

On the other hand, maybe the best illumination for the nude is diffused light beamed in a specific direction (lateral, fig. 249; zenithal, fig. 250). It is especially suitable for painting without hard shadows, thereby depicting the volume with soft lines (fig. 252).

## The color of light

Natural and artificial lighting can be hard, soft, directional, or enveloping. The main difference for the artist's eye is the color with which it stains objects. In photographs 255 and 256 we illustrate the contrast between two lights of varying chromatic quality: one cold (daytime lighting) and the other warm (light bulb). Interesting results can be obtained by combining lights, exaggerating the colors (fig. 257).

Figs. 253 and 254. Two examples of backlighting with varying degrees of definition in the body's darkest parts. Backlighting is interesting whenever there is also a small amount of light coming from the front, thereby allowing the colors to be seen.

Figs. 255 and 256. The artist often uses two lights, one warm and the other cool, in the studio: one is natural light and the other is a light bulb.

Fig. 257. Joan Raset, *Nude Lying Down,* pastel on paper. Private collection.

# Esther Olivé de Puig executes a charcoal drawing with light as the motif

258

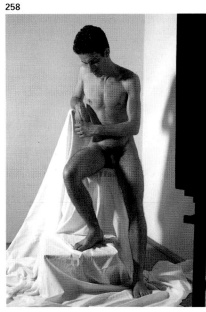

Having drawn a large sketch (fig. 259), Esther Olivé starts on the definitive drawing by changing certain aspects. First, she uses a few simple slanted lines to block in the subject, then several curved lines to indicate the direction of the limbs and torso, joining the head and right foot in one single straight line. When drawing on paper as large as 100 × 70 cm (about equivalent to an elephant-size sheet measuring 40 × 29 1/2″), as here, it is essential to fill in the spaces and block in the different elements quickly, synthesizing the general forms in a few lines (fig. 260).

In an attempt to define the outline of the figure without going into too much detail, Olivé adds a few lines with the flat side of her piece of charcoal, pressing down more firmly to increase the thickness in certain areas. Note the directional and expressive lines that come together at this unusually small head, the vertex of a compositional pyramid that Olivé highlights and exaggerates.

With the help of the body's axis line, the artist situates the head more accurately; then she draws the arms, torso, muscles, and legs, all at the same time. The head, which is too small, is a symptom of expressionist interpretation; after pausing to look, Olivé decides to make it bigger, since it is too small even for her purposes

259

260

261

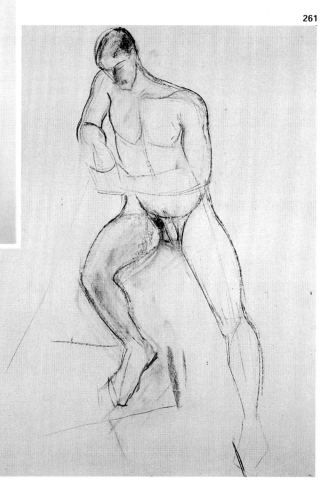

Fig. 258. The model, a young thin boy, is half-seated on a stool. Illumination is important to create enough dense shadows.

Fig. 259. Esther Olivé draws the first study in charcoal on a large sheet of Ingres paper. She decides to leave it unfinished because she prefers to draw another composition. We can see how she has used straight lines to block in the figure.

Fig. 260. This is the drawing she has just begun. Here we can see the first lines that define the angles and the curved lines that construct the body.

Fig. 261. Having increased the size of the head, Olivé begins to distribute some grays around the body before finally deciding to draw a silhouette.

**262**

**263**

Figs. 262 and 263. Here we see Olivé working with charcoal, using the tip to obtain fine lines and the flat side to rough in tone, which she spreads with her fingers to create flat grays and dark tones.

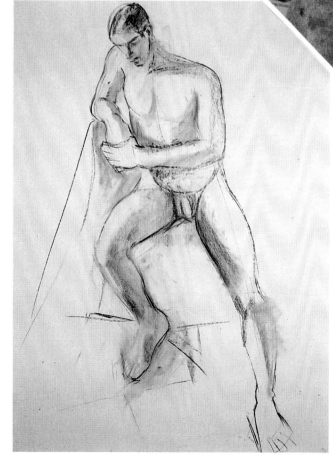

**264**

(fig. 261). Note how certain grays start to appear, while at the same time she continues to search out the correct position of the left leg in relation to the right one with more strokes.

Using the flat side of the charcoal, the artist shades all the areas in shadow (fig. 262). The drawing begins to display the illumination chosen for the model: slightly intense lateral light, somewhat elevated, coming from the left-hand side, which casts dark shadows on the body. Note how compact, descriptive, and transparent the shadows are on the head, neck, and shoulder. The lights surrounding the figure produce reflections that soften the shadows in certain places.

Fig. 264. Olivé removes more of the charcoal with a cloth, thereby obtaining very tenuous, almost white, grays. See how the valuation progresses in these three photographs.

**265**

Fig. 265. The drawing is going precisely according to plan, with several areas of light and shadow defined and the forms clearly established. The soft grays are an interesting aspect, since they allow the artist to darken the values little by little.

# Adjusting value to express light

**266**

**267**

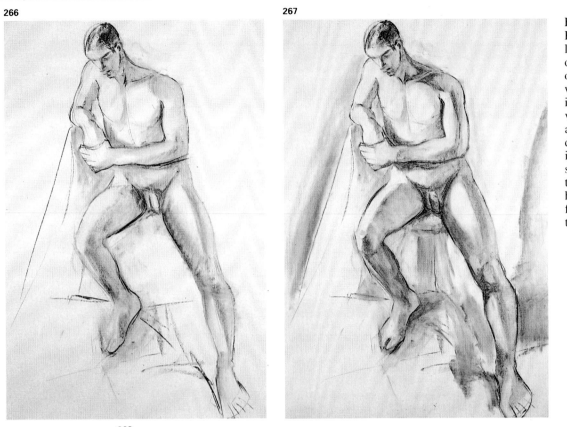

Figs. 266 and 267. Here we can follow the progress of the value plan of the drawing, which defines the illumination of the volumes. The artist increases the darks by comparing the different shaded areass of the body, squinting her eyes and carefully examining the model.

**268**

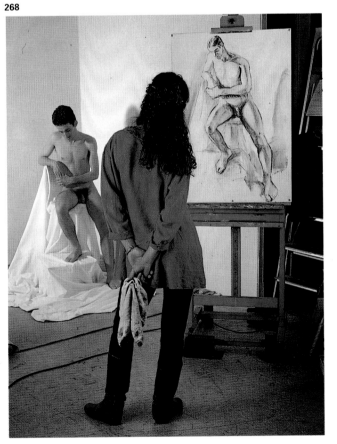

Fig. 268. When drawing on a large sheet of paper, it is essential not to get bogged down in any particular area of the picture. Distance yourself from the paper and the model, comparing the grays without losing yourself in details.

Now Olivé begins to adjust the grays that already form part of the figure, which define the volume and allow the light of the figure to be perceived. Compare the grays: the shadow under the left arm is equal to that on the right-hand side of the torso, below the pectoral muscles; the shadow cast by the hand on the body is as dark as the one cast by the left leg on the right one; the shadow on the right arm is transparent and light, similar to the gray of the illuminated middle thigh (fig. 266), etc.

Powerful, expressive, straightforward, daring–all these adjectives can be employed to sum up this work. This is an excellent example of a personal interpretation of a nude. Nonetheless, the artist has taken great care in evaluating lights, darks (fig. 267), and proportions. The artist has used all the resources at her disposal to successfully execute it, in order to

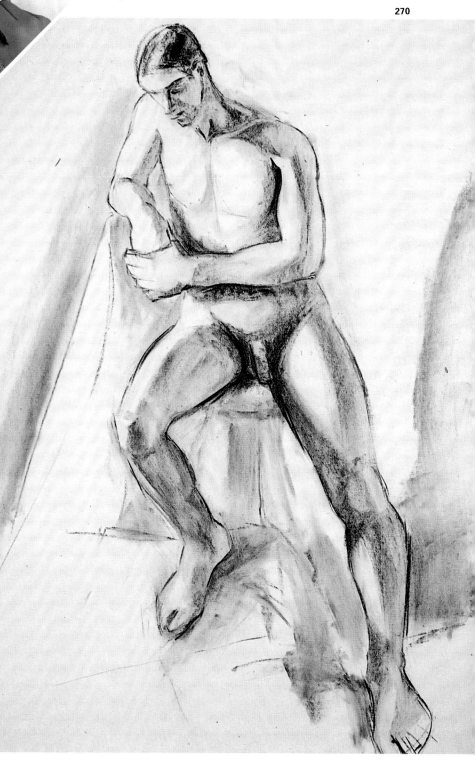

**269**

Fig. 269. The artist uses a kneaded eraser on just one occasion, almost at the end of the process, to clean up one or two areas.

Fig. 270. Then she works with almost pure blacks in smaller areas to highlight the contrasts. The entire musculature has been defined, as well as a light background. The drawing is now complete.

**270**

prevent it from becoming a series of superficial forms and lines without a background. It is a person that is being drawn, with hands and a character, a view of the world, feelings, inner peace or instability... all of this must be conveyed by the work, but it can only be interpreted if the resources, the starting point, are correct, thus enabling the viewer to "read" what is represented.

A kneaded eraser is used to clean up certain areas (fig. 269), but after closely examining the drawing, the artist discovers that the darkest blacks need adjusting. Therefore Olivé increases the contrast so that the drawing more faithfully reflects the lighting chosen for the exercise. Compare the value of the shadows that appear darkest–the inside leg, the head, the armpit on the right; with a few additional touches of charcoal, the picture acquires much more volume (fig. 270). And that's where we leave it, in the strongest and tenderest moment, without overloading it. Many thanks, Esther Olivé, for your magnificent collaboration.

# Miquel Ferrón paints a side-lit nude in oil

**271**

Figs. 271 and 272. Miquel Ferrón begins by chatting with the model and giving her ideas for poses, using several sketches he has drawn beforehand. Finally he chooses this pose with lateral lighting, which brings out the shape of her body, and a background of cushions and curtains.

As in the previous work by Esther Olivé, we will attempt to summarize in this step-by-step the knowledge and advice presented since the beginning of this book: on anatomy, the study or sketch, posing, and lighting for an artistic result.

This time we are going to follow Miquel Ferrón through each step as he paints a picture. First of all, with the help of the photographer, Ferrón sets up the backdrop, comprising sheets, curtains, and several cushions of lively primary colors. Then he speaks with Rosana, the model, a young, thin, dark-skinned woman from Brazil. Ferrón asks her to lie down and try out several poses: with her face to the artist, showing her back... in the end, he chooses the pose you can see in fig. 272. Although this is not the most comfortable of poses, Rosana says she is ready for him to begin. Ferrón gets

**272**

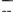

**274**

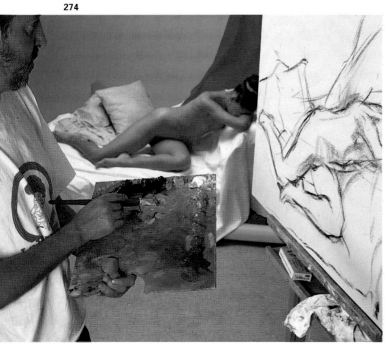

**273**

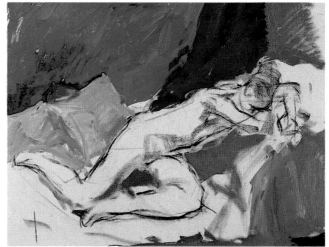

Figs. 273 and 274. The subject is drawn with charcoal in a preliminary sketch in which the entire body fills the canvas. The artist even draws the first chiaroscuro in charcoal and, without including too much detail, loads the palette with colors to get down to painting.

**275**

**276**

straight to work with his charcoal, a common way of starting an oil painting. It is essential to take note of certain factors: the distribution of light and shadow, which is clearly delineated by the lateral spotlight that leaves the front of the body in shadow; the pose, which transmits a feeling of restfulness; and Ferrón's method of drawing. In fig. 273 the lines help Ferrón to correctly situate the foreshortened legs, both the one "distancing" itself and the one "approaching" the viewer. These lines relate parts and construct boxes for the body. Note also the position of the body within the painting itself, occupying a large part of the canvas and leaving most of the background above the body.

Loading the colors onto his palette (fig. 274), Ferrón begins to paint the primary blue and red background, followed by the cushions and several light stains (mixed with turpentine) on the white sheet. Cool tones predominate to contrast with the warmth inspired by this beautiful brown-skinned woman. The artist starts to paint with ocher and umber tones and even a little olive green, reserving an orange area with white for

the lighted zones of the back and the arm.

He applies the paint with loose, frottage-like brushstrokes, creating flat zones without repeating exactly the same color twice.

Figs. 275-277. Ferrón begins to paint the part of the background above the model. These lively colors, which are cool for the most part, contrast with the pure red curtain. Then he works below the figure, painting violet shadows cast by the body on the sheet, and finally, very loosely, the artist stains the body with umber colors (some light, some intermediate, and others dark) that are appropriate for the model's brown skin tones.

**277**

Observe how Ferrón paints the light and shadow of the body, starting with the area in shadow that goes from the left knee to the head. Then he paints the lighted part with brighter colors (ochers, oranges, pinks). Next, he differentiates the color of the right leg from the left one, reserving orangish colors for the one nearest us and umber colors for the more distant one. Ferrón continues using his frottage technique, sometimes with the brush loaded with turpentine, leaving spaces untouched, never "filling in" zones but painting one color over another. The shadow cast by the body on the sheet is painted violet, which complements the warm, illuminated body tones. The violet, together with the carmine, is also present in the areas of the body in shadow. These areas are painted with a mix of ocher or yellow with violet and white: broken colors, with a cool or warm tendency according to the quantities of color used. Then Ferrón continues with the sheet and at the same time paints the head of the figure–even maintaining the model's hairstyle–giving a reddish tone to the face.

Slowly, the colors come together in a group, which is no easy task with those primary colors in the background. At the same time, the painter carefully applies details with delicate brushstrokes, rounding the body, removing the planes, providing concrete direction to the muscles and the flesh. In this respect, notice the brushstrokes on

Fig. 278. The next step consists of painting the entire body, first the right leg, with orangish colors; the brushstrokes must be short and abrupt, thereby creating planes with which the body will be constructed.

Fig. 279. Finally Ferrón decides to paint the head with the same hairstyle as the model's, while graying the parts of the body in shadow and working on the light areas of the sheet.

Fig. 280. In addition to the white of the sheet, we can see in the photograph that Ferrón has painted over the first dark areas of the stomach and breast. He does this to obtain the reflections of the sheet on the shadows; that is, dark areas that are not as dark as they appear. The painter also "cools" the illuminated areas of the model.

Fig. 281. The violet, pink, and white are cooler than the ochers and oranges that the artist applied at the beginning of the process.

**278**

**279**

**280**

**281**

the leg farthest from the viewer, which Ferrón rounds off, and those that construct the arm and its main muscles, as well as how certain colors are repeated to convey that the value (light) is the same in the back, arm, and leg on the right.

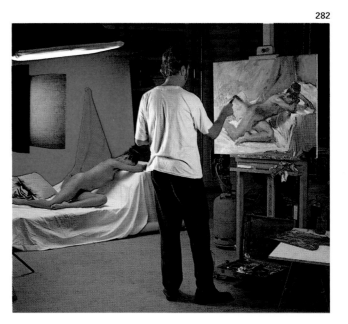

Fig. 282. We continue to observe the development of the work; here we see the artist concentrating more on the background, to give the cushions more consistency, and working on the light that defines the sheet and the model.

Fig. 283. This is the final stage. Ferrón has removed those small planes that were present at the beginning to give the skin a more modeled appearance, a smooth, shiny surface, and some highlights.

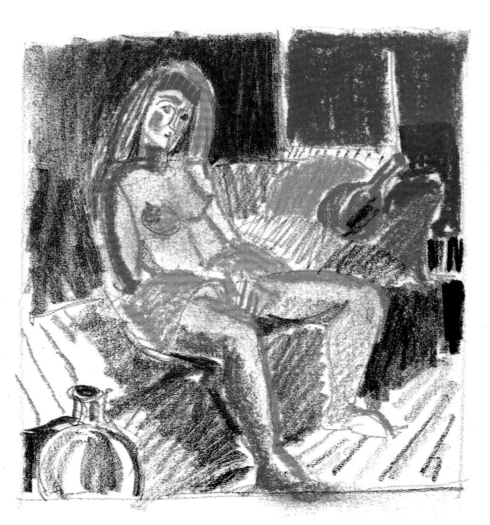

# THE ART OF THE NUDE: COMPOSITION

When an artist decides to paint a nude subject, when he or she paints a setting in which the body moves, in which a story is told, the composition on the canvas can be expressed in various ways. Composition is art's great mystery, because it can give any particular subject a special significance. And it is a mystery because we are not able to apply any logic to its variations.

Fig. 284. Muntsa Calbó, sheet of studies. The exercise of planning the composition of a scene is highly advisable. On this page is an example of such an exercise: starting with the model's pose in a chosen space, the search for a good composition does not end with merely studying the form; the weight of the colors also plays an essential role.

# An introduction to composing with the figure

**285**

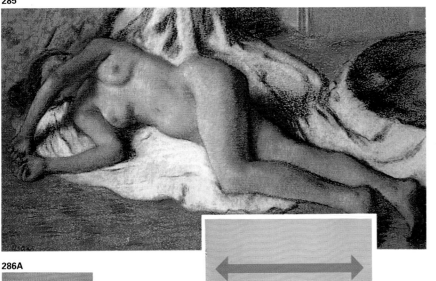

**286A**

**285A**

**286**

Figs. 285 and 285A. Edgar Degas, *After the Bath,* pastel. Paris, Louvre Museum. This painting is an excellent example of a horizontal composition that conveys rest and stability.

Figs. 286 and 286A. Edgar Degas, *Woman Drying Herself,* pastel. Washington, D.C., The National Gallery of Art. The model's vertical pose is supported by Degas's chosen format, one that is ideal for observing activity as well as providing balance and energy.

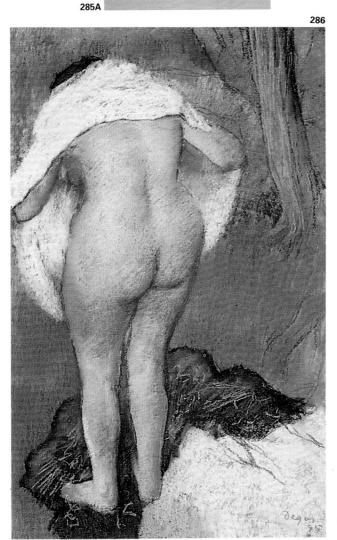

Composition is fundamental, no matter what the image, genre, or subject is. It is one of those aspects that converts the interpretation of a subject into art. It is not easy to explain and is especially difficult to teach, because the uniqueness of each composition is the result of a series of decisions by the artist–to situate an object on the right or in the center, to take up the entire canvas or only a part of it, and so on. In every picture the artist paints, he or she makes multiple decisions to express an idea.

Composition is the distribution of elements in a picture. The nude appears to be a rather simple composition: most of the canvas is taken up by the main subject (the body) and that is it, we might say. But even then we would have to consider the format of the painting, since it is best to choose one that suits the figure. To avoid problems, choose a format that will help you block in the figure.

This is not the only question to take into account. We may want, for example, to paint only one part of the figure, cropping it in some way (see fig. 287); or we may choose to paint multiple figures at the same time (see page 104); or we may wish to depict the nude in a specific setting, describing the surrounding space and objects in the scene, etc. (see fig. 286 on page 102 and fig. 296 on page 106).

Let us consider different distributions or compositions. We will begin with the simplest, following the schemes on these pages and the examples of paintings.

The first consideration is the position of the center of interest (the nude in this case): vertical, horizontal, or diagonal. Vertical lines express activity, energy, strength, spirituality. Horizontal compositions are relaxed, expressing stability, rest, and sensuality;

diagonal ones are unstable, expressing movement, energy, dynamism (see figs. 285-287A).

On the other hand, the main element can be situated symmetrically or asymmetrically on the canvas. Symmetry is stable and may even appear boring, although it can be appropriate in certain cases. Asymmetry is more varied and creates other sensations: solitude, movement, emptiness–or elegance, if it is related to the golden section, for example (figs. 288 and 289A).

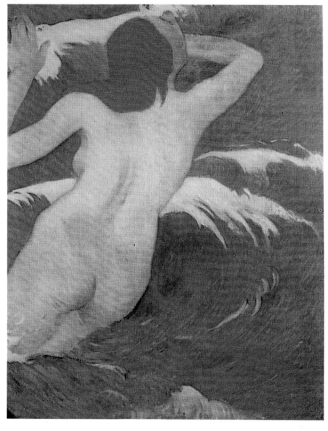

Figs. 287 and 287A. Paul Gauguin, *Ondina I,* 1889. Cleveland, Cleveland Museum of Art. The diagram shows a slanted line, the basis of this composition; there is nothing counterbalancing it, but it is supported by the green sea. The incline suggests movement and instability.

Figs. 288-289A. These two diagrams illustrate the sensations conveyed by the symmetry and asymmetry of two paintings by Badía Camps.

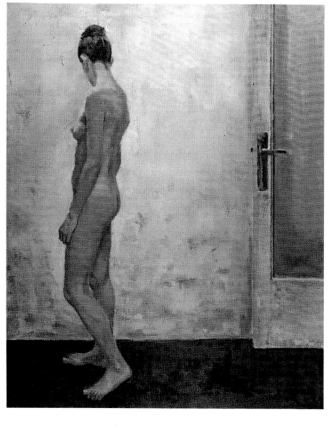

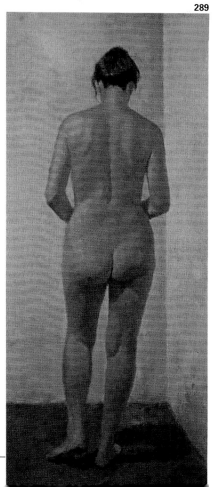

**290**

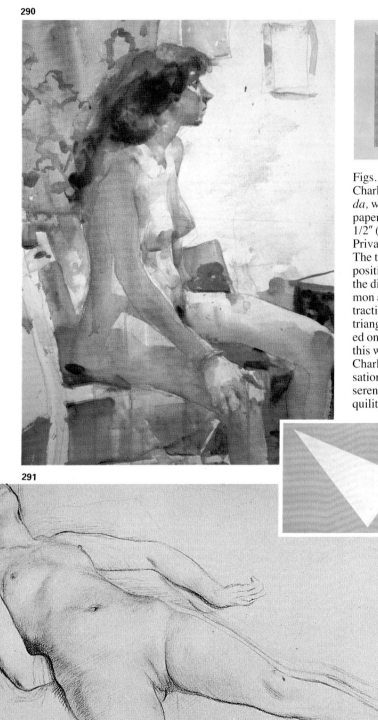

**290A**

Figs. 290 and 290A. Charles Reid, *Varda,* watercolor on paper, 30″ × 22 1/2″ (76 × 57 cm). Private collection. The triangular composition shown in the diagram is common and very attractive. When the triangle is supported on its base, as in this watercolor by Charles Reid, a sensation of stability, serenity, and tranquility is conveyed.

**291**

**291A**

We will increase the complexity by considering the form that joins the essential elements together: the box. This box is very often a triangle of varying shape and position (many more than what we have reproduced here as examples). When a composition is supported on a base, it always conveys a feeling of stability, weight, and especially classicism and serenity. If it is situated like the one in fig. 291, the feeling is more open, unstable, modern, but other aspects influence it, such as the head in the corner, the foot that is cropped out, and so on.

If we continue examining these "boxes" and the shapes that "fill" them, we can classify other shapes as organic, curved, circular, and oval. These shapes convey different attitudes and feelings.

A circular composition (fig. 294) is also stable, but adds an intimate meaning, that of protection and withdrawal. They are feminine forms–curved, womblike, cupshaped forms that are secure and loving.

In addition, open curves, in the form of waves or curls, are equally feminine and organic, provocative and sensual (figs. 292 and 293).

Figs. 291 and 291A. Edgar Degas, *Nude Lying on Her Back,* black chalk. Paris, Louvre Museum. When the compositional triangle is not supported on either side, we obtain a vanishing perspective, a foreshortening, or simply more modernity and less stability.

Figs. 294-295A (opposite page, below). Left: Edgar Degas, *Woman in the Tub Drying Herself,* pastel. Paris, Orsay Museum. Right: Pablo Picasso, *Nude in the Garden,* 1934. Paris, Picasso Museum. These paintings illustrate two typical and complete compositions: a circle or an oval that incorporates the central subject. They are compact, curled up, and intimate.

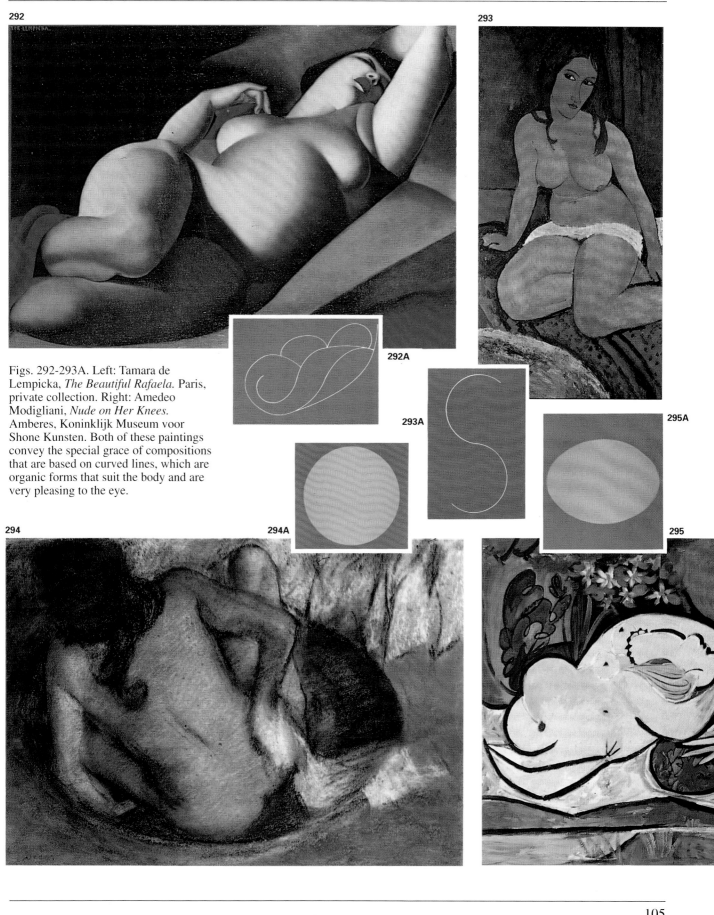

**292**

**293**

**292A**

**293A**

**295A**

Figs. 292-293A. Left: Tamara de Lempicka, *The Beautiful Rafaela.* Paris, private collection. Right: Amedeo Modigliani, *Nude on Her Knees.* Amberes, Koninklijk Museum voor Shone Kunsten. Both of these paintings convey the special grace of compositions that are based on curved lines, which are organic forms that suit the body and are very pleasing to the eye.

**294**

**294A**

**295**

Another problem that we have mentioned occurs when the nude, although still the center of interest, is accompanied by part of the surroundings in which he or she is situated (a vase of flowers, curtains, the entire room, etc.). It is necessary to choose, distribute, and arrange the composition. In these studies by Charles Reid (figs. 296 and 297), the artist realized that he had made an error by working too quickly: in the painting you can see that the artist could not decide whether the stove or the nude was more important. It is essential to identify what we are attracted to in a subject–it cannot be everything–and understand that, whatever it is, we cannot simply put it in the center. We must balance all the parts, not only in position but also in light and color.

This balance allows a series of elements or forms to express a unified idea instead of looking like a collection of samples. One way of achieving this is to arrange these objects into a powerful shape, such as a triangle, a circle, or the like, and situate the shape within the picture plane. You can see a graphic example of this in Gauguin's painting in fig. 311 on page 109. When composing groups of figures or complex environments, the same general principles used for one figure or for a still life remain valid: unity within variety. Forms and objects must not appear too far apart or bunched together in the center. They should relate to one another, even if they do not appear complete or perfect. The shape that joins them together must be energetic, like the oval motif Matisse used in his painting *The Dance* (fig. 301). Another important factor of composition is the relative weight of forms and zones. Weight greatly influences color; one color can compensate another, whether the relationship is light and dark contrast or one of tonal complementaries.

Figs. 296 and 297. Charles Reid, *Sperry's Studio,* oil on canvas, 50″ × 50″ (127 × 127 cm). Here, Charles Reid illustrates a composition in which the scene contains several elements. For this reason the nude does not necessarily have to be the largest or the most important. In the artist's view, the picture is not correctly resolved; either of the other two compositions shown in the accompanying sketches would be better. Therefore we should study them carefully. The composition of the painting is not very good because the artist has not decided what importance each element has.

296

297

**300**

Figs. 298 and 299. In principle, when painting groups of figures, it is essential to avoid boring or illogical compositions. The figures in the first scheme are too isolated from one another. In the second, they are too close together: little variety and a bad choice of format.

**298**

**299**

**300A**

Figs. 300 and 300A. Henri Matisse, *Game of Bowls*, 1908. Saint Petersburg, Hermitage Museum. On the other hand, in Matisse's painting, the figures combine in an arch form, creating a center of interest in the balls.

Figs. 301 and 301A. Henri Matisse, *The Dance*, 8' 6 1/2" × 12' 9 1/2" (260.4 × 389.9 cm). New York, Museum of Modern Art. Another of Matisse's superb compositions shows a group of several nudes conforming to an oval, the main motif of the picture.

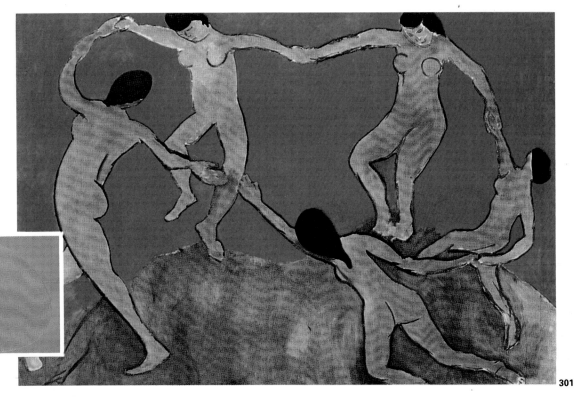

**301A**

**301**

We are now going to study several paintings to see how the composition can be related to the purpose and outlook of the painter. The first thing one should remember is that nothing is obvious; when we are standing in front of the model with our palette in hand, we cannot simply start painting "what we see" because what we see is too extensive: we must choose and decide which parts we will include and how we will arrange them. When creating the painting at top right, Charles Reid decided to focus on just part of the model he was working from rather than show her in her entirety; the same is true of the picture below by Teresa Llácer. The painter chooses the format and orientation of the canvas (horizontal in fig. 302, vertical in fig. 305) according to what suits the treatment of the subject. Moreover, the composition is never symmetrical; it lies within the golden section and in both cases is triangular. In the painting by Teresa Llácer (fig. 304), balance is created by two complementary colors, with the point of interest in the orange part (the figure's face), surrounded by blues. Note that the relationship between the two colors is also not symmetrical: there is more blue than orange.

In *Puberty* by Edvard Munch (fig. 308), symmetry is broken with just one dark shadow on the right of the figure. The body is small in relation to the overall space of the picture, but it is nevertheless the main element, almost the only one. This solution, supported by the darkness surrounding the adolescent, creates a feeling of loneliness, abandonment, and fear.

Figs. 305-307. In this painting by Teresa Llácer, we can see a pyramid-based composition, but it is also based on two triangles. The center of interest is highlighted by bright red; the remaining colors compensate for this intense contrast.

302

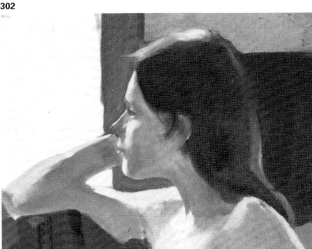

Figs. 302-304. Charles Reid, *Kim at Studio II*, oil, 40" × 50" (102 × 127 cm). This oil painting by Charles Reid is a composition depicting only a part of the figure, which was resolved through the distribution of lights and darks using the golden section to place the bust and the head.

303    304

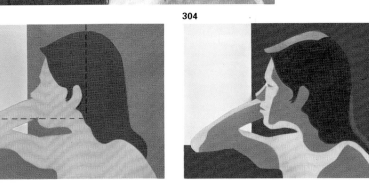

305

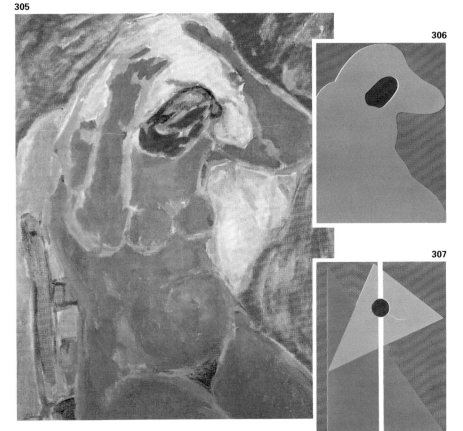

306

307

In Gauguin's painting (fig. 311), two figures merge into a single shape between a triangle and a circle, which the artist situates to one side, countering its energy with a slanted line on the opposite side of the picture, a line that expresses the change in color.

Another example of different resources that can be combined in a particular composition can be seen in the painting by Matisse (fig. 314).* Matisse was an outstanding composer, so much so that his paintings are always vivid and cheerful and incredibly relaxing at the same time. In this case, he used the golden section together with color contrast and combined the figure's organic lines with the straight lines of the background. The result is fresh and light, yet still firmly rooted on earth.

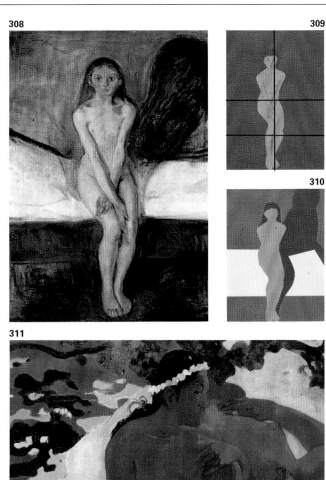

**308**

**309**

**310**

**311**

Figs. 311-313. Paul Gauguin, *Aha Oe Feii,* 1892, oil on canvas. Moscow, Pushkin Museum. This composition demonstrates how complex a relationship can exist between two figures. In this case they are situated to one side of the painting, forming a compact block.

Figs. 314-317. Henri Matisse, *Pink Nude,* 25 3/4″ × 36″ (66 × 92.5 cm). Baltimore, Baltimore Museum of Art. This is a wise composition that combines the use of the golden section, cool and warm colors, as well as geometric and organic lines.

Figs. 308-310. Edvard Munch, *Puberty,* 1894, oil on canvas, 59″ × 43 3/4″ (149.9 × 111.1 cm). Oslo, National Gallery. The desire of the artist was to create an atmosphere of anguish and loneliness, maybe even fear of the future and ignorance of the present. The figure has been drawn between the shadows, centered in and enclosed by the oppressive atmosphere.

**312**

**313**

**316**

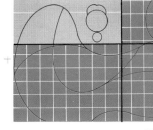

**314**

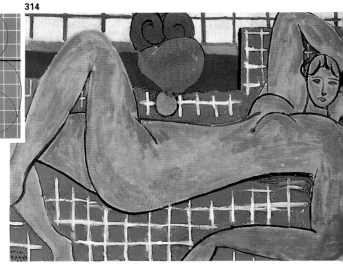

**315**

**317**

# Compositional studies without color

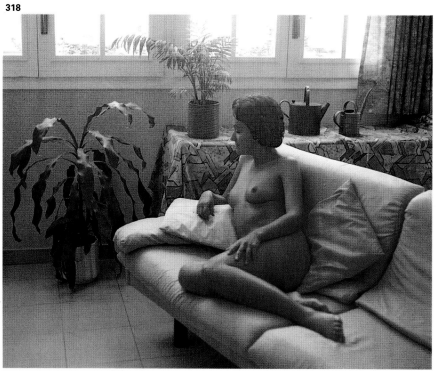

Fig. 318. Once you have decided on the scene, it is not necessary to stick to it. The picture can vary according to the chosen composition and according to the colors, although there are certain limitations.

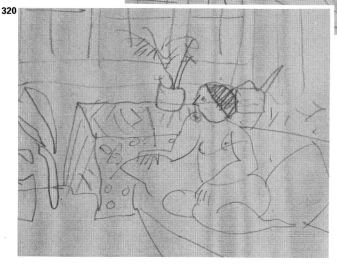

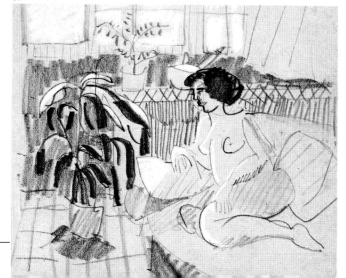

Having read the previous pages, you are probably ready to paint a female or male model at home or in the studio.

The model should position herself or himself in a chosen area–perhaps on a sofa, half seated, half stretched out (as in the pose adopted in fig. 318). You may ask the model to assume the pose you want.

The illustrations on these pages represent the work I do using the model; some are drawn quickly and others more slowly. What I am doing, in reality, is "warming up" by drawing different compositions to find the one most interesting for use in the final picture. Naturally the composition has to have some connection with the format (square, rectangular, etc.).

Here I am using daylight consisting of both backlighting and enveloping light, which I must take into account in planning my composition. I must decide, for example, whether I want the light of the

Figs. 319-321. The first studies (figs. 319 and 320) are always very schematic and include most of the scene, but they are different. Note the sizes, appearance or lack of a window, plant, etc. The two sketches are combined in fig. 321, in which the values have been studied, and it seems the best choice.

window in the background or not. I draw a few very simple sketches to obtain a composition that takes in most of the scene (figs. 319 and 320). In one of them there is hardly any glimpse of the window; in another it is an essential element (fig. 320). Then, to check out the combination of values–the lights and darks–I draw a few more studies. In fig. 321, I continue to work on the same composition and make a rough value plan; the picture seems attractive. I imagine a vertical format (fig. 322) and try it out. It looks okay... it is going to be difficult to choose. Everything depends on what I decide to emphasize, the overall atmosphere or the figure herself.

To give the sensation of the body being more curled up, I choose a square format with the model in the center and draw some lines (fig. 324). Since this also seems to be a good composition, with the model a little more to the right but still centered, I draw a new picture with beautiful backlighting (fig. 325). Finally I attempt to crop

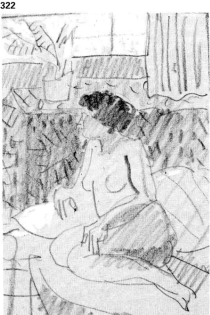

**322**

the model, focusing the attention on the head (fig. 323). This isn't bad either: the model is on the right because she is looking to the left, and there is an unusual combination of lights and shadows. So many possibilities do not always occur; maybe I will paint more than one picture.

Fig. 322. I select a vertical format and include fewer elements to center the attention on the model, and also work on the values and details.

Fig. 323. In this case, I have decided to crop out part of the figure, reduce the scene to a minimum, and center the attention on the torso and head, which are turned toward the light; the darkness of the plant compensates for the other light colors. This is one possibility.

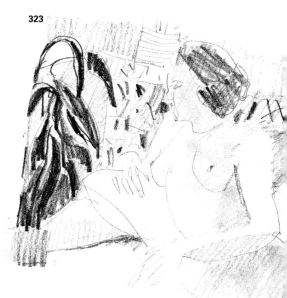

**323**

Figs. 324 and 325. I try out a new composition with a square format, because a square is ideal for including the entire figure along with some of the background. It is a suitable composition, perhaps the simplest of all. To try it out, I draw another study with a few very slight alterations while leaving the backlighting in.

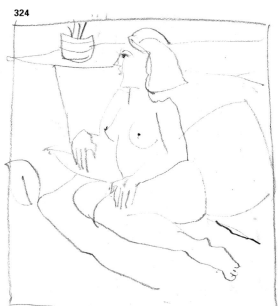

**324**

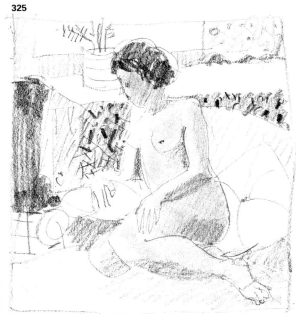

**325**

# Compositional studies of form and color

**326**

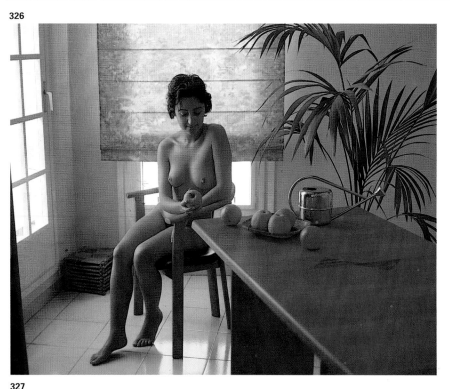

**327**

Diagonal, triangular compositions, symmetrical and asymmetrical compositions, static or unstable compositions... study the previous examples and also the ones on this page and compare them with the photograph here, which captures (in a somewhat expressionless manner) the atmosphere in which the painter is situated (fig. 326). The environment is complex, with several light sources, all natural, half-backlighting, and a table that partially blocks out the model. A few studies must be drawn first, even one trying out color to test the balance of masses.

I draw most of the scene (fig. 327) in pencil to see what a horizontal format will turn out like (rather surprising at first): the model is almost centered, there is a light mass on the left and details and darks on the right. I draw a few more quick sketches to check out the composition and color, slightly varying them; in fig. 328 I try a harmonious warm tone and a round table, which

**328**

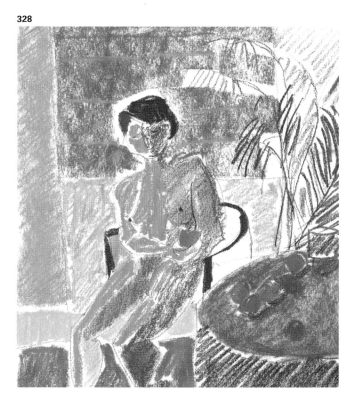

Figs. 326-328. Every time you find yourself facing a scene, no matter how simple it may appear, study it to compose it. Nothing can be taken for granted in painting. This scene is more difficult than the previous one due to the lights and combination of elements. But one can invent if necessary. For the moment, I concentrate on two compositions that include almost the entire scene, but in the second one I have cropped the feet and drawn the table round, as well as tested the relationship of colors. Nonetheless, I continue to prefer the first format without any cropping.

**329**

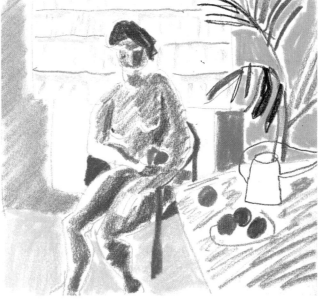

looks better than a rectangular one (fig. 329). I prefer, however, the harmony of blues, which greatly enhances the composition by giving the model a better "frame."

In fig. 330, I have drawn in a vertical format, removing the plant and changing the color for an assortment of greens. More of the model disappears behind the table; the composition now looks better, much more compact than the others, both for the color and for the shape.

Finally I draw a few sketches to decide how to crop the figure, and find fig. 331 especially interesting. I synthesize the scene, with the woman holding an apple and the essence of backlighting. Fig. 333 is similar but it is vertical; I definitely prefer the horizontals–they are more original.

These exercises are your best guide to finding a good resolution for your final painting. Don't just go for the first idea; above all, use your imagination.

Fig. 331. I draw another picture without color to try out a new idea: cropping the nude and concentrating more on her as the subject. The first impression is positive.

Figs. 329 and 330. I try out two new formats, one square and the other elongated and vertical; in addition, I add a contrast of blue and warm colors in one (fig. 329) and a harmony of greens with a few contrasting oranges and reds in the other. Both look promising, but the greens are warmer and more attractive.

**330**

**331**

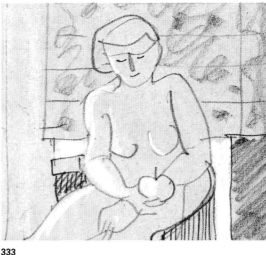

**332**

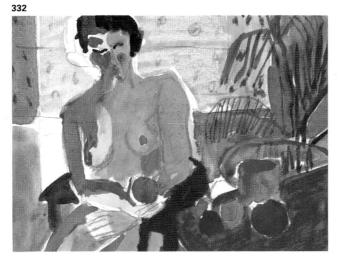

**333**

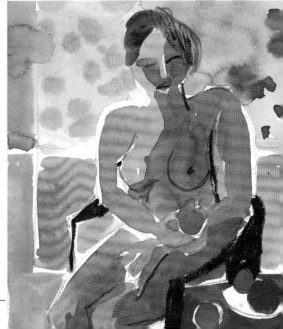

Figs. 332 and 333. Using the last idea, I try out two placements on a horizontal and a vertical surface and at the same time apply a few stains of color. The horizontal one looks better because it joins the elements together.

# DRAWING THE NUDE

The evolution of the drawing goes hand in hand with the development of the nude genre. Drawing was not recognized as an independent art form until at least the Renaissance; at about the same time, the nude ceased to be used in purely symbolic terms and was considered as a subject in itself.

Any drawing begins as a sketch or study, and the same is true for the nude. For this reason, working with a model is one of the best ways to learn how to draw. The first professional models did not appear until the 15th century in Italy and much later in the north. Up to the 18th century there were practically no female models (before that, artists used their wives, lovers, prostitutes, and so on).

To explore the nude genre is to learn how to draw.

Fig. 334. Detail of a drawing in progress in charcoal and pastel, the work of Francesc Crespo. Note the wide range of qualities that the dry medium can provide, and then compare it with other methods of shading and with other techniques, such as line drawings. Drawing and the nude are closely tied in art.

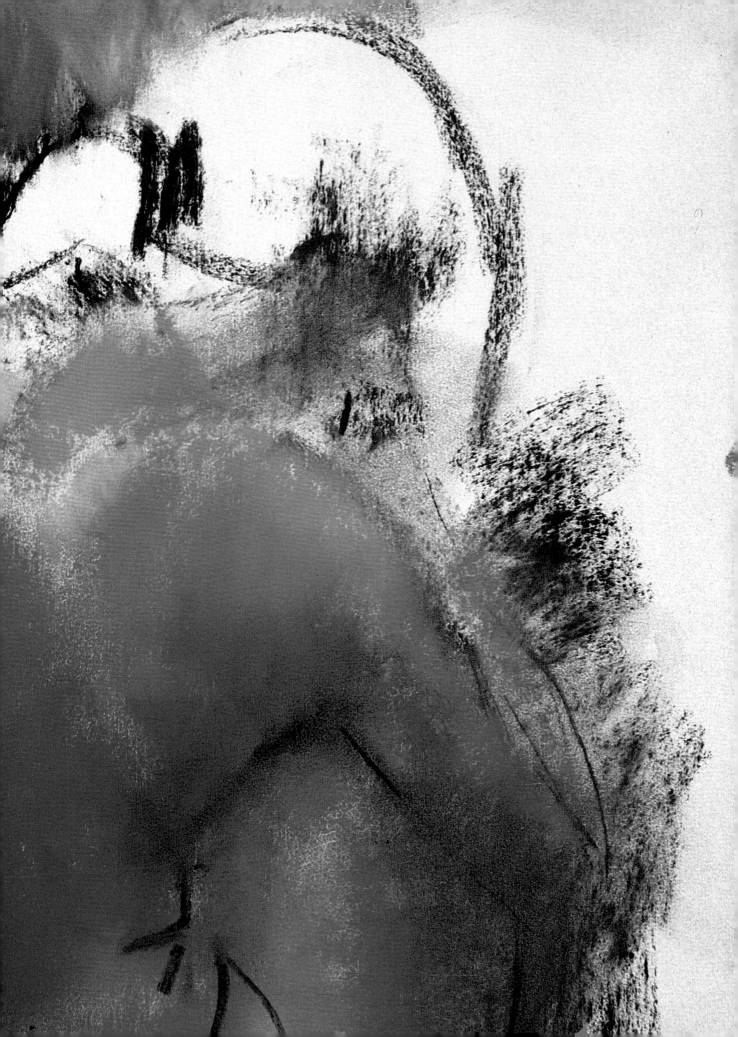

# Artistic drawing and the nude as a subject

The nude is an obligatory subject for students of art because it enables them to familiarize themselves with the different mediums and, above all, learn how to draw. That is, drawing nudes teaches you how to draw in general. This observation was first made around the 16th century. Before then no one paid much attention to the human body, and it was not until the Renaissance that drawing began to be recognized as an independent art form.

It is difficult to explain why the nude is so appropriate for teaching art. Perhaps it is because it is a very defined subject, which facilitates the work, while at the same time it is complex, despite its familiarity and simplicity. It could also be that it enables the study of countless artistic aspects, of which balance and proportion, structure and surface, line and modeling are equally important. In one single subject we can find nearly all the questions the artist must know how to solve in order to paint a work of art. It requires the artist to synthesize, to simplify, to choose, to search out the essence.

On the other hand, the artistic nude, so omnipresent in the art of the last centuries (and it is possible that the earliest drawings have been lost because they were not regarded as important), has an attractiveness that other genres lack. It seems that we cannot separate drawing from the nude because drawing is the ideal medium for interpreting the human body. Perhaps it is because drawing is light, sketching more than it describes, suggesting more than it explains, and provides the artist with a living, active, weightless way of interpreting the human body, which is, without doubt, something living, mobile, unattainable, despite the apparent rigidness of the model. Drawing is the synthesis of our ideas and our vision of a particular world; it is the most

Fig. 335. Henri Matisse, *Nude Seated with Hands Behind Her Head,* lithograph, 24 3/4″ × 18 7/8″ (63 × 48 cm). New York, Museum of Modern Art. In his magnificent drawings, Matisse was capable of extracting the essence of the subject using any resource, in this case the modeling.

Fig. 336. Henri Matisse, *Odalisque with Striped Slacks,* lithograph, 21 1/4″ × 17 3/8″ (54 × 44 cm). New York, Museum of Modern Art.

335

336

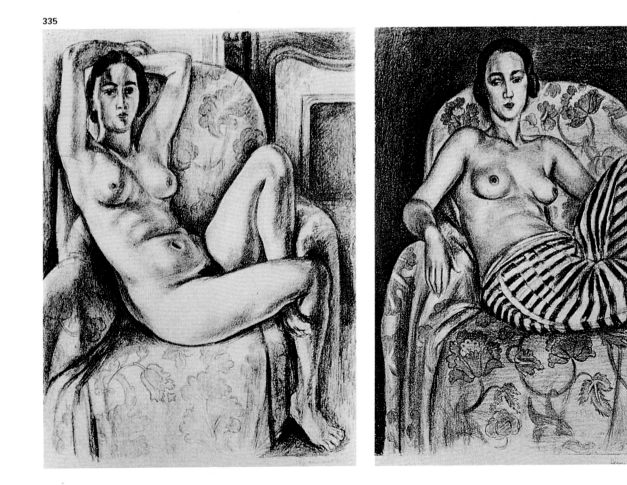

abstract medium for interpreting because it is closer to our minds than the real environment is. Lines and whites, quivering strokes and light touches of wash do not exist as such in reality: they are symbols that, when distributed on paper, recreate reality and eloquently express the artist's spirit.

Fig. 338. Auguste Rodin, *Two Female Nudes,* pencil and watercolor. Mora, Zornmuseet. Rodin's countless drawings in graphite and wash express apparent eroticism. Is this because of the soft curved lines, the softness of the water, the poses?

Fig. 339. Willem de Kooning, *Woman Seated,* 1952, pastel and pencil. Boston, Massachusetts, private collection. An expressionist, abstract version of a woman.

**337**

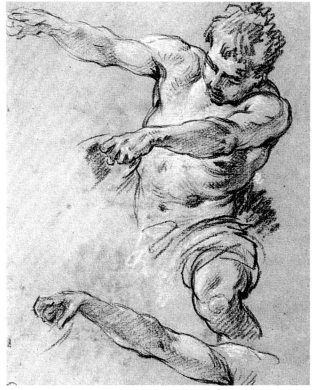

Fig. 337. François Boucher, *Study of a Male Nude.* Fort Worth, Texas, Kimbell Art Museum. This surprisingly fresh drawing was executed in charcoal with several touches of white chalk on gray paper. We can see right away that it is a study and not, like the previous ones, a finished drawing. Nonetheless, during the French Rococo the drawing was valued as an artwork, something it had seldom been considered previously.

**338**

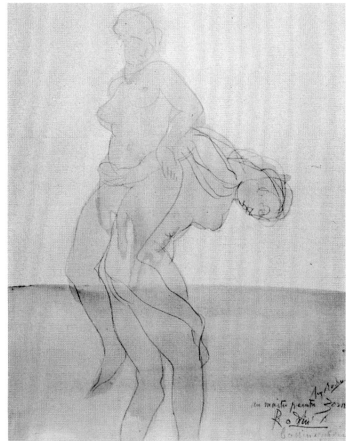

**339**

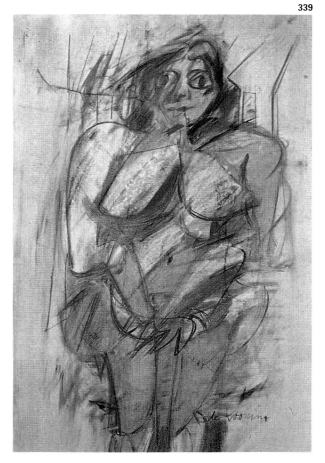

# Line as the basis for drawing the nude

In effect, it is line that transmits, with all the immediacy that we spoke of, an idea onto paper. How strange it is to see the world as a group of color stains or to represent objects as silhouettes, using lines on paper to convey the reality of a subject.

Lines–thin strokes, thick strokes, curved lines, parallel lines, crisscrossed lines–are the basis of a drawing and proof that drawing is, above all, mental, ideal, and creative. It is the artist's imagination that is left as a mark on the paper, his or her state of mind, and especially his or her way of seeing the world.

Making quick sketches (15 minutes maximum) of the nude working from a live model is the greatest expression of that creative search we have spoken about. The artist must free his or her hand and sketch a definitive outline from among the multitude of existing lines, using light or energetic strokes to capture the essence of the subject.

340

341    342

Fig. 340. Drawing materials: graphite pencils, charcoal pencils, charcoal sticks, stumps; pencil sharpeners and kneaded erasers; ink, nibs, reed pens, chalk, sanguine pencils, etc. This wide range can provide us with an almost limitless number of treatments, lines, and shadings.

Figs. 341-345. Ballestar has drawn some lines with a soft pencil (fig. 341), a hard pencil (fig. 342), charcoal (fig. 343), ink (fig. 344), and chalk (fig. 545). In reality, there are numerous other types of lines.

**343**

**344**

**345**

The line drawing takes delicateness to the extreme but clearly demonstrates the complexity of representing an object in only two dimensions. The world is three-dimensional–at the very least, since we could include time–but we are able to represent and understand it in two. Even when we are not modeling or using chiaroscuro, we can evoke volume, gesture, and the movement of bodies in space through lines. Perhaps it is for this reason that the basis of drawing and, by extension, art itself is the line or the materialization of an idea.

The possibilities of lines are numerous, and more so if we take into account the many different mediums that provide us with different treatments. There are thick-line mediums, such as charcoal, sanguine, and chalk; fine-line mediums, such as lead pencil, charcoal pencil, and felt-tip pen; and liquid mediums, which give fine, flowing, and definitive lines in ink or watercolor, with a brush, nib, or reed.

And now some advice: never draw two nudes alike, since models are all different according to age, color, and other physical characteristics; choose natural poses; and above all, concentrate on the nude's main proportions and volumes, reducing them to basic geometric shapes. It is not important whether the face is attractive or the figure is exact; it is a question of reflecting the poetry of the body, its fundamental gesture, presence, and balance. Don't erase any lines, even if they are incorrect, because the proximity of false and correct lines gives the picture life by reflecting the continuous process it has undergone.

**346**

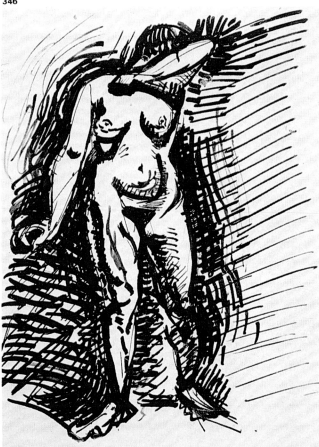

**347**

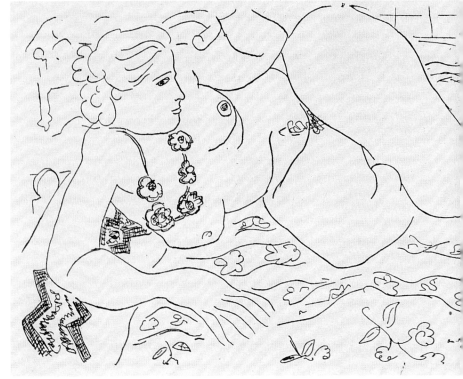

Fig. 346. Henri Matisse, *Standing Nude*, pen and ink, 10 1/4″ × 7 7/8″ (26 × 20 cm). New York, Museum of Modern Art. An exquisite example of what can be achieved using ink with lines, in this case, bringing out the shadows.

Fig. 347. Henri Matisse, *Female Nude in the Studio*, pen and ink. Private collection. Using the same technique, Matisse could create a completely different drawing, using only lines and no modeling, conveying everything he considered essential for the subject.

**348**

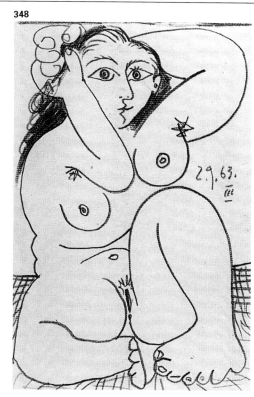

**349**

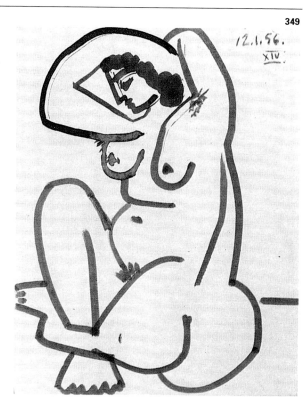

Figs. 348 and 349. Pablo Picasso, drawings from the painter's albums. Left: Barcelona, Picasso Museum. Right: New York, collection of Geoffrey Clements. Picasso demonstrates the variations that can be obtained using a single line, very fine in one drawing and very thick in the other. The important factor here is the artist's resolution and knowledge of the human body. The composition fills the entire paper.

**350**

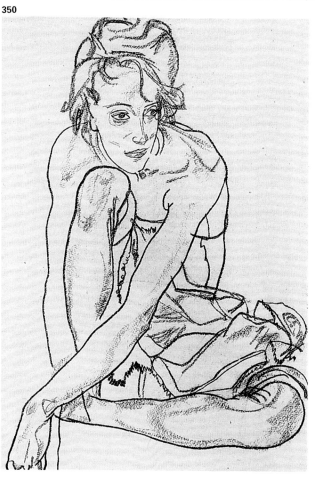

Fig. 350. Egon Schiele, *Half-Seated Nude,* 1918, charcoal. Vienna, Albertina Museum. Dry mediums can also be used to draw lines. They create a very distinctive type of line that always has a slight lack of definition at the edges.

**351**

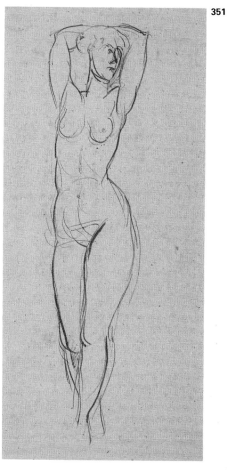

Fig. 351. M. Calbó, sketch of a female nude, drawn with a felt-tip pen. Here we can readily see the search for the definitive line.

# Line drawing: Miquel Ferrón draws several poses

We are going to take photographs of some drawings by Miquel Ferrón. Using only one line, the artist conjures up different poses with a graphite pencil and, occasionally, a stick of compressed charcoal. In reality, Ferrón uses the same process and proves something we stated earlier: the drawing of a nude is above all a linear drawing. The abstract line can depict this male figure in a tense pose. The line, which does not exist in reality, separates two zones for our eyes: the background and the figure. Ferrón begins working on the trunk and arms of the figure, having drawn several faint lines situating the entire body on the paper. He draws lines to define their shape, bringing out the bone structure and musculature with lines that are thin or thick, depending on how much pressure he applies to the pencil.

For his second example, Ferrón draws the model from behind. A line drawing is resolved faster than

Figs. 352-356. We can follow the drawing process that Miquel Ferrón is demonstrating in charcoal pencil, with the limitation we imposed on him, to use only one line. It is essential in this case to establish the position of the torso on the paper by first faintly marking out the general composition.

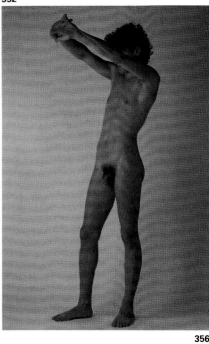
352

353

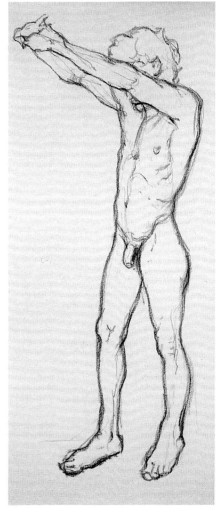
356

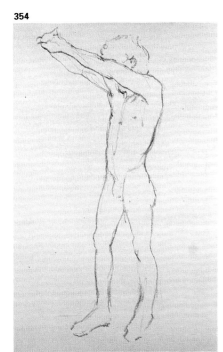
354

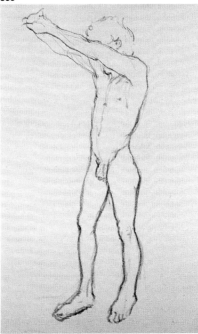
355

**357**

a drawing with lights and shadows because of the technique, just as a watercolor is painted faster than an oil painting. For this reason, the artist draws several pictures in one session. In the first drawing (fig. 358), as well as in the others, there is a series of imprecise lines that do not define anything in particular; they are merely trials. For example, in fig. 358 the body seems slightly tubby, and the head is too big; the drawing process itself will rectify these anomalies. The painter makes the body slimmer, reducing the head, outlining the muscles, pressing harder on the pencil where the body bends and on the leg supporting it, although, in this drawing it is still not clear which part is actually supporting the body; perhaps the reason for this is that it was not determined at the start.

Figs. 357-361. Miquel Ferrón draws a male nude from behind, also using charcoal pencil and one line. The artist barely blocks in the subject, and perhaps for this reason the distribution of the body's weight is still not clear. Nonetheless, Ferrón's experience will enable him to overcome this hurdle.

**358**

**359**

**360**

**361**

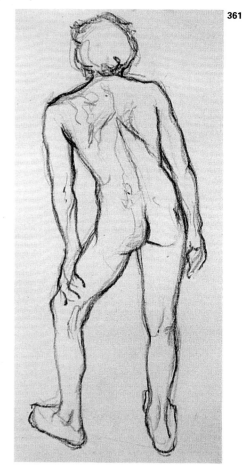

# Line drawing: Ferrón draws two more poses

**362**

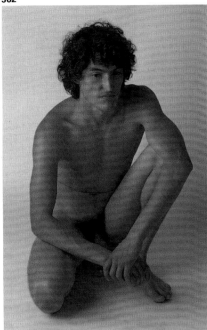

Figs. 362-366. Line drawings and quick sketches are ideal for drawing nudes in complex poses, which are difficult for the model to maintain for long periods of time and are often characterized by nooks and crannies or unusual foreshortening. A drawing comprising shaded areas, on the other hand, normally takes longer to execute.

The following drawings were done in a relatively large format, about 25 1/2″ × 19 3/4″ (65 × 50 cm). Because of his experience, Ferrón does not block in the lines beforehand. His wavy lines appear to correctly guess the composition from the beginning. But if you

**363**

look closely, you will see that the artist sees the figure as an oval and blocks it in that way. Now Ferrón draws the body's vertical axis, which is slightly slanted; he draws the circle that forms the shoulders, arms, and hands. During the process he takes into account the slanted line that joins the inner part of the left thigh to the trunk and the inner line of the right thigh, as well as the box of the head, seen from slightly above and appearing to approach us. Thus we have a number of clues to help us start the drawing, although we do not have Ferrón's experience.

**366**

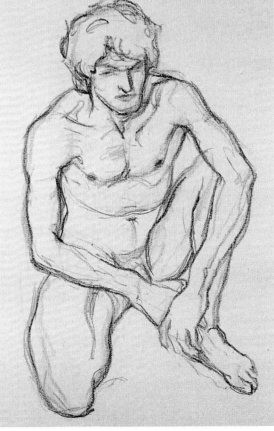

**364**

**365**

Although using tone to define volumes is the most common way of achieving chiaroscuro, we can get similar results in a line drawing. When trying to understand volume, lighting is a great help. The system of lines is nothing more than a mental resource that creates order on the paper: this order is what we know and can interpret as a nude. In the second drawing, which starts from an attractive pose, we can observe what happens after it is blocked in: Ferrón uses a charcoal pencil more resolutely, going over certain areas, especially thickening the line in the areas in shade. At the same time, using fine curved lines, he constructs the muscles, the body's outer appearance, also using soft lines in its interior. We believe that you, the reader, will come to your own conclusions from observing these drawings.

Figs. 367-371. This is a rather tiring pose for the model for obvious reasons. Therefore Ferrón has to sketch the pose quickly, first blocking in with several faint lines, relating the lines of the knees, shoulders, hips... which enable him to correctly draw the body muscles.

**367**

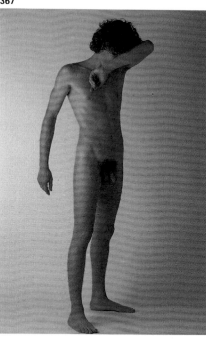

**368**

**371**

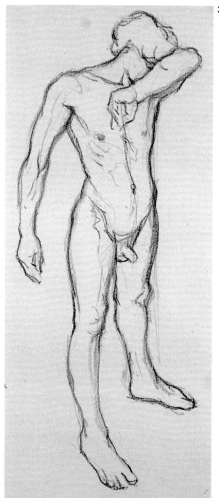

**369**

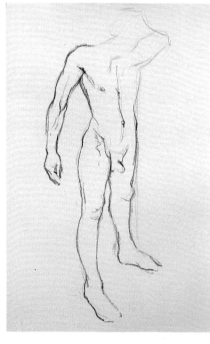

**370**

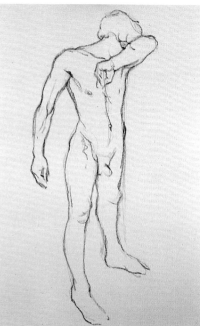

# Using tone to define volume, light, and shadow

Here, we are going to look at the use of tone in drawings, that is, the use of grays of different values to interpret the nude.

Shading has been used to define volume based on a gradation of values, thanks to the possibility of creating different shades of grays with most of the line techniques we have spoken about. Grays also "explain" light and shadow–above all, light–and this is the main purpose of washes or stains in liquid mediums such as watercolor.

Shading can also be used to begin a drawing. It's a good way to confront the emptiness of the paper with a rapid overview of the subject. We start by laying in the dark zones; we can draw the entire body. Then, using this is as guide, we attach structural lines, loose

372

Fig. 372. Nicolas Poussin, *The Triumph of Galatea,* black chalk and sepia wash, 5 1/2″ × 7 7/8″ (14 × 20 cm). Paris, Louvre Museum. A prime example of drawing with shadow, a very common technique of the time, which produced a perfect representation of light.

silhouettes that weave in and out of the shaded areas, and add darker values, enhancing the transparency (if we are using a wash) or stumping, lightening, and restoring the clarity (if using a medium that will allow this, like charcoal or sanguine). Whatever the case, we must never entirely cover the paper.

373

Fig. 373. Using the same drawing mediums (pencil, charcoal, chalk, ink, watercolor, etc.) we can produce any kind of stain, whether by stumping or by allowing the grain of the paper to "breathe" through. The shading and the line normally merge together, and the artist cannot tell where one ends and another one begins.

**374**

Figs. 374 and 375. Egon Schiele, *Nude on a Colored Background,* 1911, pencil, watercolor, and gouache, 19 1/4″× 12 1/4″ (49 × 31 cm). Graz, New Gallery of the City. Henry Fuseli, *The Nightmare Removes the Sheets from the Two Sleeping Maidens,* pencil and watercolor. Zurich, Kunsthaus. Drawing using a wash technique in combination with line.

Figs. 376 and 377. Georges Seurat, *Seated Nude,* Conté crayon. Edinburgh, National Gallery of Scotland. Ramón Sanvisens, *Nude,* pastel. Private collection. Dry techniques give beautiful shading.

**375**

**376**

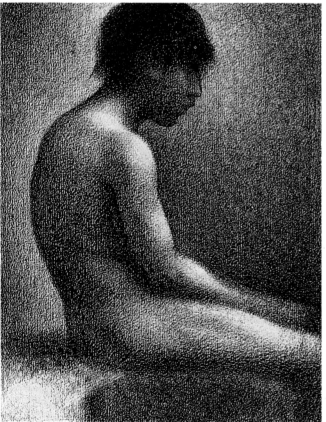

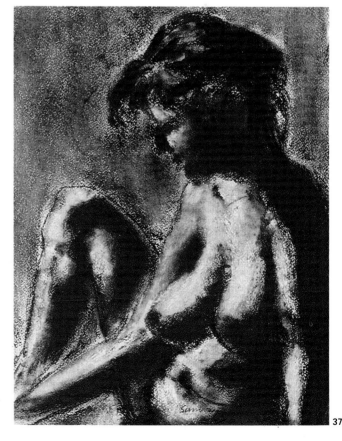

**377**

# Pere Mon creates a tonal drawing with sanguine

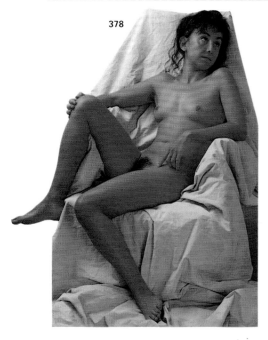
378

Pere Mon is a young artist who often draws nudes. His own particular treatment of the subject results in drawings that are vivid, ephemeral, and suggestive, in which everything is depicted with abstract shading and strokes.

This morning he begins by choosing the model's pose, the one you can see in the photograph. The pose appears to be natural and relaxed. After attaching a medium-sized sheet of paper to his drawing board, he arranges the materials he will use on the table: a pot of sanguine-colored pigment; sanguine, umber, and white chalk; charcoal;

flat brushes; a stump; an eraser... and right away the artist gets down to work. First he studies the model to decide on the composition. Then he starts to apply the dry pigment to the paper, using a brush and his fingers.

Pere Mon goes about this work by sweeping large brushstrokes across the paper to place the figure, blocking it in with curved lines, bringing out the main forms (see fig. 380). He uses his fingers and stump to spread the pigment, so that he paints almost the entire body, leaving the area of the face and breasts untouched, where the

Figs. 378 and 379. Here we can see the pose chosen by Pere Mon. Since the model is relaxed, the artist can spend more time on the picture. The second photograph shows the artist well into his work. Compare the relative positions of the model to those on the paper.

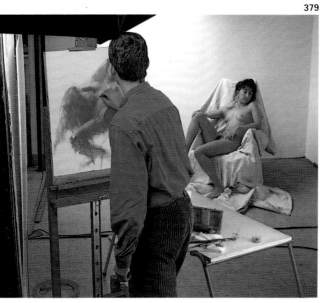
379

380

Fig. 380. As we have seen, like most artists, Mon stands while drawing. The first thing he does is apply abstract shading over the entire surface of the paper, placing the general form of the figure.

Fig. 381. Pere Mon basically works with sanguine pigment powder, which he spreads over the paper either with his hand or with a brush that he soaks in water to make the powder adhere to the paper.

Fig. 382. He uses a normal eraser to draw white parallel lines over the applied pigment.

381

382

lighting is greatest. He applies purposeful, rhythmic strokes that balance one curved line with another, covering the entire surface of the paper.

Note how the artist goes back over certain lines with chalk, first with sanguine, then with brown, to reinforce the parts that need to be darker–above all, the thighs and the body. He continues to use a brush to apply more moderate amounts of pigment in other areas, and uses each stroke to gradually define the shapes of the model. The painter also uses an eraser to remove pigment, but in the same way as he would paint (fig. 382), because this medium enables him to bring out whites. Mon begins to define the curved lines that represent the model's back, legs, and arms. He does not mind if these strokes penetrate the other parts of the model; he uses them as construction lines. Note in fig. 385 how the artist has "erase-painted" the illuminated parts of the hand and right leg, reserving specific darks in the adjacent areas while always allowing the previous application to be seen and even the white of the paper.

Fig. 383. We can see in this photograph the looseness of Mon's strokes. Nonetheless, despite the fact that the areas are still not defined, the pose and the lighting are clearly indicated.

383

384

Fig. 384. Little by little, Mon's picture acquires substance and weight. He superimposes shading with a brush, sometimes with pure pigment, other times with sepia chalk, in a way that gradually builds up open planes that are never precise.

Fig. 385. More shadows appear with the addition of ever darker color and the first use of sanguine: on the right side of the ribs and thigh we can now make out the right arm and hand, which receive more light. Pere Mon constantly compares all the figure's shadows and produces the volumes by darkening or lighting an area.

385

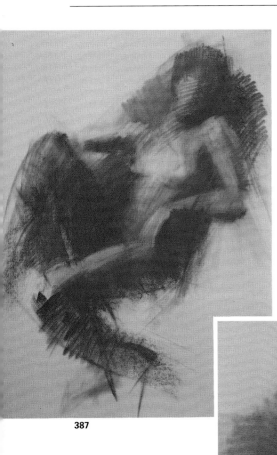

**387**

**389**

**386**

**388**

The next phase (fig. 387) of this process consists of adding new strokes, always using the shading technique by applying "brushstrokes" in the same direction. Mon paints them in the face and neck, even in part of the shoulders (fig. 386), spreading the color from right to left, thus creating a half-shadow. He also does it by mixing sanguine and umber together in the right leg, especially in the calf, relating its value to that of the thigh and thereby indicating the other part of the leg. At this stage the body and pose are defined; now it is time to work on various parts of the body.

Using the flat side of the sanguine stick, Mon shades the inner part of the left thigh, obtaining a more vivid color, as if to reflect the model's golden flesh. With the umber chalk, he begins to separate the figure from the background, drawing a series of diagonal lines "behind" the figure, on the left of the picture, and uses the same color to paint the hair and the darkest area of the head. Sometimes he leaves these lines just as they are; on other occasions he rubs them with his hand to create fluid, transparent shading.

Fig. 386. Here you can see the process of making diagonal lines by removing color (with an eraser) or rubbing and spreading it (with the stump).

Fig. 387. Pere Mon continues the diagonal pencil work that builds planes without edges, this time defining the right leg with sepia or, better said, beginning to place it. He applies the same color in the background, thus separating it from the figure while also complementing certain areas of the figure.

Fig. 388. Then the artist builds more small planes and draws finer diagonal lines in chalk.

Fig. 389. Note in the photograph how the right calf finally appears, with a slight suggestion of a foot.

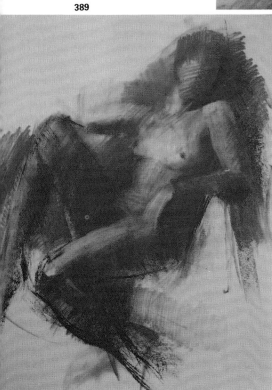

**390**

Fig. 390. Pere Mon continues using the same technique until the drawing is finished: loading pigment on a sometimes damp brush, thus obtaining extraordinary qualities and a highly unusual pictorial density. It is important, therefore, to see the long process of applying these layers, one on top of the other.

Fig. 391. Note the resolution of the right leg in the final drawing. Pere Mon uses a few rounded strokes with his flat chalk to correctly situate the forms.

**391**

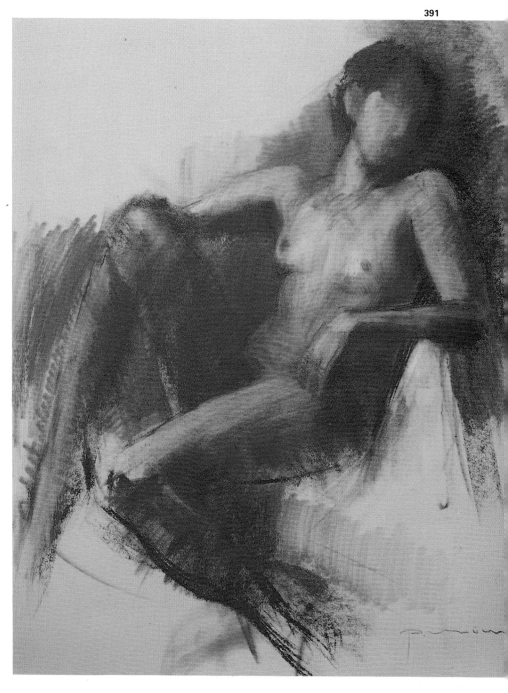

Note in the details and in fig. 389, with the drawing almost complete, how Pere Mon has finished defining the limits of the leg, back, and head with loose strokes of umber. Then he shades the left side of the drawing a little more, thus finishing the leg and merely suggesting the hand resting on the knee. Then he lightly erases the lighted area of the calf and defines the planes of the face and the ear. Finally, he "paints" with the eraser and joins the breasts, stomach, and thighs together (fig. 391). It is important to note the wealth of treatments the artist obtains with such simple materials. We congratulate him and thank him for his collaboration. And we hope that this work will inspire you, the reader, to draw with chalk.

# Esther Serra draws a nude in charcoal

Esther Serra is going to draw a nude in charcoal, using shading to construct the body. But the procedure this young artist is going to use is totally different from that in the previous drawing. Using charcoal, she will cover the entire surface of the paper with a rather uniform value that she will then erase. Let's see how she does it.

It is interesting to observe how Serra first chats with the model and helps him to find the pose, asking him to look from side to side, etc. It is important to freeze the model in the desired pose, in this case a classic, almost sculptural one, seated but active. The model is a rugged-looking young man. The artist attaches the paper with some drawing pins to the top part of the drawing board and then places it on the easel. This is an excellent way to draw (standing in front of an easel) because it allows the artist to distance herself sufficiently from the drawing and from the model.

Esther Serra's tools are also simple: charcoal, a rag, an eraser, and nothing else. Charcoal is an excellent medium for all artists, even if they are just beginning, because

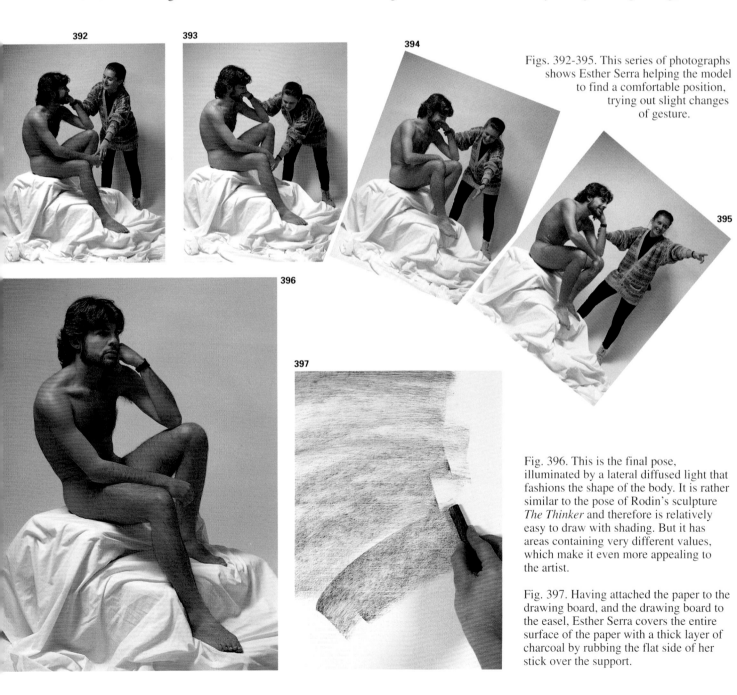

**392**

**393**

**394**

Figs. 392-395. This series of photographs shows Esther Serra helping the model to find a comfortable position, trying out slight changes of gesture.

**395**

**396**

**397**

Fig. 396. This is the final pose, illuminated by a lateral diffused light that fashions the shape of the body. It is rather similar to the pose of Rodin's sculpture *The Thinker* and therefore is relatively easy to draw with shading. But it has areas containing very different values, which make it even more appealing to the artist.

Fig. 397. Having attached the paper to the drawing board, and the drawing board to the easel, Esther Serra covers the entire surface of the paper with a thick layer of charcoal by rubbing the flat side of her stick over the support.

it enables you to apply and change values easily.

As you can see (figs. 397 and 398), charcoal allows you to shade and fill in large areas very quickly. At the same time, it is easy to erase and stump with your fingers or a rag. The fingers do not remove much charcoal; rather, they spread it over the paper, and that is how Serra will "paint" the entire surface of the paper, to lay a foundation to work from.

Although this drawing appears different from the previous one by Pere Mon, it is rather similar, because both drawings start with large planes that block in the figure. In this case, Serra creates the planes by removing color, that is, by drawing large white strokes that from the very start reveal the seated human figure. The white strokes are lifted with a kneaded eraser, but without rubbing too hard, removing only part of dark pigment on the first attempt. Then the artist picks up her charcoal and draws several rounded loose lines to block in the figure on the paper. She does not draw a silhouette but seeks it out with one or two lines. Having blocked in the figure (fig. 400), she continues drawing large flat planes with charcoal in those parts of the figure that are much darker in comparison, without including detail.

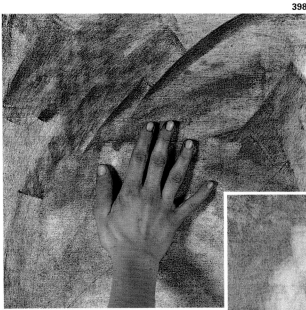

**398**

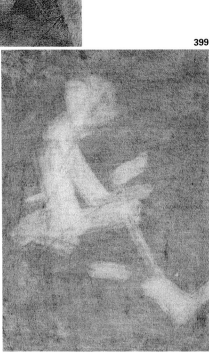

**399**

Fig. 398. Our guest artist astounds us by spreading and stumping over the previous layers, thus obtaining a uniform dark gray.

Fig. 399. Now Esther Serra is going to create a drawing in shadow, essentially, out of the gray of the background. She blocks in the figure by "erasing" pigment, drawing white areas with an eraser.

Fig. 400. These white areas locate the entire figure on the paper, and Esther draws a few fine lines to indicate the shapes of the body.

Fig. 401. Then the artist immediately returns to the thick charcoal to emphasize several very dark planes.

**400**

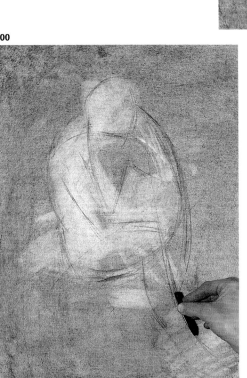

**401**

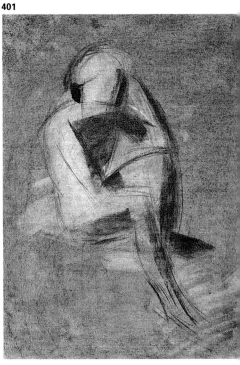

**402**

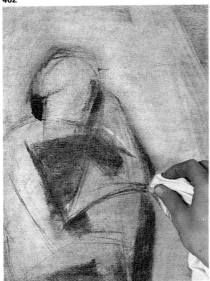

Fig. 402. Now Serra sees that the gray background is too dark, which reduces the possibilities of contrast in the figure, so she removes some of the pigment with a cloth.

Then Serra sees that the gray covering the paper is too dark, and so she must severely lighten the values of the figure. With her cotton rag in hand–a strip of an old sheet–she removes the excess powder, creating a much lighter gray while reserving certain areas of the first, darker gray in the figure.

Right afterward, the artist goes over the lightened areas with a kneaded eraser to clean them up some more, always leaving them in the form of abstract planes. She now chooses another of the few tools she is working with, the stump, and starts to relate all the grays of the body. She uses the stump to spread pigment, creating some new intermediate grays joining the whites with the blacks, thereby producing several transitional areas, but without losing the sculptural feeling of the drawing. In reality, Serra is draw-painting, as if she were constructing the figure with a series of planes, giving the picture a rather unusual weight and stability.

She does not stop to work on details or the outlines of silhouettes; instead, she concentrates on values, placing a light one here, a darker one there. As the artist creates smaller planes, the body's elements appear to emerge on their own accord. Small dark squares, small white and intermediate gray strokes convey the volume, thus giving the body a sense of sculptural solidity.

In the last stage of the drawing, Serra concentrates on the sheet on

**403**

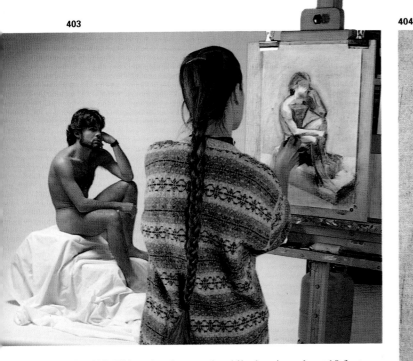

**404**

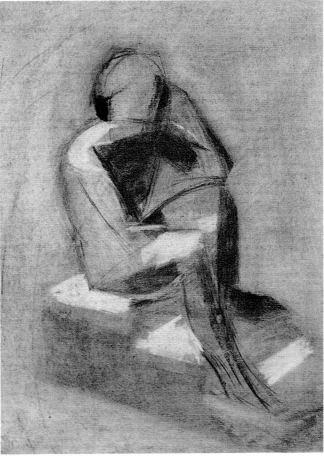

Fig. 403. This artist also stands while drawing, about 10 feet (3 meters) from the model, sufficient to see the entire model without any distortion, which, on the other hand, might be perfectly valid.

Fig. 404. Now that Esther Serra has lightened the gray background, she needs to create lighter areas on the figure. She carries out this task with a kneaded eraser, without detailing any specific part of the anatomy.

405

Fig. 405. The artist uses a stump, as well as her fingers, to spread the pigment. The difference between the two is that the stump is better at spreading pigment and can be used to paint in linear strokes, whereas the fingers pick up too much pigment, due to the oil on the skin, which finds its way onto the paper and consequently hinders the application of charcoal.

406

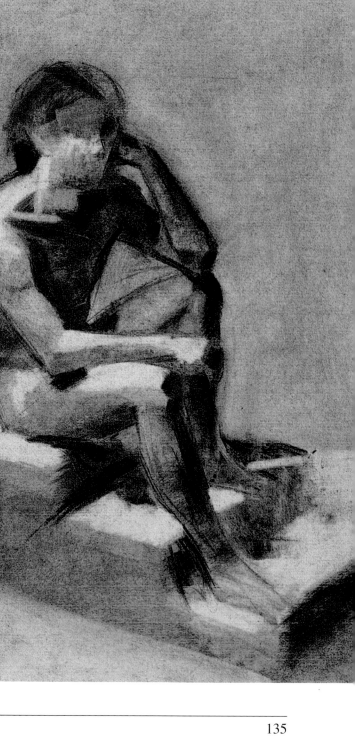

which the model is seated and gives it a slightly different treatment. She applies loose strokes, both white and gray, to express the different surfaces and enrich the drawing.

The artist has also rounded the figure, giving it muscles, shaping the legs and arms, and she even applies some light touches to the face, without going into any detail and without losing sight of the main interest of this picture–the comparison of values. Thank you very much, Esther.

Fig. 406. Serra leaves the drawing like this. It is still in an abstract stage, although the male figure, the pose, and the lighting that conveys the volumes can clearly be made out. However, there is no detail–all the work has been accomplished by using planes, which the artist gradually reduced in size.

# Miquel Ferrón executes a drawing in charcoal, sanguine, and chalk on colored paper

**407**

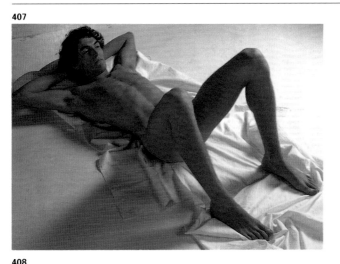

Fig. 407. Ferrón has asked the model to lie on his back with his hands supporting his head, his legs bent and slightly open. The concentrated light produces a very interesting contrast.

Before Miquel Ferrón draws the following picture, we ask you, the reader, to consider drawing's many aspects: from blocking in to lighting. You will then see how this drawing follows a classical technique that allows you to see the whole process as well as how rich color is obtained with a few simple materials.

The drawing is going to be large, 39 3/8″ × 27 1/2″ (100 × 70 cm), and for that reason the artist must spend some time observing the pose and deciding on the composition (taking full advantage of the large format, so that the figure will be as big as possible) and the integration of forms before he places the first lines on the paper (the straight lines joining the elbows, knees, and feet in a square shape in fig. 408).

Ferrón then lightly "erases," or softens, the first lines with a rag (fig. 409), so that he uses the sanguine without dirtying the paper. We can see this process in the adjacent images (fig. 410). The artist's lines define the form, and he even indicates the separations between light and shadow (fig. 411). Then Ferrón shades in the area in shadow with an almost uniform value (fig. 412).

**408** **409**

Fig. 408. Using a piece of charcoal, Ferrón first blocks in the figure with a few lines that connect the elbows and other parts of the body through geometric forms.

Fig. 409. Then he half-erases the drawing and draws another one in sanguine chalk.

**410**

**411** **412**

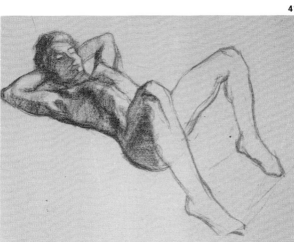

Figs. 411 and 412. The artist finishes drawing the outline in sanguine, constructs the musculature, and outlines the separations between light and shadow; then he softly shades the area in shadow.

When the illumination of the figure has been correctly defined, the artist uses the same sanguine to intensify the darks in certain areas (the model's left leg, etc., fig. 413), at the same time using his fingers to lighten the values in other areas (fig. 414).

In figs. 415, 416, and 417, we can see how Ferrón uses the charcoal and gray chalk (for the shadow on the sheet, which extends onto the torso and legs), the cloth to blend this mixture, and the yellow ocher chalk to highlight the most brightly lit areas.

**413**

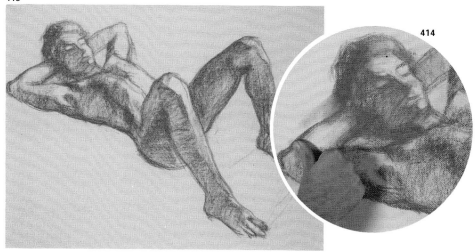

**414**

**415**

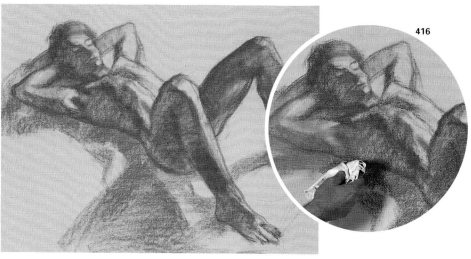

**416**

**417**

Figs. 413-418. Although it is best to read the discussion in the main text, note the process of the first shading. The artist has carried out this task using his fingers to stump by superimposing ever-darker layers in certain parts. Ferrón uses gray chalk to shade the sheet, and white and ocher yellow chalk to highlight and define the lights that project from the background of the paper.

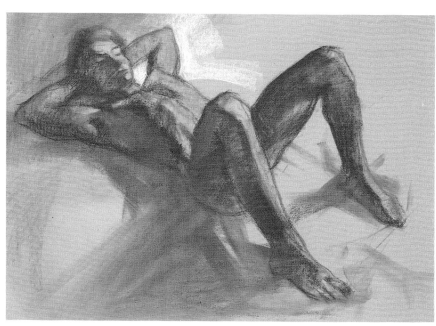

**418**

# Ferrón continues drawing

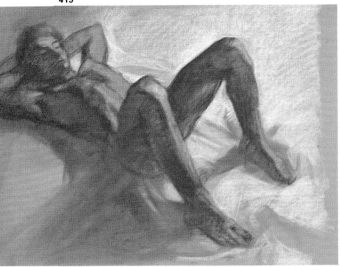

In fig. 419 we can see that the next stage is to add some white for the background on the right, since the composition lacks a horizon, reserving the color of the paper for creases and shadows. Sanguine is added to the intermediate tones of the body, such as the face, legs, and right arm, and black is applied over the shadows cast by the body on the sheet.

The artist then shades several light but perceptible areas of black and gray both on the body and on the sheet, all the time searching for an improved valuation, a correct adjustment of shadow tones. Every now and again, he darkens the shadows in a particular area gives them sharper definition (fig. 420). Ferrón bravely darkens the left leg, the right shadow (fig. 421), and the small shadows on the left shoulder, face, and torso (fig. 422). The important thing is to compare all parts of the body–we keep repeating this–by squinting. This will allow you to see, for example, that the shadows of the legs are not as dark as the hair or the dense shadows of the sheet (fig. 423). This way you will finally construct a result as complete and attractive as this one (fig. 424), in which we can see a beautiful drawing with a

Figs. 419-421. Layer by layer, the drawing advances. The artist continues using the same colors, allowing the previous colors to be seen. The planes of light and shade are clearly discernible, but the shadows are not dense, since the sanguine can still be seen underneath. Then he works on the face and the right-hand side of the figure (for the most part in shadow), differentiating the legs with a dark brown color.

Fig. 422. In this photograph we can see the development of the drawing through the soft shadings, and above all in the contrast between the two legs; the one on our right is much darker because it receives backlighting. But Ferrón does not shade it in a uniform tone; he defines the volumes instead.

great range of tonalities (blends of colors that construct transparent shadows, whether reddish, bluish, or violet), which perfectly convey the body and the pose, the light that illuminates it, and the volume that even appears to approach the viewer. An excellent work. Many thanks, Miquel Ferrón. We hope the reader has also managed to study the process in the photographs in greater detail.

Figs. 423 and 424. To finish the drawing, Ferrón applies gray and black chalk, going over the shaded areas in the model's left leg, torso (even over the lights), right arm, and head, thereby obtaining somewhat cooler shadows.

**423**

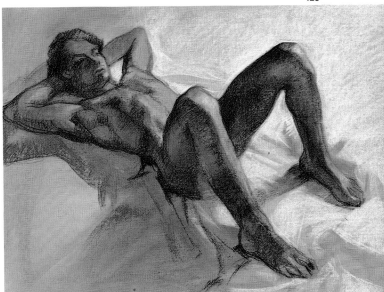

**424**

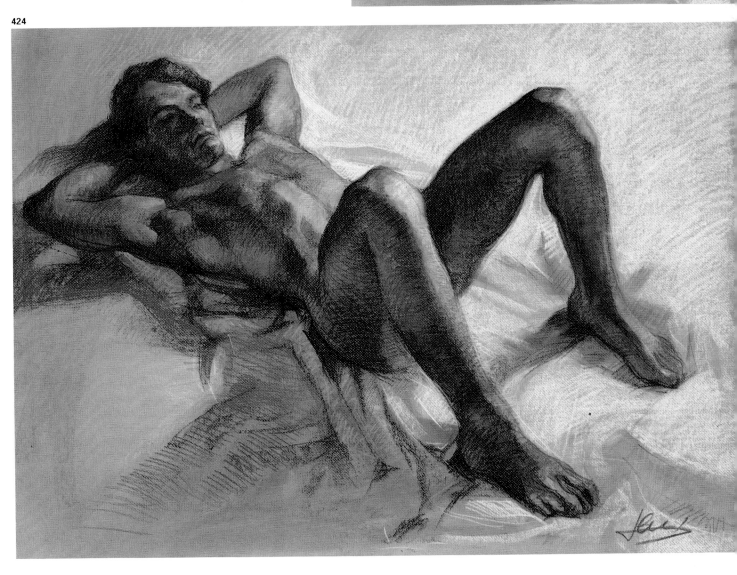

# COLOR AND THE NUDE

In this chapter we will be concerned with the subject of color. Forget the idea that a nude can only be painted with flesh colors. There is no one single way of painting. It is the artist who finds his or her own colors, harmonies, and contrasts, the musical harmony that gives life and expression to nude paintings.

Fig. 425. Detail of a color study in oil by Muntsa Calbó. It is evident that the study was painted with rapid brushwork to test the relationship of colors, which we are going to address in this chapter. In this case, the dark warm colors of the body create backlighting by contrasting with the lights and blue of the background.

# An introduction to color

Some may consider that in painting the nude, color is just a question of formality because the variations are apparently limited, something that is not so in landscape or still life painting. This presumption is only half true, first because the range of flesh colors is extremely wide, even unlimited; second, because the 20th century has witnessed the possibilities of painting with just about any color, without maintaining naturalism; and third, if Delacroix was right when he stated, "Give me mud and I will paint the skin of Venus," the question immediately becomes more complex with the problem of color harmony.

Therefore we will briefly study the fundamentals of color theory, essential for gaining a foothold in the world of painting. The color of objects depends on the kind of light they receive. White light comprises the color spectrum we all know: the rainbow. The color of an object is not exactly its own; objects are made up of substances that absorb and reflect colors.

426

427

Figs. 426 and 427. The result of mixing primary colors (yellow, blue, and magenta). The first shows the result of mixing two colors; the second shows what is obtained when mixing the three together.

Fig. 428. Neutral, or "broken," colors are produced by mixing two complementary colors together (those that lie directly opposite each other on the color wheel) and white; but combinations of varying quantities provide countless variations.

Figs. 429 and 430. The first illustration is a value scale showing the same color with greater or lesser intensity. The second shows the complementary pairs green and magenta, orange and blue, and violet and yellow.

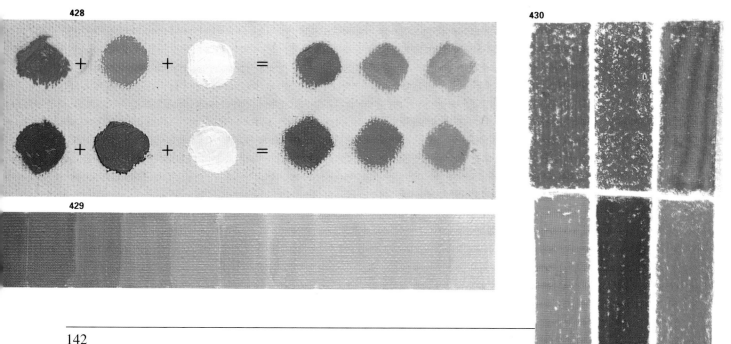

428

429

430

What we really need to know is how so-called color pigments work. That is, the color we use and the pigment through which we apply a tone on the support. The first point is that all colors can be obtained from three, and these three colors cannot be created by combining any others. They are the primary colors: yellow (yellow), blue (cyan), and red, or magenta (in painting it is carmine). If we mix any two primary colors together, just as we have done in fig. 426, we get what are known as the secondary colors: green, orange, and violet. By mixing primary colors with secondary colors, we obtain the six tertiary colors: red-orange, blue-violet, etc. All such mixtures are pure, meaning they contain no white or black. *Hue* is the term used to describe a pure color, and is simply the color's name, such as blue or blue-green. The relationship among the primary, secondary, and tertiary colors is commonly illustrated by a color wheel.

If we mix the three primary colors together, we get black. Likewise, if we add a small amount of a primary color to a mix of the remaining two primary colors, the result is a neutral, or gray, because it takes on a blackish tendency. On the other hand, white lightens color. Sometimes it is only necessary to add light to a color; for example, in watercolor we add water and therefore luminosity. Consequently, a tone can be gradated from black to white. This characteristic is known as *value* (see fig. 429).

It is easier to see value by squinting your eyes, thereby seeing only the "light" of objects and ceasing to see the colors. This way we better see which area is light and which is dark, with a range of intermediate tones or grays.

Every color has an opposite, or complement; yellow and violet are complementary colors, because violet is composed of blue and magenta and contains no yellow. In the same way, green and magenta, and blue and orange, are complements (fig. 430). The maximum contrast that can be obtained is between complementary colors.

**431**

**432**

Fig. 431. Edgar Degas, *The Baker's Wife*. New York, Metropolitan Museum of Art. In this pastel painting, the skin colors are neutral flesh colors, which together give the painting its warm harmony.

Fig. 432. Paul Gauguin, *Manao Tupapán* (*The Spirit of the Dead Is Watching*). Buffalo, New York, Albright-Knox Art Gallery. Although the body is painted with dark warm tones, the contrast is accentuated by the complements.

# Color relationships

At first sight, color may seem tangible and exact, but in reality it is subjective and relative. It is difficult to agree on color; it is also difficult to understand what Delacroix meant in that famous phrase. That is precisely the point: color is relative. There is no such thing as an independent color; one color ends where another one begins. Color is defined according to the colors that surround it. A color may appear completely different if it is surrounded by "similar" tones or totally distinct ones. The same color changes its aspect if we paint cool or warm colors around it (figs. 433-435). This is the reason why, when painting a picture, we must have the entire canvas in mind. We must paint, at least in our heads, all the colors at once. It is not a question of choosing a flesh color but of choosing a range or deciding on the contrast we wish to create. And when considering one or the other of these two questions, all colors must be taken into account, not just one.

For example, we tend to believe that red expresses passion. If we paint a picture using only reds, pinks, and oranges, we obtain a sensation of warmth but not strength. If, on the other hand, we contrast a nude in red with some strategic greens and blues in the background, around the figure, in the shadows, we immediately obtain a strong contrast that conveys energy, passion, and nerve. Color harmony is based on the relationship of similar colors; contrast is based on complementary colors, in the difference of color and value. We will examine this subject later in the book.

For the moment, let us look at one aspect that is important for beginners to painting: the color of shadows, especially when we are

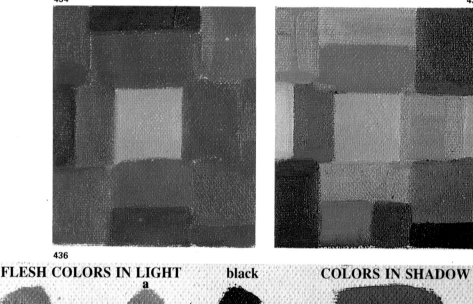

Figs. 433-435. See how a color (pink in this case) appears different according to the colors surrounding it.

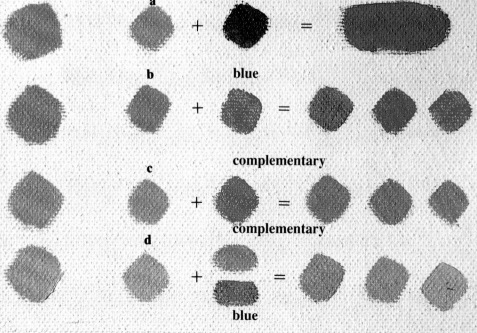

Fig. 436. On the left, we have provided a few flesh colors; on the right, colors in shadow, which are obtained (a) by adding black; (b) by adding blue, which in greater or lesser quantities produces different colors; (c) by adding a complementary color, with or without white, which in varying proportions produces different colors; (d) by adding blue and the complement corresponding to the flesh color, also in differing proportions.

**437**

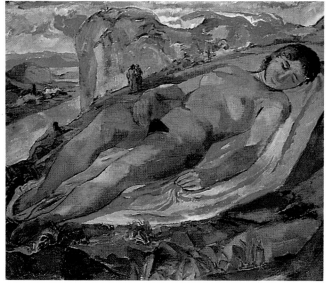

Fig. 437. Albert Weisgerber, *Woman Resting in a Mountainous Landscape.* Munich, Neue Pinakothek. In this painting, we can see how a perfect pictorial interpretation of shadows is obtained by adding blue.

dealing with the human body. In reality, the shadows of the body are no different from those of any other subject, as long as we do not use heavy, dense, or blackish tones on a light skin. This would only dirty the painting instead of darkening it. But despite this, the color of a shadow is sometimes painted with its complementary color; on other occasions, with the same color (in light) mixed with the complement; or sometimes with blue added to the color or to the local color. Another way is to paint directly in blue. You might also try adding black; there are numerous possibilities (fig. 463). The worst thing to do is to add black to a color; only do it when it is absolutely necessary.

If the painting is colorist or expressionist, the shadows will probably be painted with a more or less mixed or toned complementary color to create contrast. If you are using a range of flesh colors and want to obtain a natural effect, add a little blue and a small amount of the complement to the local color you are using in the illuminated areas. Then check to see if that color needs to be lighter or darker, and add the chosen color until you obtain the desired value. Make sure the colors you add are clean, such as yellow, green, blue, sienna, or violet. Last, if you need to neutralize the color, add white to lighten it and black to darken it.

**438**

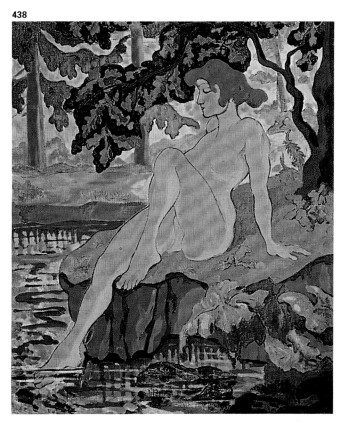

**439**

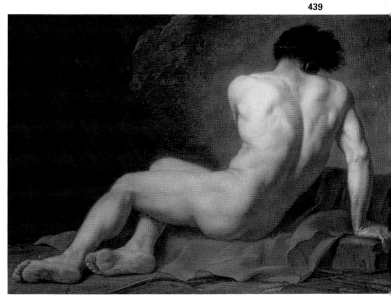

Fig. 438. Paul Ramson, *Bather,* 1890, 24″ × 19 11/16″ (61 × 50 cm). Rome, Levante Gallery. This artist chose the complement of the orangish skin tone to paint the shadow.

Fig. 439. Jacques-Louis David, *Academy of a Man Named Patroclus,* oil. Cherbourg, Thomas Henry Museum. The shadows are neutral and result from a mix of black, blue, and umber colors.

# Muntsa Calbó i Angrill paints color studies in oil

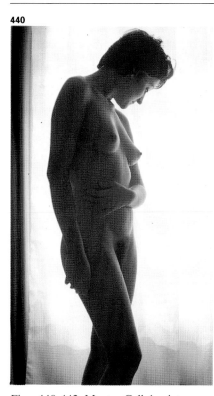

The pose, the composition, and the light are essential elements in a nude painting, but they are by no means the only ones: there is still the question of interpretation, the possibilities of which are almost infinite, depending on the medium, color, and so on. Don't think that the model and the light will decide for us (do you believe that Kirchner's figures had blue streaks in reality?). It is the artist who gives substance and meaning to the picture he or she is constructing, even if merely copying what he or she sees.

We will continue examining color by concentrating on the nude subject, a genre that may appear somewhat limited in this sense, but if you look at some of the paintings reproduced in this book, you will see that it all depends on the artist's free will, his or her sensitivity, a momentary and subjective vision, and so on.

Muntsa Calbó has painted several studies based on the model posing in the backlighted setting in fig. 440. This exercise demonstrates the expressive possibilities of color, without going into the subject of the drawing, the composition, or possible expressionist foreshortening. The artist has made no attempt to exploit all the possibilities. Her only intention is to demonstrate that this model in backlighting can be painted in countless ways.

Calbó has chosen to paint in oils,

Figs. 440-442. Muntsa Calbó paints a model bathed in beautiful backlighting. To start, she executes several color studies to find the combination that seems most suitable. In the one on this page, she paints with broken colors, adjusting them as much as she can to reality.

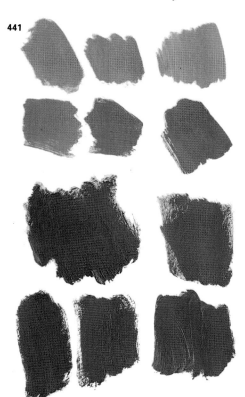

an extremely suitable medium for color studies because all the mixtures can be tested quickly using the artist's intuition.

Figure 442. This is the result of the first study. You can see most of the colors the artist has used. Calbó has painted this study from nature with warm tones, using them to create a luminous contrast. Note that these paint colors are much warmer than the skin tones of the model herself, although most have been modified somewhat. Most of the colors result from mixes of burnt umber, transparent terra rosa, deep madder, yellow ocher, and white, with small amounts of emerald green, violet, and cadmium red.

Figure 444. Having cleaned the palette, the artist starts a new study. This time she plays with the background color, reinterpreting it with very pure cool blues, which equally express the light contrast. The colors of the body are cooler than the previous ones, starting from mixes of carmine, violet, transparent terra rosa, a touch of ultramarine blue, and white. Nonetheless, when they are contrasted with the blue background, they acquire a warm, reddish aspect.

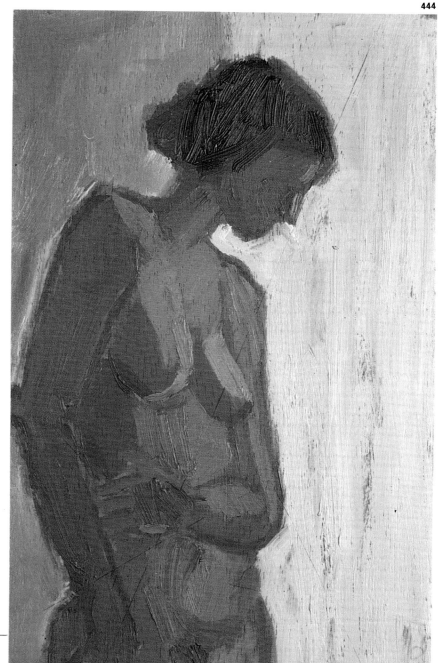

**443**

**444**

Figs. 443 and 444. The artist tries out a combination of warm colors, but rather natural flesh colors, contrasting them with several very pure and cool blues for the window through which the light is shining. This is a good solution, partway between a realist and a contrasted interpretation. If the blue were yellow, the result would be totally different.

**445**

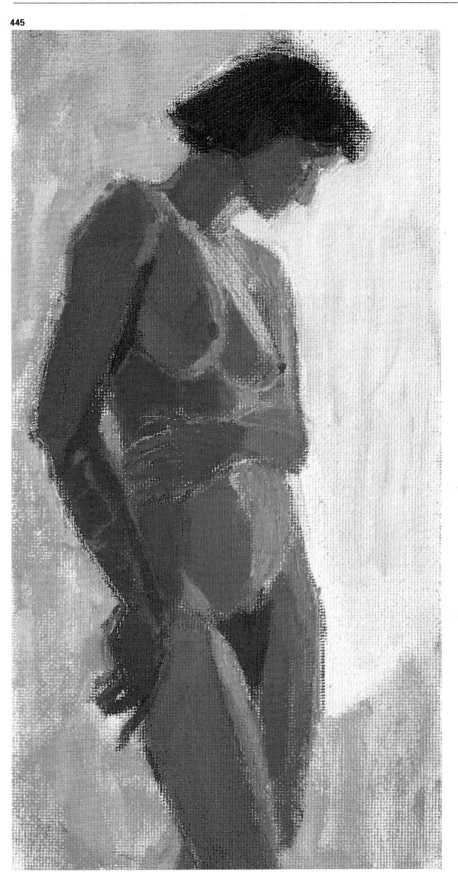

Figure 445. This study was painted in an elongated format, this time with a range of decidedly neutral and cool colors including violet and some neutralized blues, with a touch of pink (mixed from red, orange and white) for the highlights. This is a harmoniously sensitive study in terms of the grays supported by the neutral white of the background.

Figs. 445 and 446. A new color study, similar to the first one but this time with a cool broken range; these cooler neutrals are appropriate for painting flesh in backlighting conditions. On the other hand, the background has been painted with a neutral white and a somewhat warmer grayish tone to contrast with the body.

**446**

Figure 447. In a totally different approach, here the artist has sought an interpretation based on color contrast (complementary colors). The light is expressed with pure yellow, which resonates with the greenish blues of the part of the figure in shadow. These blues and greens complement the reds and oranges that express the illuminated areas. There is a maximum contrast of warm and cool colors, and if you look at the picture by squinting your eyes, you will also notice that this contrast creates very accurate volume and light.

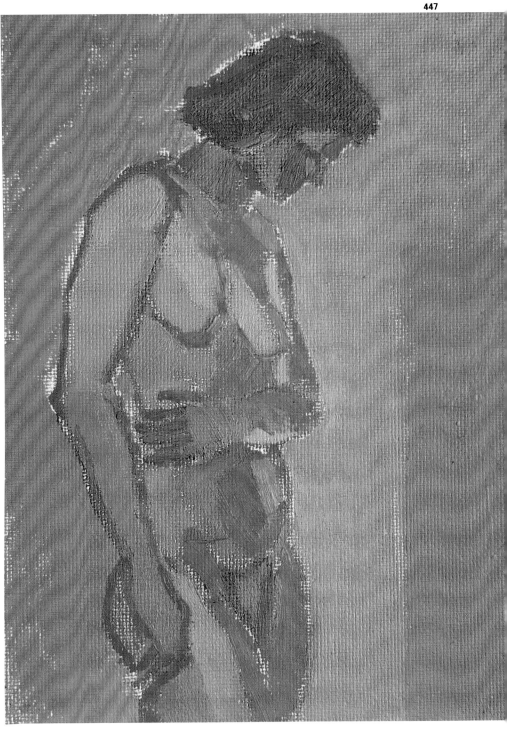

**447**

Figs. 447 and 448. Here the artist tries to see what the result would be with a maximum color contrast, that is, a contrast of complementary colors. Each color's complement is practically juxtaposed: blues and greens against oranges and reds. The artist has painted the background yellow on the blue side and green on the red side of the figure, thus obtaining a series of pure and vivid colors. Note that she has not forgotten values, since the colors are perfectly situated on a light to dark scale, which correctly express the figure's volumes.

**448**

Figure 449. This is a less academic color contrast than the previous one. Nonetheless, the result is just as powerful, vivid, and expressive. Blues, violets, and greens complement the very pure yellow light. The neutral colors, which take on a cool tendency in the interior of the body, soften this contrast and give the figure a more sensitive expression. The contrast in this picture is obtained thanks to the presence of yellow, the complement of blue. Although in this case the colors used are rather pure, you can also create contrast with more modified colors, as long as they are supported by their complements. Try painting a few studies yourself using two contrasting colors (green and red, for example).

**449**

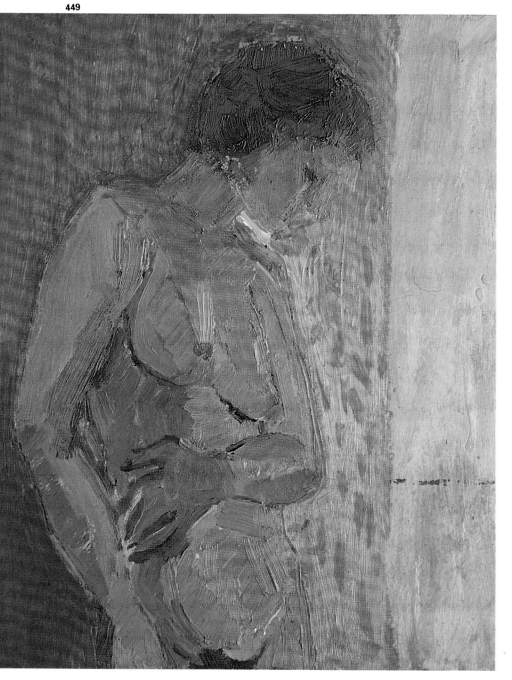

**450**

Figs. 449 and 450. Muntsa Calbó continues working with complementary colors that also possess a warm-cool contrast. This time the colors chosen are yellow and blue. However, she needs a few broken colors, mixes of yellow with blue and a touch of white, so that the result will not be too hard. She plays with these same colors in the background, which she divides into two parts to give more feeling to the square format. A reddish touch is applied to the hands because the painting requires the presence of the three primary colors in different proportions. The artist finds this study rather pleasing, like the first one (fig. 442).

Figure 451. In the last study the artist uses greens and reds that are adjusted to the flesh colors. The contrast of these two colors makes the painting particularly evocative without appearing loud (which happened in fig. 447). The result is frankly attractive, even moving in its simplicity.

This is an exercise that all artists should do occasionally to remember that it is he or she who interprets the subject. Note how each combination, each harmony, says something different: sadness, loneliness, strength, desire, anguish, madness. Color defines, once and for all, the artist's expression in drawing or painting the nude.

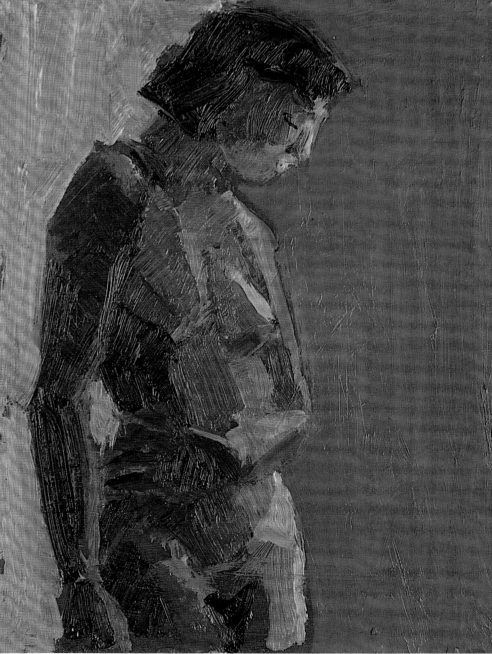

**451**

**452**

Figs. 451 and 452. This is the last color study: a combination of complementary colors but much more toned and less pure. The effect this time is much less strident. The basic colors are red and green, but both of them appear in the form of opaque and toned umber, carmine, pink, orange, and green colors. Note the number of variations that can be obtained. Everything depends on the artist's imagination. Try this exercise with any subject.

# The value of color

453

454

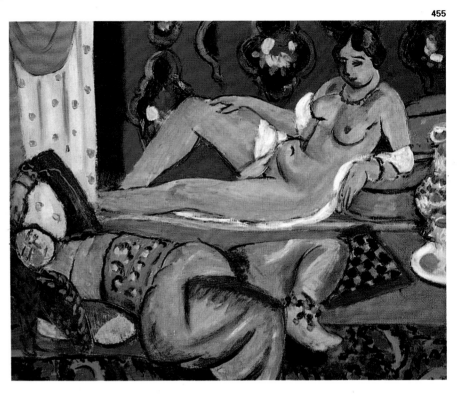

455

Now that you have seen that color is, above all, a problem of relationships, style, and mood, let us now turn to another aspect of color: value, which we briefly mentioned before. Many artists are not so concerned about a chosen color's hue as they are about its relative lightness or darkness with respect to their subject.

In effect, if we are especially inter-

ested in expressing the volume of forms or simply the light (which is the basis of painting), or if we

Figs. 453 and 454. These two ranges show the characteristics of colors on a value scale.

Fig. 455. Henri Matisse, *Odalisques,* oil on canvas, 21 1/4″ × 25 1/2″ (54 × 65 cm). Stockholm, Modern Museum. The body has been painted with values of one color.

456

Fig. 456. We can express volume with values, using only one color and gradating it from light to dark. Naturally, this method can be used to paint the human body.

want to paint objects with their natural colors, value is an essential factor. The truth of the matter is that it is not possible to paint well if one does not know how to compare values. The best way to practice value control is to create pictures with only one color, using gradations from white to black or light to dark. This compels us to translate any color from reality into a gray, which only makes sense if it has enough light with respect to the other colors (values of gray).

When we have a palette loaded with colors, the question becomes more complex but the problem remains the same: that of being able to compare all the values of a subject and translate them into any color range. See how the volume of a form (the cylinder in fig. 456, for example) can be expressed on a two-dimensional support with the correct color gradation. The same can be applied to the human body, which can also be considered as a series of cylinders.

This treatment brings us to the problem of so-called flesh color, since there is no such thing. There are too many flesh colors to speak of a single solution.

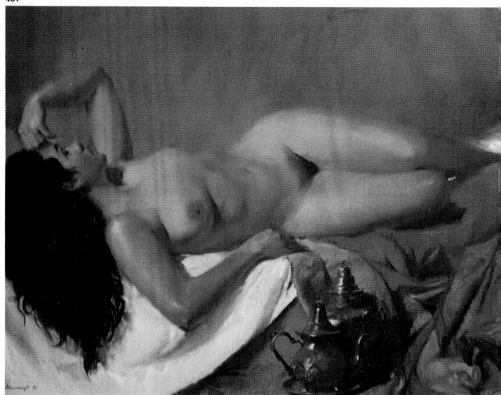

**457**

**458**

Fig. 457. Santamans, *Nude*. Private collection. This modern-day pastel painting comprises a classical pose that has been given an academic treatment, using flesh colors and expressing volume with values in the same range.

Fig. 458. Flesh colors in pastel can be purchased in separate boxes or with mixed ranges.

# The color of flesh

**459**

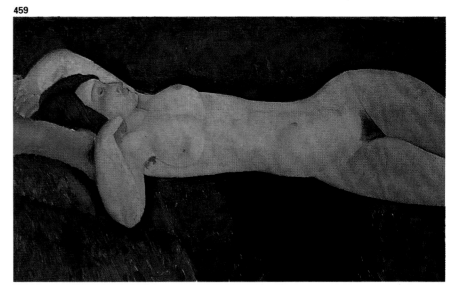

Every artist has his or her own way of painting the color of flesh (it is not uncommon to find violet, orange, or green figures). If we do try to paint a "white" skin in orange or pink, we are venturing rather far from the true-to-life idea of color. Therefore we should consider that flesh colors are neutralized mixtures that always contain a touch of white and the complementary color. Of course, everything depends on the medium you are using to paint, as you will see shortly.

An excellent medium for obtaining realistic skin colors while evaluating light and shadow correctly is pastel, because there is a wide range of colors to choose from. There is a color available for almost every skin hue, even in shadow. They are sold in special boxes labeled "flesh colors."

With oils the question becomes enormously complex, since they can be mixed in a thousand and one different ways; therefore the choice becomes personal. We have asked our artist friend Vicenç Ballestar to provide us with several possible mixes to obtain the color of various flesh colors (fig. 460). By using these mixes as a starting point, you will discover that by adding white, orange or ocher, blue, red or umber, it is possible to create an almost infinite range of flesh colors.

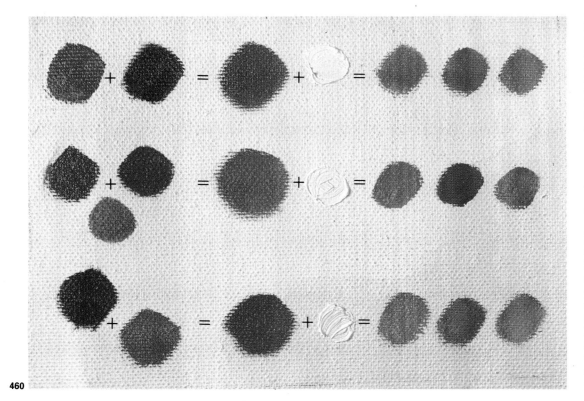

**460**

Fig. 459. Amedeo Modigliani, *Nude Resting,* 1919, oil. New York, Museum of Modern Art. This nude was painted entirely with flesh colors.

Fig. 460. We can obtain flesh colors by mixing, for example, blue and sienna with a quantity of white; by mixing colors like pink, ocher, and orange with white; or two complements with white.

**461**

You must decide immediately if you need a little more turquoise blue to obtain a silver-toned flesh color, or a touch of sienna to give flesh a dark intonation, brown and reddish at the same time. Always consider the possibility of mixing color from the start (ocher, red, yellow, pink, carmine...), adding a complementary color (green, blue, violet...) and a touch of white. You will almost always acquire a tone that you can use to start looking for variations. Try adding pure colors before adding black or white. The same goes for watercolors and other mediums, although the problem is not identical. On the one hand, the possibilities in watercolor are somewhat more limited; on the other hand, white is water, that is, the luminosity of a color is increased by adding water. Mixing is slightly more difficult than with oils, but it has the advantage of producing much cleaner colors and more transparent colors, something

that is not possible with oil paints. We have asked Ballestar to mix some colors for us to start painting with, to discover which type of

colors we can mix together and, if necessary, add water in greater or lesser quantities to each one of them.

Fig. 461. William Orpen, *The Model,* 1911, watercolor. London, Tate Gallery.

Fig. 462. Flesh colors in watercolor are obtained by mixing colors as distinct as green, orange, and red; or the three primary colors; or blue and sienna. All of these in varying amounts with water produce countless possibilities of appropriate flesh colors.

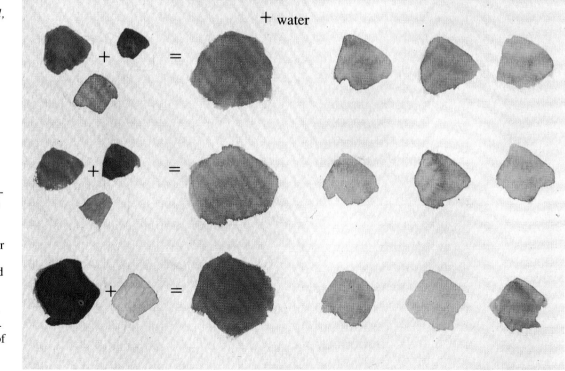

+ water

**462**

# Miquel Ferrón paints a nude in oil with flesh colors

We have already seen Miquel Ferrón execute an oil painting and several studies earlier in this book. We have managed to persuade him to paint another nude so that you can follow the process by way of the photographs. Luckily, Ferrón is accustomed to our insistence and our continual and necessary interruptions.

So Ferrón sets up the subject. He has already chosen the model and now arranges a large bed with a mirror on the right–the mirror is used to take advantage of the reflection for artistic purpo-ses–cushions, a curtain for the background, several flowers, etc. Then he explains to the model what kind of pose he wants: sitting with her legs tucked under her thighs on the bed, with her arms crossed, facing the artist. It is an original pose, somewhat

463

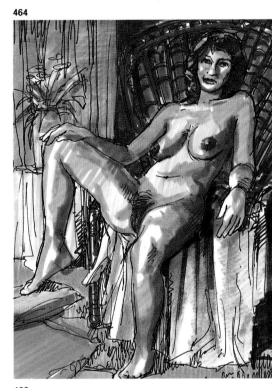

464

465

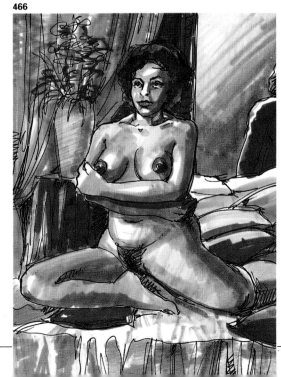

466

Figs. 463-466. Miquel Ferrón works with the model in exactly the same manner we described previously: by speaking to her and explaining the type of pose he wants, helping her set up the place where she will position herself, in this case, on a bed next to a mirror, with some curtains behind. As the model tries out various positions, Ferrón makes color sketches, studying the composition and the possibilities offered by these poses. Using felt-tip pens, he looks for a provocative pose. Finally he chooses the one we can see in fig. 466.

provocative and assured at the same time.

Ferrón always starts by drawing with charcoal on canvas, in this case using a "figure" format canvas. Note the differences in the composition between the first sketch and final drawing: in the first, the figure appears much smaller, but Ferrón is interested in the nude and decides to change it. He draws with wavy lines, using the flat side of the charcoal, searching out the powerful curves of the legs, constructing a symmetrical triangle that forms the figure. Then he draws the arms, the breast, the stomach, and the pubis, leaving the head for the end, and then adds a "touch" of the background, at the same time drawing the back reflected in the mirror.

When you set up a subject like this, remember that the beauty of the furniture, the cushions, or the curtains is not important. A positively ugly vase can provide us with a very aesthetic detail. Moreover, once the composition has been chosen and even when we begin to paint, we are not required to be faithful to our idea; we can add colors, tones, and so on, as we wish. The plan we start off with is merely a guide, not a limitation. We can even change the model's flesh color, as long as it does not stray from the final result of the picture.

Here we will see how Ferrón carries out the most important part of his work (with respect to the color), because this stage is the

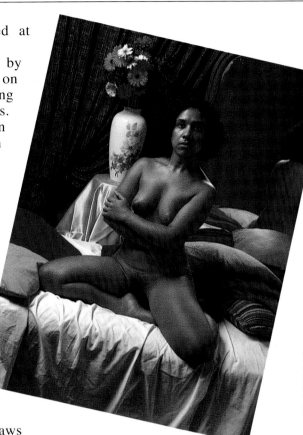

Fig. 467. This is the photograph of the pose and the setting around the model. Soon we will see how the painter deals with them, what colors he chooses and how he begins.

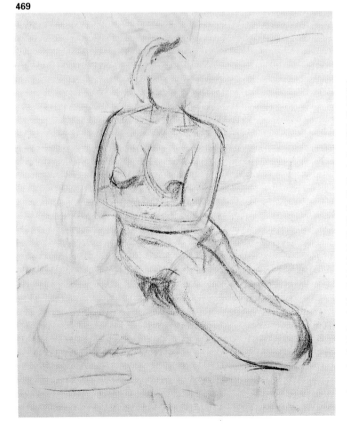

Figs. 468 and 469. Having studied the composition in the previous studies, Ferrón begins to drawn on canvas with a charcoal stick. In spite of the studies he has drawn, the artist recomposes the drawing because the first blocking in (fig. 468) includes more of the scene than the model; the nude would have appeared tiny and insignificant. So the artist erases the first lines and starts over, placing the body in the correct position.

**470**

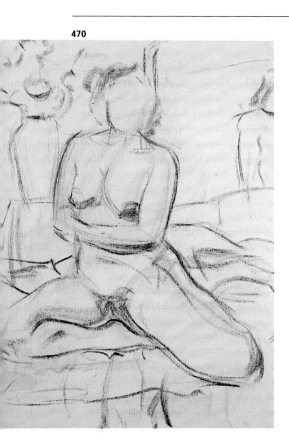

Fig. 470. The artist draws with charcoal, stumping and erasing with his fingers, going over some of the dark areas, without adding any details to the head, hands, or background yet, for the moment only concentrating on the elements as a whole.

Fig. 471. After wiping the surface with a rag to remove excess pigment, Ferrón paints with turpentine using two basic colors: ultramarine blue deep and burnt sienna, which he uses to create a multitude of cool mixes for painting the background.

Fig. 472. With the same colors as before, this time adding some white to obtain a pinker but still cool result, the artist paints the body with directional strokes on the different planes.

moment when he will decide on the harmony. The end of the painting, the fact of completing it, is almost a consequence of this preparation instead of simply being a goal. It is very interesting to observe that despite the evident "warmth" of the theme, composed of reds, umbers, and yellows, Ferrón paints with cool colors, such as silvery blue and violet. He paints a few shadows mixed with turpentine in the background, painting into what will eventually become the hair; then, with a brush loaded with violet, the artist redefines the shape of the head.

**471**

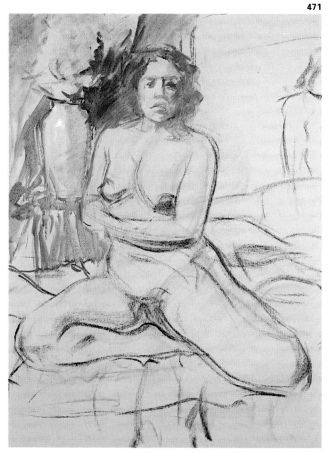

**472**

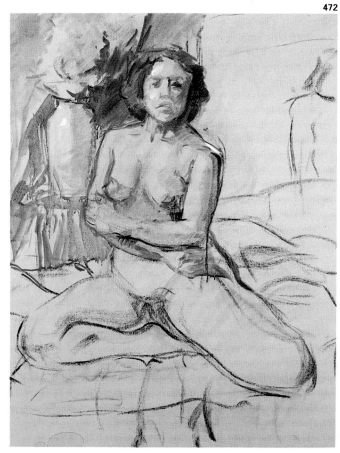

Working rapidly, almost as if he were going to color in the entire canvas at once, Ferrón prepares some exquisite violet mixes–a touch of carmine, a little white, a dab of blue, on occasion some burnt sienna, all very light–which he uses to paint those parts of the body in half light, expressing from the very outset the values as well as the volume of the figure. He does this by applying wide parallel strokes that construct planes (see the legs in fig. 473). Continuing at the same pace, Ferrón adds some orange with white, a pale warm pink, to the mixes, which he applies directly to the canvas in the most illuminated parts of the figure. He even adds a white, cold stroke in the right shoulder.

Ferrón has the figure under control, so he moves on to the background, first adding light strokes of clean colors to the flowers and cushions, and white to the sheets, but allowing them to "dirty" with the warm colors. The artist paints with turpentine in the area of the mirror. Note how the flesh colors appear different from those of the previous stage simply because they are surrounded by new colors (fig. 474). They seem much cooler and opaque. Precisely for this reason, Ferrón starts mixing reds and oranges with white again, and the same with carmine and violet, and applies them to the body in order to increase the contrast. The pubis and the shadow of the right leg are painted in yellow and sienna. The painter leaves the violets in the face, but adds pink and red in the lighted area. All the colors used comply to a cool tonality, maybe because of their relationship to the surrounding reds and yellows.

As we mentioned, the most critical part of this picture was executed in the previous stage. The

**473**

Figs. 473 and 474. Note the pinks and oranges in the illuminated areas, comparing them to the violet zones. Next, the artist begins to stain over the turpentine in the background with bright and warm colors.

**474**

**475**

Fig. 475. In this detail we can see how Ferrón uses a wide and rather thick brush to apply denser applications over the lights of the face and neck, thus obtaining flesh colors with the mix of orange, ocher, and white, with a few touches of vermilion and blue.

**476**

picture is now ready for the finishing application of color, value, and brushwork.

Ferrón completes the painting by working with many mixes, cleaning the palette now and again so as not to dirty the colors.

Now the painter works on the body, taking great care to apply colors in very specific areas, without mixing them together. He paints a cool pale pink made of carmine and white in the illuminated area of the foot and thigh; a brighter pink, with some carmine, next to the pale pink; a warm orange and an ocher in a few areas of the illuminated zones; a flesh color, the result of burnt umber mixed with white and a little blue, in the shadow of the right leg; and a much cleaner color, mostly containing carmine and violet, in the very marked but transparent shadows of the left thigh and right knee. The shadows have to be kept clean because the human body has a color that reflects light; it is never opaque, we can nearly always make out the forms in shadow. Ferrón has even painted some small touches of orange and light violet in certain shadows, like the one below the elbow, where the model is resting her hand, to lend it more light and resonance. In this way, the shadow becomes cleaner, thanks to the artist's pointillist touch.

Ferrón also defines the bluish shadows in the sheets of the foreground a little more, leaving the

**477**

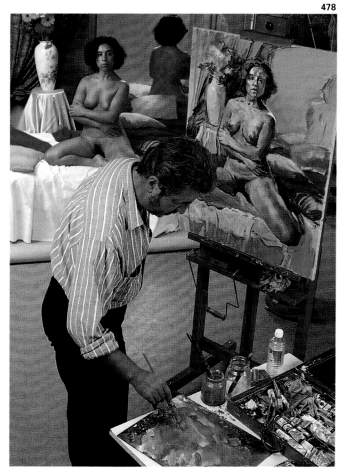

**478**

Fig. 476. The artist continues to paint with the warm flesh colors, creating contrast with the cool tones to highlight the volume. He works more slowly now, in sections, first working on the face and bust.

Figs. 477 and 478. Ferrón continues to work in the same way and in the same area, allowing the background to breathe, applying loose brushstrokes and using a little black on the body; he has painted the dark area of the pubis with several colors.

middle ground with the mirror and the vase only sketched. Since the mirror reflects white light, he keeps the white stroke on the shoulder and even adds a bluish white to the right thigh, joining the outline of the right side of the body. Note how Ferrón finishes the picture–or better said, decides that the picture is finished–and learn for yourself how to mix colors to obtain flesh colors.

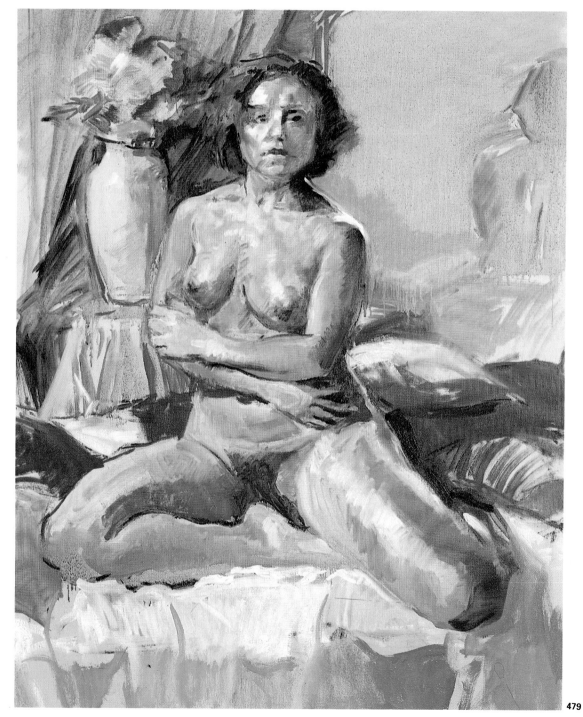

Fig. 479. Note the difference in treatment between the background and the figure, which gives the picture more interest, and especially the rich variety of colors that have been obtained from both the warm and cool ranges–the shadow of the leg, for example–and note the direction of the brushstrokes.

**479**

# Using color contrast and value expressively

A painting of a nude is first and foremost a picture. This is how most modern artists see it, as a consequence of what the Postimpressionists believed. It is for this reason that the color shadings, the treatment, the medium and texture are often more important factors than the subject itself. With these fundamentals it is logical to think that the use of color can be arbitrary. It is not essential to faithfully abide by the tones of the model and the surroundings. You may be expressionist and use color to evoke emotions by, for example, creating strong contrasts of yellow and violet or cool blue harmonies. Or you can arbitrarily choose tones but maintain their real values with respect to the surrounding tones. In short, it is perfectly possible to paint nudes without using any flesh colors or only partly so.

The paintings by the Expressionists, the Postimpressionists, and the Fauvists are good examples of the different ways in which artists have used color. Look at the reproductions on this page to see how these artists exploited new color possibilities.

When we introduced color theory, you saw how a maximum color contrast is obtained from complementary colors. In fig. 480 you can see a graphic example of this. Painters use this knowledge to bring their paintings to life, to express energy (a yellow appears much brighter when it is contrasted with violet). In addition, it is not essential that the colors be absolutely pure: a pale yellow can be contrasted with a light bluish violet, a pink juxtaposed with apple green, or orange with turquoise blue. The important point is contrast. Toned colors, which most artists use, are contrasted with neutralized colors of a complementary tendency. This way the painting takes on life while maintaining its

**480**

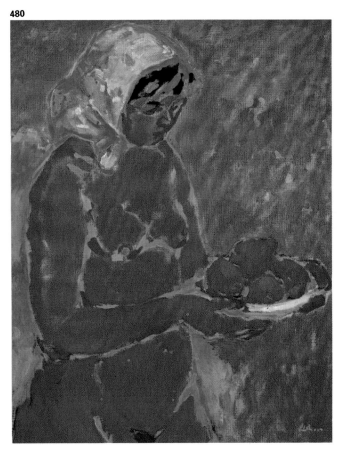

Fig. 480. Teresa Llácer, *Offering*. Private collection. A beautiful painting based on the complementary relationship of green and red.

Figs. 481 and 482. In these two color studies, you can see the different effect obtained by the painter with cool colors and warm colors on a green background. The best solution is the one painted in warm colors for the contrast of green and red. Don't you agree?

elegance, and does not appear too loud.

Naturally, painting is fundamentally a question of defining color in relation to the whole.

One way of using this knowledge is to paint on a colored support. Titian painted his nudes and portraits on a reddish primed format, so as to brighten the pale skin

**481**

**482**

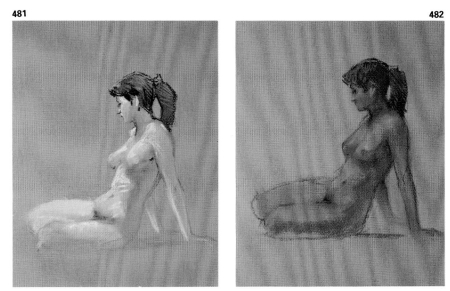

colors and obtain reflections of flesh and fire. It is also possible to paint on a complementary color in order to create a contrast from the very outset (fig. 506). Another interesting aspect that we must not forget to mention is color value. We can choose a color arbitrarily but adapt it to the light we perceive: we can paint the correct values with pure colors that have no relation to those of the model's. The result is a much more "modern," expressionist painting that nonetheless conveys volumes and light interpretation. See how it is possible to relate any color with any range of values in fig. 484. The truth is, once you are able to use color freely, you will instill more of your personality in the painting. Therefore it is better express your purpose and attitude far more than if you attempt to merely reproduce what you see. Nonetheless, what really stands out in a painting is the painter's sensitivity.

Figs. 483 and 484. Here we compare a scale of values from white to black with an unconnected color scale that also goes from light to dark. Whether the choice is arbitrary or expressionist, the painter can paint the appropriate values to express volume and light with pure colors, which do not exist in the reality of the subject.

Figs. 485 and 486. Left: Karl Schmidt-Rottluff, *Young Woman Washing Herself,* 1912, oil. Berlin, Brücke Museum. Right: Ernst Ludwig Kirchner, *Two Nudes with Earthenware Pot and Stove,* 1911, oil. Offenborg, Burda Collection. These two paintings are fine examples of early 20th-century German Expressionism.

**483**

**484**

**485**

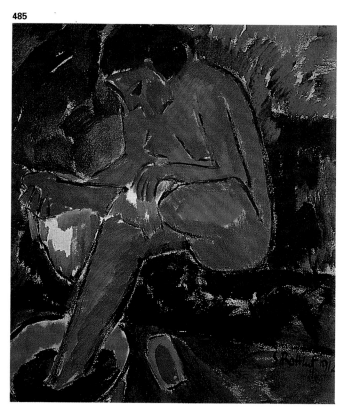

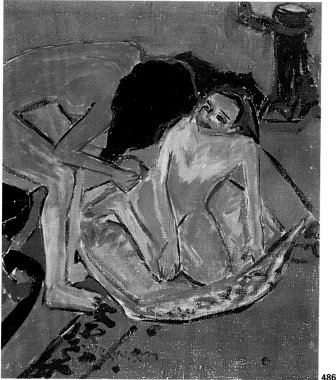

**486**

# Colorism: Joan Raset paints a nude in pastel

Figs. 487 and 488. Here you can see Joan Raset speaking with his model. He asks her to adopt the pose on this makeshift bed, which is covered by a bright pink sheet.

**487**

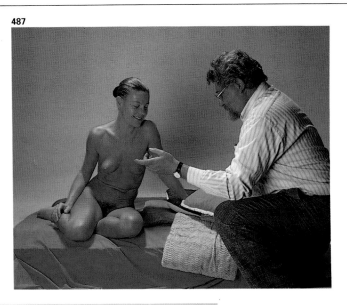

**488**

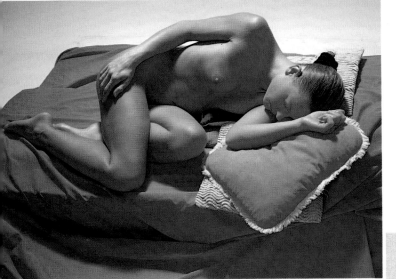

Fig. 489. Raset begins the sketch by drawing with a pencil, blocking in the curved shapes and searching out the forms without pressing too hard on the lead.

Joan Raset in an artist who specializes in the nude as a subject, which he often paints in pastel or oils, although he explains that he began by using pastel, which enabled him to obtain a maximum result with the minimum amount of pigment. The painter likes to apply pastel in such a way that the color of the paper breathes through. For Raset the pigment must appear fresh, transparent, and vibrant; therefore he never applies thick impastos and dense shadings.

The painter has arrived with his model, a beautiful young German woman with an athletic body, who works very often with Raset. The artist has also brought along a sheet and several cushions for the setting. He asks the model to adopt the pose he wants: half curled up on the makeshift bed, a very intimate pose, which he will paint close up so he can see her from above. Note the artist's interesting box of pastels (fig. 490). This collection of broken, pyramid-shaped pieces contains very few flesh colors. The unusual shapes are the result of applying them on their flat side, for obtaining sweeping flat strokes.

Raset always begins his pictures with a drawing, because pastel cannot be corrected or erased. He gets down to work with apparent ease, filling most of the paper with soft pencil sketch lines, cropping the leg somewhat, gradually blocking in the figure without detailing the fingers, eyes, or arms. This loose, expressive drawing reminds us of Schiele's work because of its angles and pose. See how he relates the figure's curves, just as we demonstrated in an earlier chapter of this book. The artist avoids covering the pores of the paper, so that he can finish the construction of the figure in pastel. Once the preliminary drawing is finished, Raset

**489**

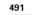

rubs a cloth over the paper, partly to erase the lines and partly to remove some of the graphite. Then, starting with the head, he begins to paint with a piece of red-violet pastel. Rapidly, the artist applies dark, flat, shaded areas, then he goes on to the shoulder and arm, and from there to the breast, using the corner of the pastel to define lines.

Fig. 491. The drawing is more or less finished. The most important lines and forms were defined beforehand, since pastel is a medium that cannot be erased or corrected.

Fig. 492. Raset removes part of the drawing; rather than erasing, he lightly runs a cloth over the paper to pick up some graphite so that the pastel will adhere sufficiently to the paper. For this reason the artist only sketches the figure.

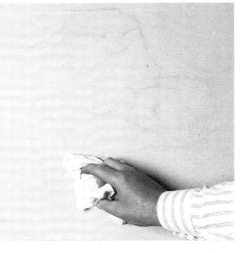

Fig. 490. Joan Raset's "palette" of pastel colors.

Fig. 493. Raset starts painting with a piece of red-violet, applying the flat side of the stick to the paper.

494

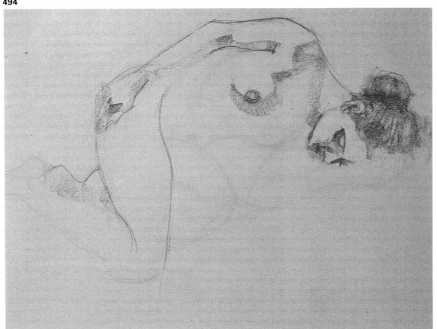

Fig. 494. The artist proceeds to paint and draw at the same time with this color in the body's silhouette and shaded areas, always with the flat side of the stick, whether he is drawing lines, as in the leg, or painting flat shaded areas in specific directions, as in the work we can see in the face, hair, shadow of the neck, and breast.

Figs. 495 and 496. We can now see the development of shadows in the area of the face and bust. The painter continues to paint in violet, and when most of the shadows have been defined, he chooses several new colors: some blue for the background, a few touches of red and orange around the body, and some yellow cadmium medium on top of the original shadows, thus providing the picture with needed contrast.

Raset, very concentrated on his work now, proceeds with the red-violet pastel; he continues defining the silhouette with curved and straight lines in certain areas, while other areas are reserved for the shaded areas that also outline the figure, in the shadows of the stomach and the knees, for example. In addition, Raset begins to indicate values with this color, since he has started it by placing the darkest areas, enhancing the volume, which is defined by the rather bright top and side lighting. The artist now paints darker tones in certain areas, such as the head, the hand, some parts of the stomach, etc.

Raset now takes up a broken piece of violet pastel to reinforce certain areas with somewhat lighter shadows. He goes over some previously shaded areas with soft strokes. Then he chooses some more colors, red, blue, and green, which he uses to apply a few touches here and there. Afterward, with cadmium yellow medium, he searches out the contrast and value. Note how much the yellow is highlighted by the surrounding violets (fig. 496).

Now with a warm salmon pink, Raset paints over the original shaded areas in order to obtain intermediate and warmer tones. Immediately, he applies some square touches of red and carmine to the hair, hand, and arm the figure is resting on. Thus the painter manages to apply darks in the unlighted areas, but without using a dirty color: in fact, he uses a bright red, which acts as a dark value. Incredible!

Raset seems quite fond of the red in shadow; he continues using it in the legs and the most illuminated part of the arm. At the same time, he goes over the violet cushions and the figure, joining the different parts of the body together. And

495

496

**497**

now comes the most interesting part: the artist paints bright yellow in all the illuminated areas of the figure, using the flat side of the pastel, sometimes pressing down firmly on the paper, other times merely caressing it.

Raset has created a wonderful contrast; the light and the volume are correctly expressed and appear elegant at the same time. Now you can see that he has used a relation of complementary colors (yellow and violet).

Then the artist paints a touch of turquoise green and blue to break the contrast somewhat.

Fig. 497. The artist now applies square-shaped areas of red and orange in the face and the breast, sometimes blending a little with his fingers, hardly applying any pressure so as not to lose the freshness of the pigment or cover the grain of the paper.

**498**

**499**

Fig. 498. Raset brings out both form and volume thanks to the definition of light and shade with pure colors, especially red and violet in the shadows, and bright yellow in the lighted zones.

Fig. 499. Raset's pastel sticks have acquired these unusual pyramidal shapes because he always applies them on the flat side.

Raset adds the final colors to bring the picture to an end. He concentrates on reinforcing and toning the contrast, volume, and illumination that have previously been established. He uses an orangish hue and the salmon pink to blend and tone the rounded yellow shadings. Gradually, and with great care, the artist fills the support (a neutral gray, excellent for bringing out bright colors), leaving very little of the paper visible. But he never intentionally tries to cover the paper, it happens "by accident" as he fills the paper with more and more light strokes of color. Now and again the artist resorts to his fingers to mix colors and obtain a denser treatment, for example, in the area of the breast and in some shadows of the arm. Nevertheless, his light additions of color always give a feeling of transparency. Note in the detail (fig. 501) the different treatments and how the violet and carmine in the shadows let the pores of the paper breathe through. Another point to note is the simple planes obtained despite the amount of superimposed colors. They consolidate the areas in light and shadow and give the picture its strength and force.

Although Raset has practically finished the picture, he continues applying violet and two blues, one ultramarine light and the other even lighter, in the cushions and shadows, reinforcing the contrast between the complements. The painter adds some touches of ocher and orange to the hair, one more stroke of red in the ear and face, and some very bright turquoise green in the background, above the head, thus contrasting it with the reddish tones there... and that's it. Graceful, fresh, strong; these are just a few of the adjectives that sum up this artwork. Thank you, Raset.

Fig. 500. After blending the first yellows, Raset immediately adds some even brighter yellows. He has also used very light green and blue in certain areas, merging the background and figure into one.

Fig. 501. Although not very noticeable, the green and blue strokes of the silhouette create a vibrancy that enriches the picture.

Fig. 502. This is the setting in which the model and the painter work.

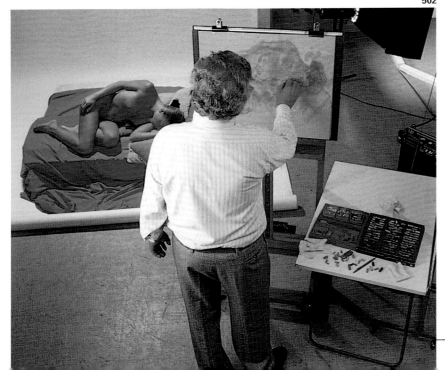

**503**

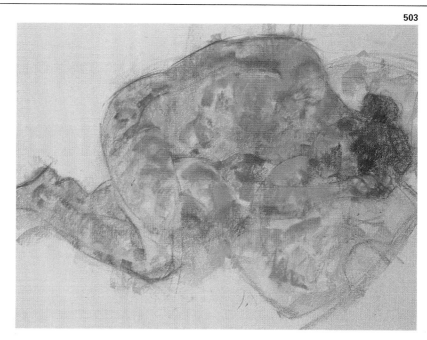

Figs. 503 and 504. The final photographs of this pastel painting process. The painting may appear colorist and arbitrary in color, but not in the correct light assessment. The last stages of the work consist of reinforcing the yellows, working on the hair, and making sure that some of the paper remains visible through the pastel colors.

**504**

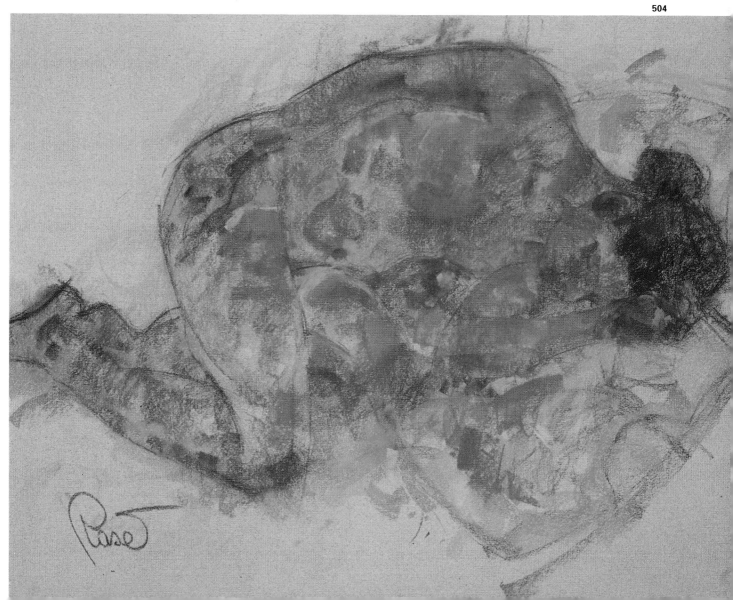

# Color ranges and harmonies in painting the nude

The relationships between colors are fundamental in painting. A picture painted with blue tones is very different from one painted with a stark contrast of green and red. Moreover, the same colors on different backgrounds produce different results. One can also paint with or without luminous contrast or changes in value. The possibilities are almost limitless. Until now we have paid special attention to the valuist aspect of color, the question of expressionist color, color contrast, flesh color mixes, and so on. Now we are going to examine one aspect that unifies most works of art: color harmony.

Artistically speaking, color harmony is always present. Even in pictures where we basically perceive color contrast, there is always a predominant color range that is enhanced with some touches of a complementary color.

We could explain harmony as the relation between similar colors of the same family. That does not mean, for example, only violets. A family may contain violets, reds, and also blue-violet, umber, pinks and blues, etc. It is a question of playing around with colors that are closely related in the color wheel, with the added possibility of lightening or darkening them. These families are known as ranges.

There are three families, or ranges, that painters speak about because they are very useful to them: warm, cool, and neutral, or "broken," ranges. Warm colors, as you may already suspect, are those that are nearest to yellow and red-orange, pink, yellow, and red, fuchsia, carmine, umber, ocher, sienna, and so on–the colors of fire and the desert. Cool colors are those nearest to blue: green, blue, certain grays–colors of the sea, colors of the fields. Neutral or broken colors may be warm or cool, but the one characteristic that links

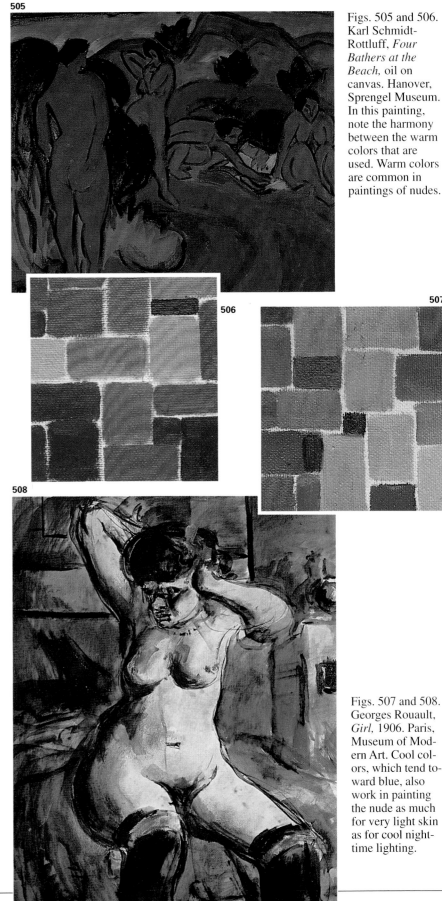

**505**

**506**

**507**

**508**

Figs. 505 and 506. Karl Schmidt-Rottluff, *Four Bathers at the Beach,* oil on canvas. Hanover, Sprengel Museum. In this painting, note the harmony between the warm colors that are used. Warm colors are common in paintings of nudes.

Figs. 507 and 508. Georges Rouault, *Girl,* 1906. Paris, Museum of Modern Art. Cool colors, which tend toward blue, also work in painting the nude as much for very light skin as for cool night-time lighting.

them together is their lack of purity (we spoke about this on pages 152-155); they are composed of two complementary colors in unequal proportions, with a greater or lesser amount of white: grays, browns, undefined colors. This is a marvelous and wide range, especially if the painter mixes them with other, purer colors.

In reality, a color's immediate surroundings dictate whether it will be warm or cool; lemon yellow can look cool if it is surrounded by reds and oranges; on the other hand, if the lemon yellow is surrounded by blues and violets, it will appear warm.

Colors can be light or dark. Note what can be achieved just by combining colors, the multitude of variations (Figs. 511-514). We can decide on color for color's sake, color based on the relations within the picture, color to express ourselves, etc. We can also choose a warm or a cool range of colors on the same cool background for the same figure: the results will be radically different. Doesn't it make you want to start trying out colors and backgrounds with harmonic ranges and daring contrasts?

Don't take it for granted that a nude should always be painted with warm or broken-warm colors. There are exquisite nudes painted with cool colors, transparent blues, silvery grays, pinks and violets.

509

510

Figs. 509 and 510. Matisse, *Black and Gold Nude,* 1908. Saint Petersburg, Hermitage Museum. A range of broken colors always looks elegant and varied. It can be cool or warm, as in this picture.

511

Figs. 511 and 512. Compare these two studies and see the enormous difference between them. The colors used are identical; the only thing that changes is the background color. Which one would you choose and why?

512

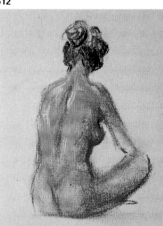

513

Figs. 513 and 514. Here we can compare the result of painting two figures with the same color, one on a light background and the other on a dark one. The contrast is striking.

514

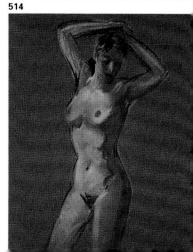

# Ballestar paints a nude in watercolor with cool colors

**515**

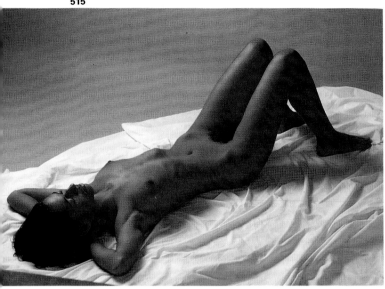

Figs. 515. This is the pose Ballestar has chosen for his painting, which he will paint in watercolors. The point of view is highly original: the model's head is closer to the artist than the rest of the body.

Ballestar is regularly asked to collaborate in our publications because his great experience and talent are second to none. He knows most of the mediums and genres well, but the medium he is most attracted to is watercolor. Let us test his knowledge and watch him paint a nude in watercolors.

Whatever your subject is, watercolors demand a different treatment from other mediums. One of the main differences is that you very often have to work in sections to take advantage of the dampness of the area you are painting. This can create difficulties for the beginner because the artist must have a mental picture of the entire painting, and even though it is impossible to paint everything at once, he or she has to maintain the unity and harmony without really seeing it.

Ballestar chooses an original pose for this picture. The model is lying on her back with arms folded behind her head, and her knees are legs are raised and bent. It is not a simple pose, and he will have to use his imagination to transfer it onto paper.

Ballestar starts by dividing the paper with a diagonal line and filling as much of the space as he can with the figure. He is so familiar with the human body that he directly draws the figure's outline, using a stick of compressed charcoal, without pressing down too much, as well as a few lines to define the separation of light and shadow. This is important because watercolor is a luminous medium that facilitates a maximum contrast between light and shadow. Therefore it is essential to define the dark and light zones of the picture at the beginning because the lights can only be painted by reserving the white of the paper and then, if necessary, using very dilute, transparent color.

Fig. 516. Using a stick of compressed charcoal, Ballestar draws with a loose wrist, roughly defining the position of figure with a diagonal line. The foreshortening effects here are produced because of the proximity of the head and shoulders to the artist.

**516**

Fig. 517. The drawing is concrete and correct, even detailed, because watercolor allows even fewer corrections in process than pastel. We can appreciate the austerity of the subject: a body on a white sheet.

**517**

Once the drawing is finished, Ballestar "erases" most of the lines, leaving only faint marks, so that the charcoal pigment will not dirty the watercolor paints.

Then, using a wide brush, he applies diluted indigo in the area that separates the background from the sheet. Note in the following photograph how Ballestar paints the body: first the shadow with carmine mixed with the original blue, then some burnt sienna on the left leg. Ballestar reserves a large white area on the body, and he takes advantage of the just-painted area by applying a very dilute orange beside it and allowing the edges to blend together.

**518**

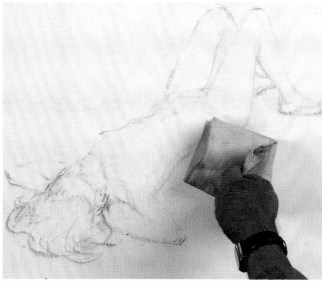

Fig. 518. Since watercolor works with water, it is essential to remove as much of the black charcoal pigment as possible, so that the colors do not become dirty. Ballestar goes about this task with a rag.

Fig. 519. He now applies diluted indigo, a dark violet, in the background while reserving the whites.

**519**

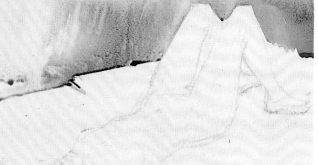

Fig. 520. With a flat brush, the artist quickly paints the area of the body and legs, first with a diluted blue in the shadow, then with a flesh color obtained from a mix of orange and water with a few dabs of blue or sienna, and finally, by going over the areas, he distributes the water, blending the two zones while they are still damp.

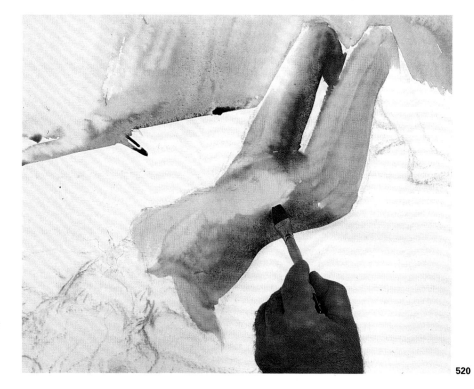

**520**

173

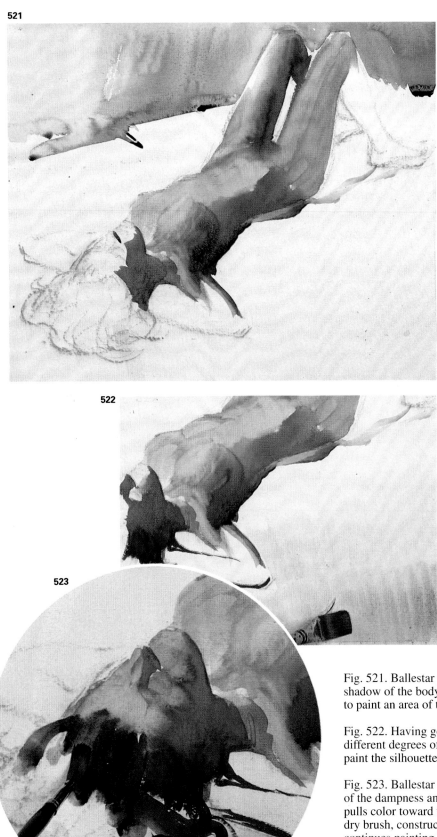

Ballestar has no other option than to spend some time painting the area he started on. Concentrating on the thighs and the trunk for the time being, he adds several strokes of the two main values, the orange for the lights and carmine, sienna, and blue for the darks.

The general intonation of body is decidedly cool, since the cool colors predominate, and even the warm pinkish-orange of the light area is rather cool.

Ballestar continues working with transparent colors, defining the area of the hips while painting the shadow cast on the sheet, for example. Then he lightly runs the brush, loaded with the color that remains, over the left leg, thus obtaining several very cool, subtle, transparent flesh colors from the mix with the siennas and oranges of the first coat. Now, using a violet-carmine (fig. 523), the artist begins painting the head. Note the perfection with which he reserves the white of the paper; great care must taken to avoid painting in the light areas, or the volume will not be so evident.

In fig. 524 we can see how Ballestar has stopped working on the body and concentrates on the head. He applies sienna over the first color on the face, making the area darker but warm;

Fig. 521. Ballestar paints some pure ultramarine blue over the shadow of the body. Then he mixes it with carmine and sienna to paint an area of the face.

Fig. 522. Having gone over the area of the face and hair with different degrees of color, the artist uses the same mixture to paint the silhouette of the arm.

Fig. 523. Ballestar continues in the same area, taking advantage of the dampness and color of the recently applied stains. He pulls color toward the lighted area, absorbs the water with a dry brush, constructing the features at the same time, and continues painting long strokes with new mixes of the same colors in the hair.

then, maintaining the reserved whites, he works on the hair. In addition, he paints the right arm in umber with a round brush, then uses the same color to apply several parallel strokes over the hair, which quickly spread to the rest of the head. Without pausing, the artist paints a very dilute transparent pink in the whites, taking advantage of the water to enter the dark area.

Ballestar continues painting the hair with red, sienna, and umber and then goes on to the pubis, the shadow of the right leg, and finally, the separation between the calf and the thigh.

Note in fig. 525 how the artist has painted both arms and, in order to express the subtle differences in illumination, has made the left arm warmer and more orange than the right one, which possesses the same cool tones as the body. These lights are obtained by lifting the wet stain with a dry brush. He uses the red tones now to paint the nipples, which appear partly in light and partly in shade.

Note how the face has been painted with some delicate dark strokes and several glazes of red and sienna, which were applied over the previous colors.

An artist who is as experienced as Ballestar can define the face

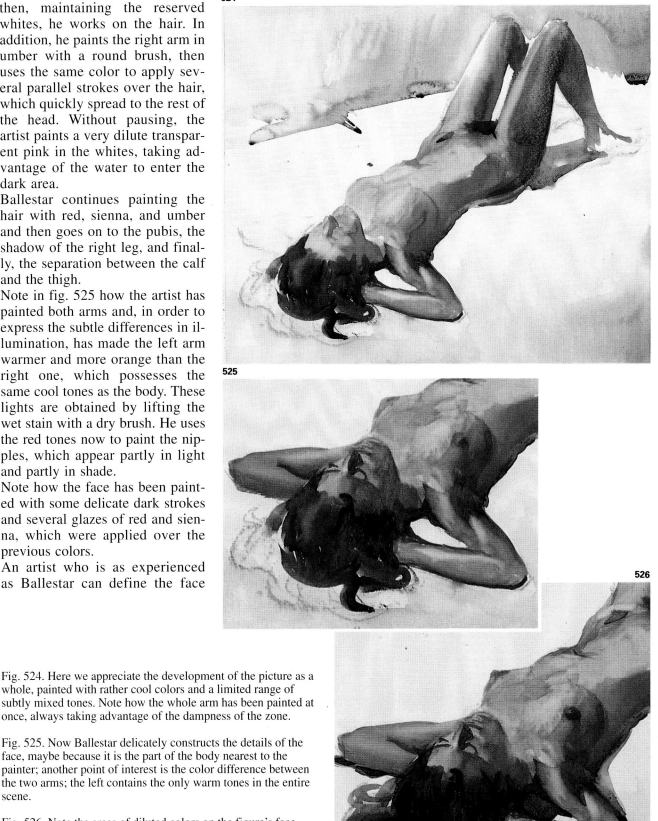

**524**

**525**

**526**

Fig. 524. Here we appreciate the development of the picture as a whole, painted with rather cool colors and a limited range of subtly mixed tones. Note how the whole arm has been painted at once, always taking advantage of the dampness of the zone.

Fig. 525. Now Ballestar delicately constructs the details of the face, maybe because it is the part of the body nearest to the painter; another point of interest is the color difference between the two arms; the left contains the only warm tones in the entire scene.

Fig. 526. Note the areas of diluted colors on the figure's face and breast.

thus without letting it look out of place. But if you are a beginner, it is better not to go into too much detail in the face; it is better to concentrate on expressing the volume of head and face, perhaps the nose but no more. Any attempt at bringing out a lot of detail could have disastrous results. Remember, we are painting a nude, not a portrait.

Ballestar finishes this beautiful nude in cool tones. The foot, which up to now has not been dealt with, is painted with the carmines and violets of the leg. Some delicate brushwork here defines the ankle and toes. In the same way, he continues constructing the head, adding glazes to the hair and increasing the warm tones of the face. If you observe any human figure, you will notice that the face is always darker and redder than the rest of the body. Ballestar applies a touch of red to the cheek and nose to give the nude more vivacity. But in this case the head is nearest to our point of view, and it is an established fact that warm colors seem to "approach" the viewer while cool colors "retreat"; pure and contrasted colors are also situated in the foreground and grays in the background.

In this final stage of the painting, Ballestar looks at his work much more than he touches it, finally adding some violet to finish off the foot, a further stain to darken the pubis and the hair, some red to the lips, the shadow of the arm, and so on. Once dry, watercolors lose their intensity; therefore it is necessary to adjust them according to the painting as a whole if we see that, on drying, some colors have little relation to the others. This is one of the dangers of working in sections, but you should be able to overcome this hurdle if, before you decide the painting is finished, you study it closely to compare values. We must be strict with ourselves in this respect: the most important

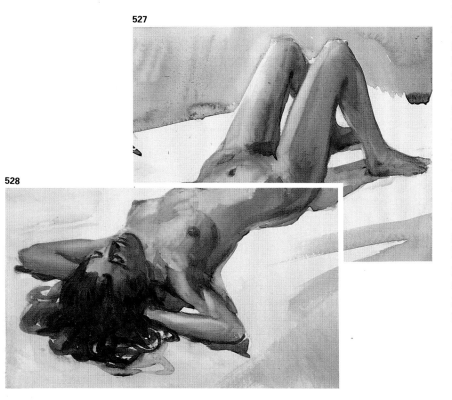

527

528

529

Fig. 527. Ballestar very delicately paints the skin of the legs with sienna tones.

Fig. 528. Here we can see how the artist works in sections; now he concentrates on the right arm and hair, also painting the shadows cast on the sheet.

Fig. 529. Here we can see how the artist (who always stands while painting) positions himself with respect to the model and organizes his work tools: the paper attached by drawing pins is on a slanted drawing board set on a table.

work of the painter goes on in his or her head; the artist must be totally aware of what is happening on the paper or canvas.

Ballestar has achieved maximum expressiveness in his work, and the cool harmony is reinforced by a small application of orange in the left arm. We congratulate him for his excellent powers of development and his loose brushwork with the colors that have construct-ed this work. Thank you for having demonstrated how beauty resides in austerity: the austerity of the subject itself, supported by such basic colors.

Fig. 530. This is the final painting, in which we can see the enormous interest a nude can possess when painted in watercolor. A watercolor painting should always be left loose, with no attempt to define every volume. It consists, essentially, of constructing and suggesting planes.

**530**

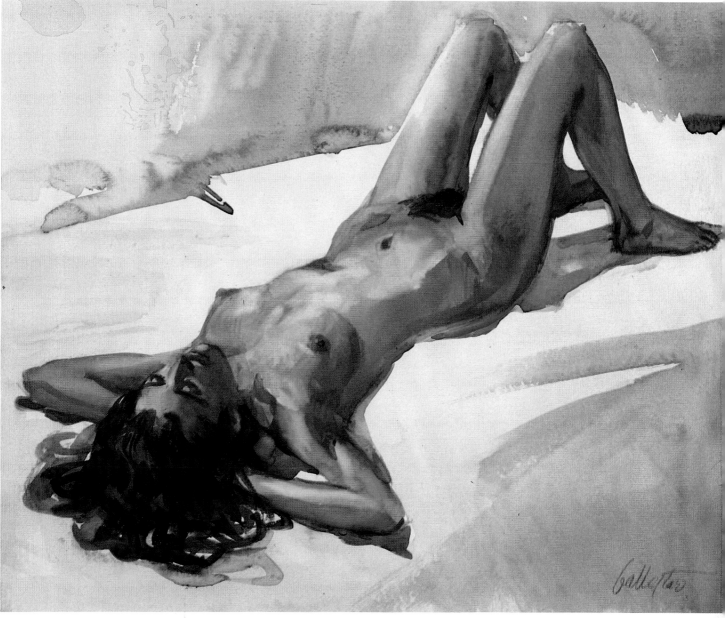

# THE PROCESS OF PAINTING A NUDE

Esther Olivé de Puig is going to take us through the process of painting a nude. This will enable us to recap everything we have learned in this book. The result is a modern, original, colorist painting, something that is possible only with preliminary sketches and studies, with careful planning of composition and color.

Fig. 531. Detail of the penultimate stage of the painting that Esther Olivé de Puig has painted in our presence so that you can see how a professional goes about the task of executing a picture.

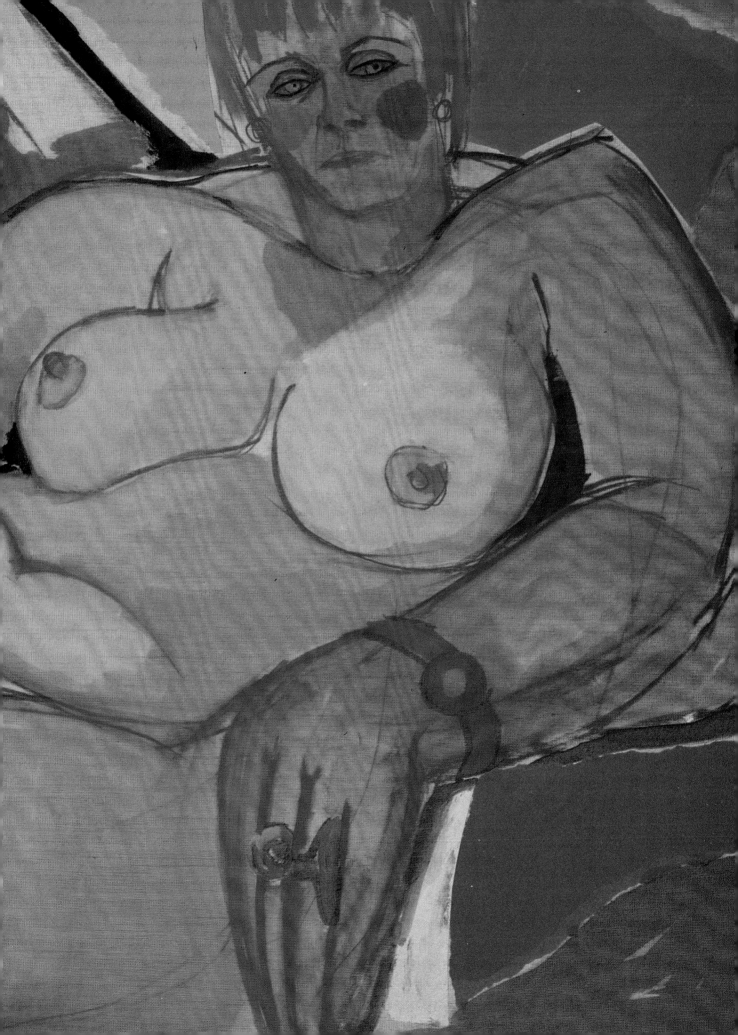

# Esther Olivé de Puig paints a nude: studying the pose

We are going to follow this splendid artist, Esther Olivé de Puig, as she paints a nude. We have photographed the session to give you an idea of what goes into the process of painting a nude. Olivé, like many painters, does not always use the same process. But her way of working happens to coincide with much of what we have explained throughout the pages of this book.

The artist has already chosen the model, a mature woman who is extraordinarily pictorial because of the broad surfaces of her body, which has a sculptural quality. The next step is to choose the pose. Since the model's character will make this process rather long, Olivé asks her to try out several different positions, half-seated and stretched out, with the head turned to the right, and so on. As Rosario, the model, adopts different positions, Olivé sketches without stopping. When she sees an attractive pose, the artist slows down (fig. 535) and tries to assess the light and shape. She starts by drawing sketches in pencil or charcoal, studying (just as we described in earlier chapters) the volume and gesture. To get a better idea of

Figs. 532-535. The artist begins by selecting the pose. She tells the model what poses she is interested in and draws them while Rosario adopts different positions. The poses, half-seated or stretched out, are suitable for such a substantial woman.

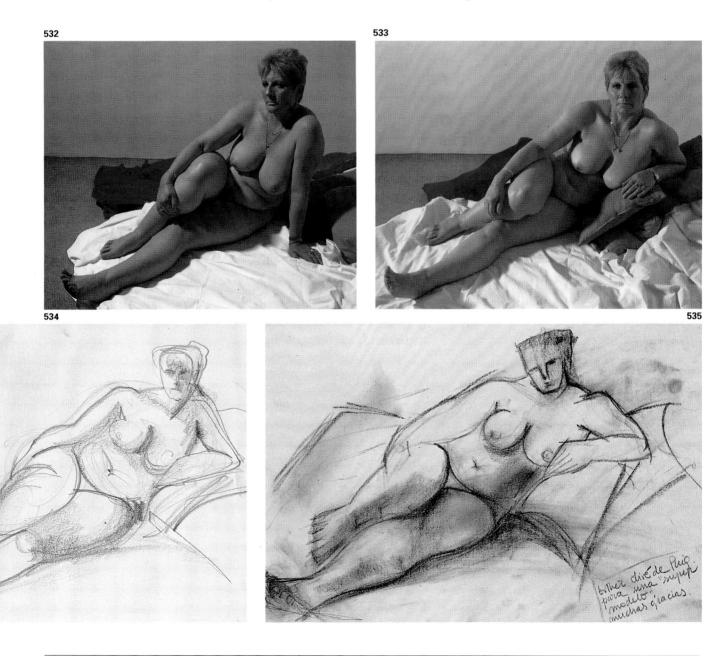

532

533

534

535

**536**

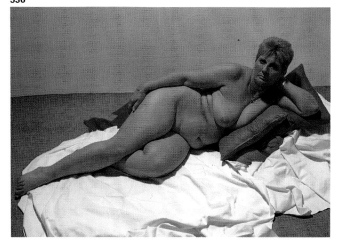

Figs. 536-538. Olivé likes this *"maja"* pose a great deal, so she draws several studies of it. Some of them are purely linear, while the others are compositional, obtained with quick strokes, defining the pose and framing the body.

what these poses will look like, she draws some small sketches of different compositions (fig. 537). They show the artist's blocking-in lines, which connect the parts of the body together. This pose, in which the model is practically stretched out, resembles that of a *maja* in its open and self-assured quality (fig. 536). Olivé finds it so interesting that she immediately sketches it on a large piece of recycled paper. Using colors, she tries out a composition by cropping off part of the arm and legs. The expressionist construction of the volumes and exaggerated shape of the body shows us in which direction this picture is headed.

**537**

**538**

Figs. 539 and 540. Finally the artist draws a rather abstract pastel and collage study of this pose. Then she tries another pose that she finds attractive and chooses it for the final painting, as we will see.

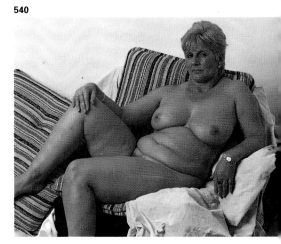

**539**

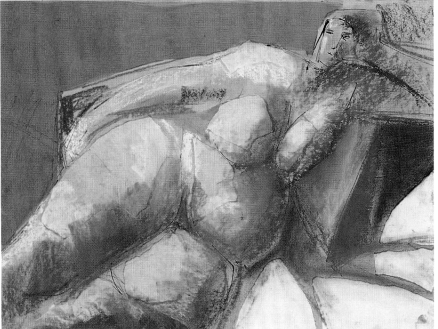

**540**

# Lighting possibilities

We have decided to give you several examples of illumination to make the process more varied, even though the pose chosen by Olivé is not included. What you can see here are some of the poses that the artist and the model were trying out previously. For the final painting, the artist has chosen an enveloping light, which will illuminate the figure from all sides, a light that flattens the volumes but defines the silhouette. This type of illumination corresponds to fig. 543. It is appropriate for this model because it highlights her body's broad planes of flat and pale colors. Another painter, or Olivé herself on a different occasion, might choose a more concentrated frontal-lateral lighting, which defines contrasted shadows (fig. 541), or even lighting from behind the model, which merges the face with the shadow of the neck and the right shoulder (fig. 542). A very lateral source of lighting would create a dark area in the hollow between the stomach and the legs (fig. 544).

**541**

**542**

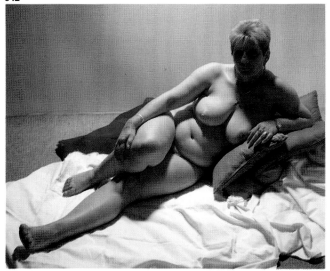

Figs. 541-544. Here we have several possibilities of lighting the same pose. Remember, though, that this work was carried out after testing all the poses, especially the one the artist chose for her final painting. The first two are distinct possibilities with concentrated light: one frontal-lateral, the other almost lateral-backlighting. Both create sharp shadows in different directions. Then (fig. 543) we try an enveloping illumination that does not create shadows, and finally lateral diffused lighting.

**543**

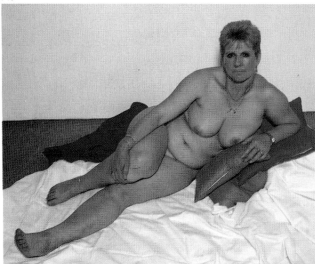

**544**

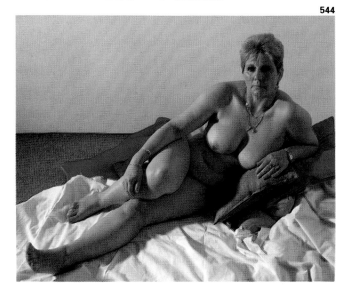

# Studying light, shadow, and composition

Olivé continues drawing small sketches and studies to assess the lights and shadows. At the same time she tries out different types of illumination in this pose (fig. 543) and the previous ones (pages 180 and 181). The studies that the artist has drawn can be seen in figs. 545-547. In two of them she includes the shadows, while in the other she chooses a flat illumination that results in hardly any shadows (fig. 546). Then Olivé tries out some new compositions, one of the most important aspects of any pictorial process. She crops the body until it fills almost the entire surface of the paper. She also paints a few trials in watercolor (fig. 548), using cool and light grays in the shadow areas.

**545**

Fig. 545. Olivé continues drawing, trying out different types of illumination; the one here corresponds to the pose in lateral diffused light.

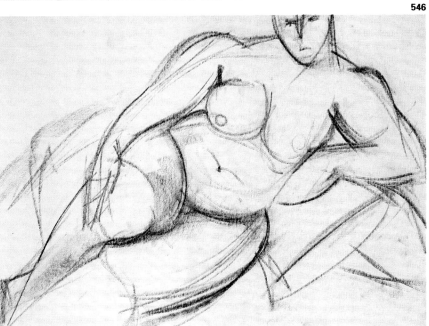

**546**

Figs. 546-548. The artist continues testing, at the same time studying lighting, different compositions, and even a possible color harmony. Fig. 546 is lighted by a flat, enveloping type of illumination.

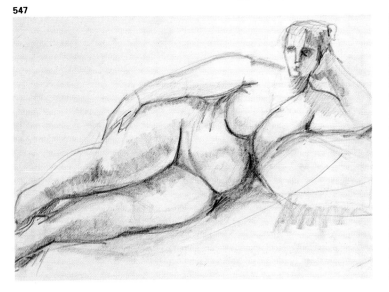

**547**

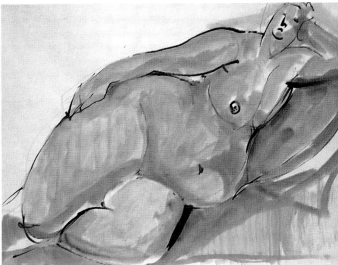

**548**

# Making decisions

Fig. 549. This is the pose chosen by Olivé after contemplating several poses on the paper. Drawing is the artist's way of thinking; it is her only way to conceive a painting.

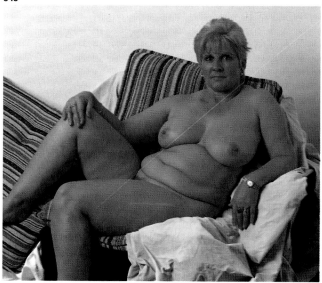

549

The painter has to make a decision about what the final painting will look like. First, she chooses this pose (fig. 549), which is the one we saw at the start. Rosario is sitting in a chair looking relaxed and self-assured. The lighting is flat and enveloping, with hardly any shadows, leaving only the color and the silhouette. Olivé thinks that the cushions in the background will enhance the picture; but for the moment she concentrates on choosing the composition and representation of the figure, as you can see in figs. 550 and 551. In the latter one, the painter begins to study the lines and even the relation of colors: pink and blue to simplify. Note the importance of the curves and rounded relations among the different parts of the body, which Olivé now paints on a large sheet of paper in watercolor and collage (fig. 552).

Figs. 550-552. In addition to the studies of the body and lighting, the artist must choose a composition and color harmony for the picture; this is reflected in these sketches.

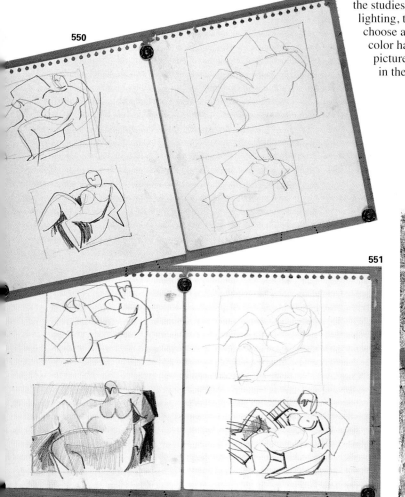

550

551

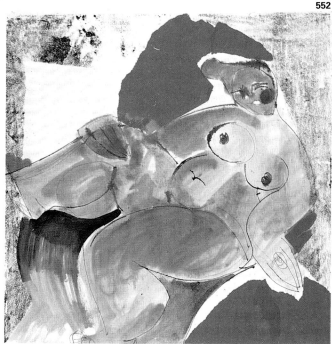

552

# A color study

Before painting the final picture, Olivé paints a color study on a prepared hardboard panel with the medium she has chosen: a mix of oil and collage (pieces of paper and other materials glued to the surface). In the process of this study, the collage allows color relationships to be tested with speed. It also facilitates building up large planes that will help the artist assess color and volume. The first stage of this study (fig. 553) is interesting; Olivé paints with two very different colors diluted with turpentine. The composition is good: the head and feet have been slightly cropped. The colors (violet, green, red) are distributed over the body in transparent planes. The next stage consists of gluing on brightly colored paper (figs. 555 and 556), blue in the background to contrast with the warmth of the body, and light pieces over several parts of the body.

Finally, she paints several darker strokes of violet around the body and others, even darker, outlining it.

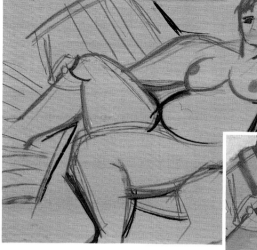

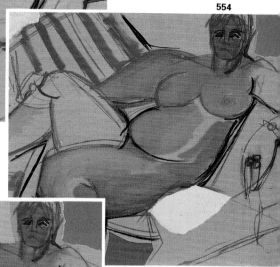

Fig. 553. Before starting the final painting, the artist paints a color study using the same technique of oil and collage.

Figs. 554 and 555. Here, the artist shades the planes of the figure using bright colors diluted with turpentine.

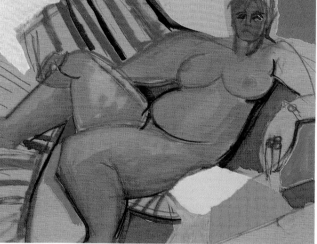

Figs. 556 and 557. The last photographs of this process show how Olivé uses paper collage for testing color relationships, taking advantage of the color of the wooden support as the model's skin color.

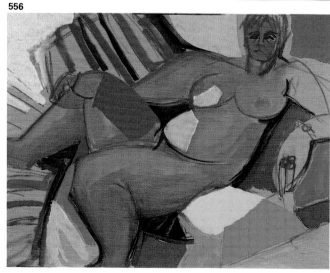

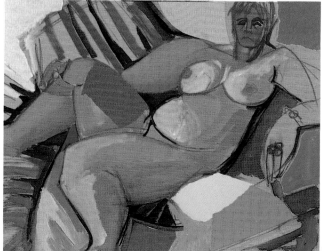

# Drawing, composition, and initial colors

**558**

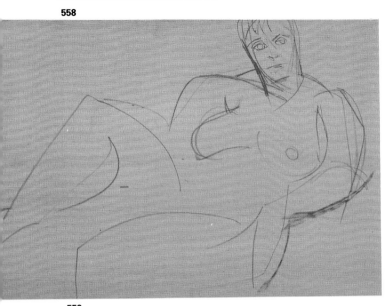

**559**

**560**

Esther Olivé de Puig now works on a much larger panel. As in the previous color study, the artist begins by drawing with a brush loaded with sienna diluted in turpentine. The photographs show the development of the lines that define the composition and figure. The first lines are sketchy but indicate a new composition that removes even more of the right leg, so that the figure now occupies almost the entire surface of the support. The artist exaggerates the size of the hands and reduces the head, then goes over certain lines in ultramarine blue broken with sienna. When the figure is sufficiently defined, Olivé stains the face and neck with very transparent sienna and, without pausing, paints the pupils and eyeshadow with a mix of blue and white (fig. 561). Having painted four shadings of a warm tendency in the cushions, hands, and face so as to test the color, the artist places colored pieces of paper over the picture without gluing them down to test color relationships (fig. 562). Then she finally glues them to the support (fig. 563). Note that the final color relationships had already been established in the original color study (blue contrasted with orange, red, pink, etc.). In fig. 564 we can see the current state of the picture, a painting that wisely exploits the background color of the wood panel as a basis for comparing tones. Then Olivé paints cool violet pink in the light areas

**561**

Figs. 558-561. Although it is better to follow the process in the main text, note how little the composition has changed with respect to the original study. The most notable difference is that the body has been framed. Observe also the care with which the drawing has been done with a brush, with shadings applied as necessary until the desired shape is found, all executed in a transparent umber-pink tone, as well as some blue to fix several points. Then the artist paints a very transparent layer in the face and then the blue eyes and eyeshadow.

**562**

**563**

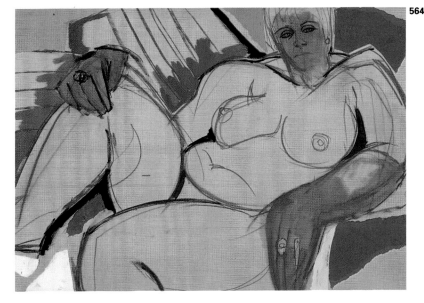

**564**

of the body. Instead of concentrating on one particular area, she applies strokes all over the painting. For this reason, at every stage of the procedure, the picture "appears" complete.

Note how the artist has achieved her work: painting lines with a brush, allowing the color of the wood to be seen through the paint, using abundant turpentine, making brushstrokes visible... In short, she has freely exploited color application and the use of diverse mediums to obtain specific effects, a combination that enriches the picture and makes for a real work of art.

Figs. 562 and 563. Olivé tests the color with some blue pieces of paper, then, deciding to use the background she chose earlier, she glues them to the board, creating an excellent contrast with the warm color of the wood and the drawing.

Figs. 564 and 565. Here we can see the development of the color treatment. First the artist paints the hands and right arm with sienna and umber, but then she mixes it on the palette to obtain a cool and light pink-violet, which she uses to paint the breasts and lightest parts of the legs.

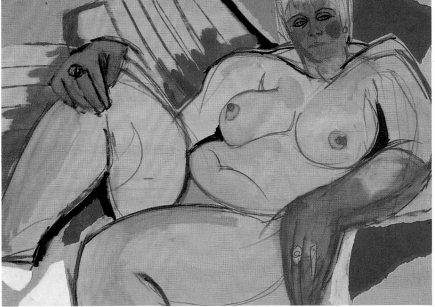

**565**

# Resolving value and color

**566**

**567**

Figs. 566 and 567. Here we follow the development of the legs; first, taking advantage of the color of the wood, the artist paints some soft transparent greens and then expresses the darker shadow with dark blue-green, a contrasting and complementary color.

Here you will see how Esther Olivé de Puig defines volumes softly by using enveloping light and color planes to express subtle shifts in value. A different effect would be obtained if she had used chiaroscuro instead. The artist begins by painting several light grayish-green shadows on the right thigh and the right breast; then she adds a strong dark shadow to the left thigh, whose color serves as a background over which she sticks a white piece of paper to obtain a softer and more transparent effect. In fig. 570, Olivé paints a reddish-pink tone in the shadows of the neck and left arm with short flat strokes. Right afterward, she adds some white and blue to the pink tone of the arm to obtain several subtle violet tones that join the arm to the left leg. She removes the paper and chooses this cooler, slightly broken tone, which creates a very pleasant color contrast.

Then, the artist relates the body to the bright reds and oranges of the background by painting the cheeks, face, and hands with the same tones. She now paints some broken green tones in the background. Finally she constructs the shadow of the right arm with carmine (at the top) and green (in the forearm), once again defining two planes without modeling. The picture is the result of a long process, without which the abstract, expressive, colorist synthesis would not have been possible. Many thanks for such a magnificent finale to this book.

**568**

Figs. 568 and 569. This color appears rather unconnected, and Olivé lightens it by gluing some white paper in the area; she also paints shadows on the arm and the neck with bright pink while observing the other colors closely.

**569**

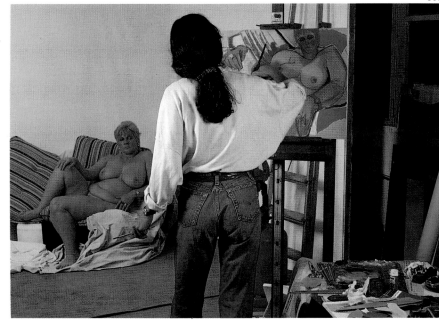

**570**

Figs. 570 and 571. The finished painting is very interesting. First Olivé paints the blue areas around the figure, covering some parts of the wood without painting, then she paints the shadow of the leg with violet, harmonizing it with the rest of the colors; finally, she applies several broken colors all over the picture, thus highlighting the rest of the bright colors. The resolution is perfect.

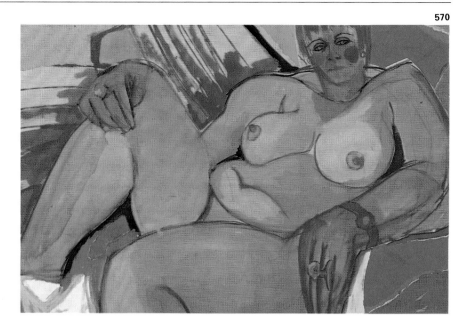

**571**

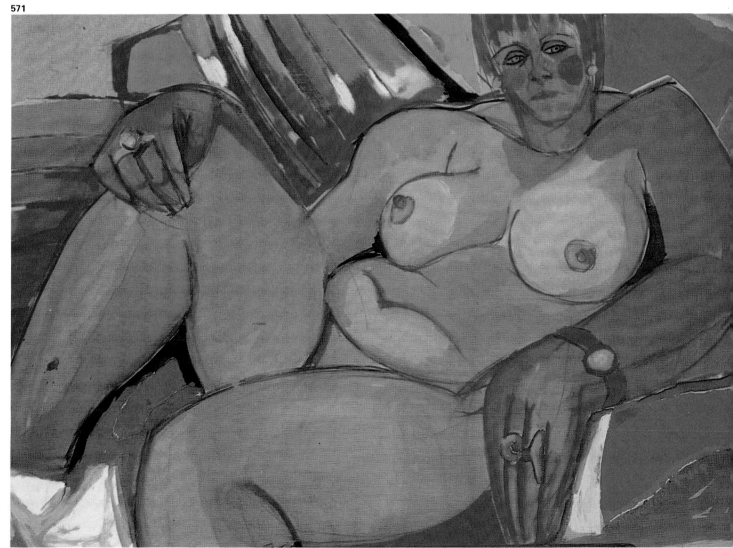

# Acknowledgments

This publication would not have been possible without the invaluable contributions of our editorial director, Jordi Vigué, who participated in many of the photographic sessions, even though this is not his usual work. Many thanks go to Josep Guasch for his sensitivity in designing the layout; to Jordi Martínez for the exhaustive picture research carried out for this publication; and to Joan, Toni, and Jaume from Nos & Soto Studio for their indispensable collaboration on the photography for the book.

I would also like to extend thanks to the artists Joan Raset, Esther Serra, Pere Mon, and all the others for their support and patience during the photographic sessions; and especially to Vicenç Ballestar for providing technical knowledge in the chapter devoted to color and for his demonstration on painting a nude in watercolor; to Miquel Ferrón for his overall collaboration, as well as for his anatomical drawings; to Esther Olivé de Puig for such wonderfully joyful paintings; to Antonio Muñoz Tenllado for his illustrations of the canon and anatomy, which more than met my requirements; to Teresa Llácer for supplying us with some reproductions of her work; to Mercè Sanvisens for the anatomical drawings by her brother, Ramón Sanvisens, who passed away in 1987; and to all the models who so patiently withstood the long sessions.

And not forgetting our mentor, José M. Parramón, whose talent and expertise are an inspiration to us all at Parramón Ediciones. Thank you.

**Picture credits**

© VEGAP, for authorized reproduction of works by Picasso, Rouault, Munch, Bonnard,
    Tamara de Lempicka, and Willem de Kooning. Barcelona 1994.

© The estate of Henri Matisse, for the works published. Paris 1994.